THE METROPOLITAN MUSEUM OF ART

Modern Europe

THE METROPOLITAN

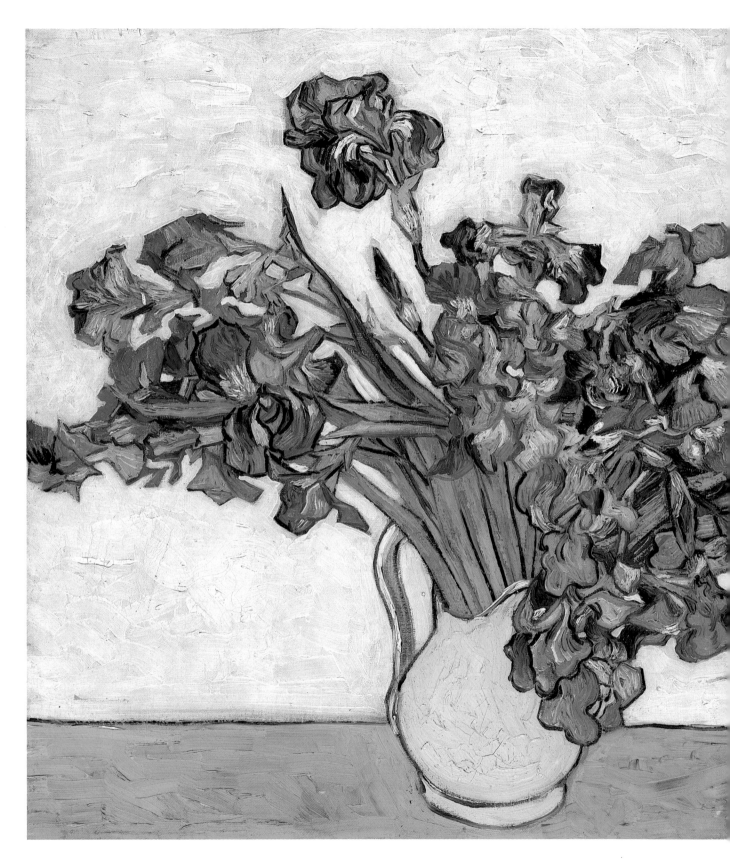

MUSEUM OF ART

Modern Europe

INTRODUCTION

BY

Gary Tinterow

ENGELHARD CURATOR OF 19TH-CENTURY EUROPEAN PAINTING
DEPARTMENT OF EUROPEAN PAINTINGS

THE METROPOLITAN MUSEUM OF ART, NEW YORK

PUBLISHED BY

THE METROPOLITAN MUSEUM OF ART
New York

PUBLISHER
Bradford D. Kelleher

EDITOR IN CHIEF
John P. O'Neill

EXECUTIVE EDITOR
Mark D. Greenberg

EDITORIAL STAFF
Sarah C. McPhee
Josephine Novak
Lucy A. O'Brien
Robert McD. Parker
Michael A. Wolohojian

DESIGNER
Mary Ann Joulwan

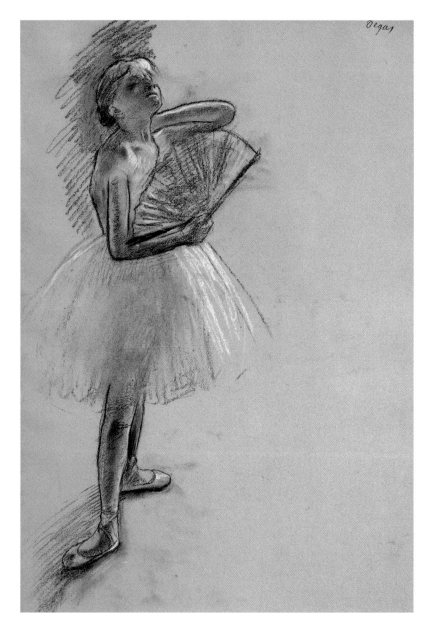

Commentaries written by the editorial staff.

The Photographs for plates 13, 35, 37, 41, 58, 64, 65, 67, 68, 70, 71, 72, 85, 86, 87, 111, 116, 119, 128, and 130 were taken by Schecter Lee, photographer, assisted by Lesley Heathcote, stylist. The photographs for plates 34 and 42 were taken by Malcolm Varon. All other photographs used in this book were taken by The Photograph Studio, The Metropolitan Museum of Art.
Maps and time chart designed by Wilhelmina Reyinga-Amrhein.

TITLE PAGE

Irises, 1890
Vincent van Gogh
Dutch, 1853–90
Oil on canvas; 29 x 36¼ in. (73.7 x 92.1 cm.)
Gift of Adele R. Levy, 1958 (58.187)

THIS PAGE

Dancer with Fan
Edgar Degas
French, 1834–1917
Pastel on paper; 24 x 16½ in. (61.2 x 41.9 cm.)
Bequest of Mrs. H.O. Havemeyer, 1929,
H.O. Havemeyer Collection (29.100.188)

Library of Congress Cataloging-in-Publication Data

Metropolitan Museum of Art (New York, N.Y.)
 Modern Europe

 1. Art, European — Catalogs. 2. Art, Modern —
19th century — Europe — Catalogs. 3. Art, Modern —
20th century — Europe — Catalogs. 4. Art — New
York (N.Y.) — Catalogs. 5. Metropolitan Museum of
Art (New York, N.Y.) — Catalogs. I. Tinterow, Gary.
II. Title.
N6757.M47 1987 709′.04′007401471 86-8343
ISBN 0-87099-458-1 (pbk.) — ISBN 0-300-08788-8
(Yale University Press)

Printed and bound by Dai Nippon Printing Co., Ltd.,
Tokyo, Japan. Composition by U.S. Lithograph,
typographers, New York.

This series was conceived and originated jointly by
The Metropolitan Museum of Art and Fukutake
Publishing Co., Ltd. DNP (America) assisted in co-
ordinating this project.

This volume, devoted to the arts of modern Europe, is the eighth publication in a series of twelve volumes that, collectively, represent the scope of The Metropolitan Museum's holdings while selectively presenting the very finest objects from each of its eighteen curatorial departments.

This ambitious publication program was conceived as a way of presenting the collections of The Metropolitan Museum of Art to the widest possible audience. More detailed than a museum guide, and broader in scope than the Museum's scholarly publications, this series presents paintings, drawings, prints, and photographs; sculpture, furniture, and decorative arts; costumes, arms, and armor—all integrated in such a way as to offer a unified and coherent view of the periods and cultures represented by the Museum's collections. The objects that have been selected for inclusion in the series constitute a small portion of the Metropolitan's holdings, but they represent admirably the range and excellence of the various curatorial departments. The texts relate each of the objects to its cultural milieu and period, and incorporate the fruits of recent scholarship. The accompanying photographs offer a splendid and detailed tour of the Museum.

We are particularly grateful to Mr. Tetsuhiko Fukutake, president of Fukutake Publishing Company, Ltd., Japan, for his dedication to the project, which has contributed greatly to its success.

The Metropolitan Museum's collection of the art of nineteenth-century Europe has grown both through the gifts of many generous donors and through judicious acquisitions made possible by funds established by the Museum's benefactors. Important European paintings of the nineteenth and early twentieth centuries have been given to the Museum by, among others, Edwin Davis, William Church Osborn, Joan Whitney Payson, Alfred Stieglitz, and Catharine Lorillard Wolfe. Especially significant is the large collection of Impressionist paintings given by Mrs. H.O. Havemeyer. Many other important paintings have been acquired through funds established by Mr. and Mrs. Richard J. Bernhard, Stephen C. Clark, Theodore M. Davis, Miss Adelaide Milton de Groot, Sam A. Lewisohn, Jacob S. Rogers, and Catharine Lorillard Wolfe. The Joseph Pulitzer Bequest has permitted the Museum to acquire both paintings and works on paper. Prints and photographs of the nineteenth and twentieth centuries have been acquired through funds donated by, among others, Elisha Whittelsey and Warner Communications Inc. Examples of nineteenth-century European sculpture and decorative arts have been acquired through the generosity of Isaac D. Fletcher, Thomas F. Ryan, Maurice Wertheim, and most recently through the gift of twenty-one Rodin sculptures from Mr. and Mrs. B. Gerald Cantor.

The Department of Twentieth Century Art, the newest of the Metropolitan's curatorial departments, was established in 1970. In February 1987 the Lila Acheson Wallace Wing, housing the Museum's collection of twentieth-century art, will open to the public. Along with many individual works given to the Museum or purchased through its acquisition funds, the galleries will display a number of collections assembled by thoughtful collectors and donated to the Museum. In 1949 the Metropolitan received a large portion of the estate of Alfred Stieglitz, the first sponsor of modern art in America. Scofield Thayer, the co-owner and editor of *The Dial* magazine from 1919 to 1925, left almost his entire collection to the Metropolitan, one of the most important bequests of modern art ever made to a museum. Miss Adelaide Milton de Groot left to the Museum her fabulous collection of twentieth-century paintings, which included many Expressionist masters. In 1984 the Metropolitan received a magnificent gift of ninety works by Paul Klee from the prominent collector, publisher, and retired dealer, Heinz Berggruen. Overnight, it transformed the Museum into one of the richest repositories of Klee's works in the world.

In order to present the most comprehensive picture of modern European art as it is represented at the Metropolitan, the editors of this volume have drawn on the collections of several of the Museum's curatorial departments and on the expertise of their staffs. We are especially grateful to Mr. Gary Tinterow of the Department of European Paintings. He prepared the introduction to this volume and, along with James Draper of the Department of European Sculpture and Decorative Arts, Colta Ives and Maria Hambourg of the Department of Prints and Photographs, and William Lieberman, Lisa Messinger, and Ann Lantzius Strauss of the Department of Twentieth Century Art, reviewed the selections, photographs, and text. Their help in preparing this volume was invaluable.

Philippe de Montebello
Director

MODERN EUROPE

The works reproduced in the first half of this book—dating roughly from the years 1860 to 1890—gave rise to the most dramatic changes in the development of European art since the Renaissance. Acted out primarily in Paris, by painters, the unfolding revolutions from an art of naturalism to various kinds of abstraction and back again to representational art were so profound—even when viewed from our doubting age—as to have fundamentally altered the very definition of art.

The initial stirrings of the pictorial revolution seem to us innocuous enough: Paintings such as Edouard Manet's *Spanish Singer* (Plate 1), a prize-winning exhibit at the Paris Salon of 1861, or his *Mademoiselle V. in the Costume of an Espada* (Plate 2), painted the following year, do not today seem subversive or even particularly provocative. Nor indeed does one find the pleasurable scene provided by Claude Monet's *Terrace at Ste.-Adresse* (Plate 14) offensive or inept, or the wide expanse of Paul Cézanne's *Gulf of Marseilles* (Plate 30) straining for effect. Yet contemporary critics, whether hostile or admiring, saw in these works incipient challenges to the rule of nature over art. Manet's left-handed guitar player and the startling foreshortening in *Mademoiselle V.,* Monet's insistent bands of land, sea, and sky, and Cézanne's imposition on his landscape of a subtle but nonetheless perceptible grid, were all manifestations of the artist's right to render nature as he perceived it, not as laws of perspective, canons of proportions, or manuals of painting would have it.

The challenges to traditional representation and conventional means of notation, nascent in the art of Manet and the Impressionists and extended by Seurat, Van Gogh, and Gauguin, became, by the beginning of the First World War, the means by which artists as divergent as Matisse, Mondrian, Braque, Picasso, Kupka, and Kandinsky could approach an art of complete abstraction. While it is significant that most of the artists represented in this volume continued throughout their careers to draw inspiration from the phenomenal world, their art nevertheless established the primacy of individual perception over description, invention over illusion, and expressiveness over fidelity to things seen. When conservative art critic Henry Havard confessed in his review of the fourth Impressionist exhibition (1879) that he "does not see nature as [the painters] do," he unknowingly touched on the fundamental distinction of modern art. It is a kind of informal history of the beginnings of modern art, as reflected in great works from The Metropolitan Museum of Art, that follows on these pages.

Many artists, among them Gustave Courbet, Jacques-Louis David, and even Raphael, have been called the founders of modern painting, but most historians agree today that it was Edouard Manet who made the decisive split with tradition that gave birth to the self-conscious style of Modernism. Ironically, Manet, more than any other modern artist, exploited the work of earlier painters in the creation of his own pictures. Accused by contemporary critics of being a "Velázquez of the boulevards," an artist so bereft of imagination that he was obliged to borrow his compositions from Velázquez, in the *Spanish Singer,* Goya, in *Mademoiselle V.,* Giorgione and Raphael, in *Déjeuner sur l'herbe,* and Titian, in *Olympia,* Manet certainly enjoyed stealing a pretext for his art. But the challenge to the viewer to find the source of Manet's quotations was only a diversionary tactic on the part of the painter. In fact, by clothing his new and different approach to art in period costume he highlighted the dissimilarity between his painting and that of the old masters. Manet had looked long and hard at paintings by Velázquez, Veronese, and Hals, for example, because in them he found evidence of what a recent writer calls the "paradox of perception"—areas of painterly description where the illusion dissipates, the form dissolves, and only the trace of the artist's hand, the brushstroke, remains. Manet exaggerated this trait until it became an end in itself: the beautiful, broad sheets of color (such as, for example, the salmon dressing gown of *Woman with a Parrot,* Plate 3) for which he is famous. No old master, not Velázquez or Hals, would have considered these passages acceptably finished, even though they are

founded in their work. Of course, the majority of Manet's critics could not see past the exotic costumes—or indeed the nudity—and they therefore criticized him for his parodies. But it was rather in his direct and frank approach to painting that Manet's innovation and importance lay. Matisse summed it up when he stated that "Manet was the first painter who made an immediate translation of his sensations into visual terms, thus liberating his instinct."

Like Manet, Edgar Degas was born to an affluent Parisian family; like Manet, he displayed an early talent for drawing, received a conventional academic training, and demonstrated a strong appreciation of the painting of the old masters. And like Manet, Degas aspired—at least initially—to official recognition of his talent, and to that end submitted pictures to the annual Salon. Degas and Manet were good friends, Degas being younger by only two years, and both were fixtures of the group of painters who gathered at the Café de la Nouvelle Athènes, the meeting place in the 1860s and 1870s of the most adventurous young artists in Paris. Neither artist ever fully adopted the plein-air approach to painting promulgated by the younger Impressionists Monet, Renoir, and Sisley. Rather, they became consummate observers of the Parisian scene, painting people in street clothes going about their everyday affairs. Yet despite their similarities —and there are many more—Degas and Manet were fundamentally very different beings. Degas's family laid false claim to noble ancestry, whereas Manet's was resolutely *haute bourgeoise;* Degas was a true prodigy of drawing, whereas Manet was obliged to overcome an early awkwardness. Degas grew disenchanted with the official art establishment and became a prime organizer of the independent Impressionist exhibitions, whereas Manet refused to exhibit with the younger artists and continued to send works to the retrograde Salon—this despite Degas's intellectual élitism and snobbery as opposed to Manet's essentially republican sympathies. No doubt Degas was affected by the experience of long stays with members of his far-flung family (from Naples to New Orleans), which could only have contrasted with his thoroughly classical education at France's premier school (Lycée Louis-le-Grand). In almost every respect he was more complex and contradictory than Manet, and this characteristic informs his art, enabling him to gain a distinctive insight into the peculiar realities of modern life, realities sometimes suggested in Manet's paintings but often overshadowed by brilliant passages of paint.

Degas was "infatuated with modernity," as the Goncourts put it in their journal of 13 February 1874. There they noted with great satisfaction that, parallel with suggestions they had made in their novel *Manette Salomon,* Degas had chosen laundry girls and ballerinas "as the most suitable models for the modern artist. Pink flesh amid the white of linen or the milky froth of gauze is the most charming pretext for light and delicate color schemes." They praised the "graceful, sinuous movements and gestures of the little monkey-girls," the ballet students Degas depicted, and concluded that because of the artist's sickly, nervous nature he was especially sensitive to the character of things, more skillful than any other painter in capturing the very essence of modernity.

Degas brought his acuity to bear on all aspects of Parisian life. Everyone from laundresses to countesses was subjected to psychological scrutiny, revealing the preoccupations of the everyday in *A Woman with Chrysanthemums* (Plate 7), the uncertainties of relations between the sexes in *Sulking* (Plate 12), the mindless tedium of ballet in *Dancers Practicing at the Bar* (Plate 8), or even the mildly comical confusion over choice in *At the Milliner's* (Plate 10). All of this took form in daring compositions and incisive drawing, executed with a variety of new techniques, many unique to the artist. A fierce and impatient experimenter, equaled in modern times only by Picasso, Degas continually developed new methods with which to render his rich drawing and extraordinary color effects. By the time he was forty, in 1874, he had already perfected and surpassed painting with oil on canvas and panel and had begun to combine traditional mediums such as egg tempera with new ones such as *peinture à l'essence* (oil paint that has been diluted with turpentine) in order to realize brighter colors and denser textures. At about the same time Degas also took up monotype and then pastel, a medium capable of providing intense color with broad handling. It was largely with sticks of pastel, manipulated in every conceivable way, that Degas made his great late works of nudes, dancers, and bathers, where color and line are fused in fiery, shimmering, tapestrylike pictures. When these works were made, at the beginning of the century, Degas's eyesight had failed considerably—precisely how much we do not know. Yet while his capacity for sustained work was impaired, his artistic judgment was intact; by then he had formulated a very modern approach to his craft, one that was taken up only a few years later by the Cubists. As he explained to a young painter, "It is all very well to copy what you see, but it is better to draw what you see only in your mind . . . then your memory and your imagination are freed from the tyranny imposed by nature."

Degas's attitude toward nature contrasted markedly with that of the great landscape painters of his generation— Claude Monet, Pierre Auguste Renoir, Alfred Sisley, Camille Pissarro, and Paul Cézanne—who continued until the end of their lives to paint out of doors, constantly seeking to give form to precisely that which they saw before them. Artists had painted or drawn outside their studios for centuries, but only in the nineteenth century did informal sketches, rendered on the spot, come to be considered as full-fledged works of art, worthy of exhibition and sale. In the first decades of the century, painters across Europe and America —among them John Constable and Camille Corot—trekked out into the countryside to make direct transcriptions of picturesque views. Back in the studio, these were often injected with some sort of incidental, anecdotal event, such as the midday pause of a peasant girl, in order to provide a narrative justification for the picture, much as, for example the seventeenth-century painter Claude Lorrain would pro-

vide a mythic pretext for his majestically composed landscapes. But by the middle of the nineteenth century, Emile Zola, the novelist and sometime critic, could proclaim the "classical landscape dead, murdered by life and truth." The painters who worked in the forest of Fontainebleau, around the village of Barbizon, were responsible for the murder Zola identified, but it was the next generation of artists, Monet, Renoir, Pissarro, and their friends, who vanquished from landscape the last tinges of emotionalism—itself a vestige of Romanticism— so as to pave the way for pure landscape as great art.

Working at various pleasure spots and bathing stations in Paris and on the Normandy coast in the late 1860s, Claude Monet forged the style now known as Impressionism in pictures such as *La Grenouillère, Terrace at Ste.-Adresse* (Plate 14), and *Beach at Ste.-Adresse* (Plate 15). While in these he adopted aspects of Courbet's broad handling of paint as well as Manet's heightened palette, his aim—to record a fleeting glimpse of a momentary coincidence of light, weather, and topography—he took from his mentor, Eugène Boudin, although from the beginning Monet's innate sense of composition, coupled with a healthy dose of ambition, led him to create larger canvases with bolder designs than any Boudin had conceived. What artists and critics first noted, however, was Monet's distinctive use of paint. Indeed, Zola commented on Monet's "utterly free and even crude" brushwork, which he employed in a new and compelling way.

Almost simultaneously with Monet's views of Ste.-Adresse, Camille Pissarro arrived at a similarly direct style of painting. In *Jallais Hill, Pointoise* (Plate 26), he used a palette knife to spread the pigment, emphasizing the physical substance of his paint in a manner analogous to Monet's rough brushstrokes. Just as Monet did, Pissarro, too, organized his compositions in horizontal bands, juxtaposing broad areas of flat color which in turn encouraged the artist to subjugate details to the architecture of the picture as a whole. In this practice a number of young painters found support in the work of Manet, who had attracted by the end of the 1860s a loyal group of admirers. Realizing their common pursuits, Monet, Renoir, Sisley, Pissarro, Cézanne, and Armand Guillaumin soon were painting side by side, each modifying according to his personality and individual talent the new manner of painting they were developing.

In 1874 these painters, joined by Degas, Berthe Morisot, Mary Cassatt, and others, celebrated their commonality of purpose with a group exhibition, the first of eight held over the course of twelve years and which became known as the Impressionist exhibitions. What these artists hoped for was a sympathetic environment in which to exhibit and sell their art, unfettered by the conventions of the academy and unrestricted by old-fashioned standards of quality or taste. What they generated was a certain amount of hostility and notoriety, and only a few sales; but certain key partisans, such as Zola and the young Stéphane Mallarmé, did emerge. After the second Impressionist exhibition, in 1876, Mallarmé attempted to define the new school of painting as "the principal and real movement of contemporary art," guided above all by the desire to recreate natural light effects as observed and painted out of doors.

Sisley's *Bridge at Villeneuve-la-Garenne* (Plate 28), executed in 1872, is consummately representative of the Impressionist aesthetic in the 1870s. Choosing a motif that is essentially neutral in subject, Sisley painted at midday in full sunlight, in bright, chalky, unmodulated colors with broad, distinct brushstrokes. While present-day historians might argue that Sisley's painting celebrates the network of canals and roads that bound the French nation together and on which traveled the fruits of her fecundity, more likely he was motivated by simpler concerns: namely, to demonstrate to the viewer that beauty could be found in forgotten corners, and that art consisted of constructing pictures, for which homely motifs served just as well as grand vistas. In this aspiration Sisley was joined by Monet, Renoir, Pissarro, Morisot, and eventually even Manet, all of whom worked with methods close to those of Sisley.

But by the last Impressionist exhibition, in 1886, these same artists had developed highly individual styles, often in opposition to the momentary vision of Impressionism. As soon as plein-air painting became *de rigueur*, it fell under attack by its practitioners. Monet, for example, increasingly reworked his paintings in the studio, and thus slowly abandoned the aesthetic of quick and direct notation. He experimented, in paintings like *The Sunflowers* (Plate 17), with new compositional formats, a lower-keyed palette, and a variety of surface effects in his search for an appropriate vehicle for his energies. Such a vehicle Monet found in the early 1890s, when he consistently began to explore the possibilities of serial painting. Having seized upon a motif— haystacks, mornings on the Seine, the facade of the Rouen cathedral, a row of poplars along the river Epte—he would attempt to paint his subject under the greatest variety of atmospheric conditions. More often than not, the motif became subsumed by the brilliant sun, pouring rain, or, as in *The Houses of Parliament* (Plate 18), dense fog, thus enabling Monet to extract from the composition its maximum abstract potential.

Renoir, too, dramatically shifted the course of his painting in the 1880s. Dissatisfied with the direction of Impressionism, he attempted to meld Impressionist technique with the "grandeur and simplicity of the old masters." Already in the magnificent *Madame Georges Charpentier and Her Children*, 1878 (Plate 23), he rejected the workaday subject matter of the 1860s and 1870s for a brilliant, high-style evocation of Boucher's portraits of the Marquise de Pompadour—brought up-to-date with contemporary dress and a passing nod to *japonaiserie*. With *By the Seashore* (Plate 24) he comfortably settled into the stylistic duality he established for the remainder of his career: the rendering of his "blushing, ingenuous, and chaste" feminine ideal in dappled light against a fluid and irreal landscape. Like others of his generation, he chose in the second half of his life to depict a timeless world of personal vision, quite in contrast to the rugged naturalism and exact observation of the 1860s.

The shift we note in the later works of Monet and Renoir —toward an art that is increasingly independent of natural appearances—was mirrored in the ways in which the next generation of artists extended and reacted against the established Impressionist aesthetic. There were thousands of young artists in Paris in the 1880s, and they induced a myriad of conflicting activities. The city had become the "capital of the nineteenth century," as Walter Benjamin put it, supplanting Rome as the center of artistic innovation. Manifestos and neologisms flourished as an ever-larger audience flocked to public exhibitions and private galleries, eager to see, read, and talk about art.

Regarding the future course to be taken, artists were fractious: Cézanne dismissed Gauguin as a "decorator not a painter," while Gauguin, who advocated "indulging in dreams in the presence of nature," denigrated the technical experiments of Seurat and the Pointillists as the work of "little green chemists piling up dots." With the ease of hindsight, after the heated arguments have long since dissipated, one can now sift through the numerous conflicting claims and detect certain principal tendencies. Among them, three interconnecting currents of artistic thought and practice came to dominate not only the end of the nineteenth century, but the course of twentieth-century art as well: a tendency toward abstraction, developed on the one hand intuitively and syncretically by Cézanne, and on the other hand consciously and systematically by Seurat; the tendency toward expressionism, developed by Van Gogh as an outgrowth of Impressionist color and technique but invested with spiritual significance; and a tendency toward fantastic, escapist imagery, most forcefully expressed by Gauguin, but no less present in the work of a diverse group of artists, young and older—Odilon Redon, Henri ("Le Douanier") Rousseau, Pierre Puvis de Chavannes, Gustave Moreau, Edvard Munch, Ferdinand Hodler, and the antinaturalist painters who called themselves the Nabis.

With the exception perhaps of Pissarro, who, after a dalliance with Pointillism in the 1880s perpetuated the Impressionist aesthetic into the next century, it was Cézanne among the older painters who remained truest to his original aim: "to produce the image of what we see while forgetting everything that has appeared before our day." What he achieved, however, was something quite different. Cézanne was, Picasso said, "the father of us all." He created, despite his theories and precepts, an art that gave birth to Cubism and Constructivism, by completely overturning the perspectival system (which had been threatened by Monet) that artists had used since the Renaissance. In Cézanne's paintings, especially in the late work, the space he depicts is no longer an independent, pre-existing entity, but is entirely generated by the objects within it. If one were to imagine, for example, removing the boulders from the foreground of *Rocks in the Forest* (Plate 34), it would be virtually impossible to conceive of the surrounding space existing on its own. It is the same kind of artificial, generated space, a space that takes time to unfold, that Picasso used in his *Still Life* of 1912–13

(Plate 94), and Braque in *Le Guéridon* of 1921–22 (Plate 96).

Cézanne did not set out to undo Albertian perspective, but he did so. Perhaps it is this discrepancy between his intentions and his deeds that makes his art so compelling: Picasso, for one, thought that what was interesting about Cézanne was his anxiety. Theoretically he remained an Impressionist, and he painted out of doors until the week before he died. But by painting slowly—over months as opposed to Monet's minutes—his extremely acute perceptions of the world before him were constantly readjusted, transposed to the process of making pictures. In his *Still Life with a Ginger Jar and Eggplants* (Plate 31), for example, we find Cézanne looking down at the objects in the foreground and up at the objects in the background, weaving intricate spatial relationships and discovering hundreds of minute color gradations. Cézanne adjusted every form in the still life to accommodate the neighboring forms, just as he had done in *Rocks in the Forest*, and in the process he gave each shape life and vibrancy. The writer Leo Stein did not exaggerate when he wrote that Cézanne succeeded in "rendering mass with a vital intensity that is unparalleled in the whole history of painting. No matter what his subject is—the figure, landscape, still life—there is always this remorseless intensity, this endless unending gripping of the form, the unceasing effort to force it to reveal its absolute self-existing quality of mass." Cézanne's innovative means of representing form —what Stein calls mass—is what proved to be the primary source of inspiration to the Cubist painters.

A different but parallel route to abstraction was suggested by the art and theory of Georges Seurat. Basing his work in the subject matter of the Impressionists—Parisians at leisure, the *café-concert*, suburban views—and using their high-keyed palette, Seurat systematized in an intellectual fashion what had been a loosely empirical method. By 1883, when he began work on *A Sunday Afternoon on the Island of La Grande-Jatte* (Plates 46–48)—the second of seven large, programmatic paintings—he was composing according to his understanding of the latest theories of harmonious proportions, the meaning of color, and the psychological effects of line and movement. In *Sunday Afternoon,* he alluded simultaneously to both the great Italian muralists of the *quattrocento* and to the advanced painting of his own time in an eclectic amalgam similar in purpose to that of Renoir's mix of old and modern elements: to make of contemporary art something durable and worthy of the museums.

Seurat is most famous for his inventive applicaton of the dot, a technique that allowed him great precision in placing unmixed color on canvas. He hoped that by working with small strokes he could invest his pictures with more intense luminosity and induce, in the eye of the viewer, certain optical effects that he sought: the heightening of color through complementary contrasts, and the fusion of color and form in the eye rather than on the canvas. These practices he derived from a number of sources: from art manuals and philosophic treatises, from popular notions, and

from scientific studies. But whether any of his theories actually worked is somehow irrelevant. The dot, and Neo-impressionist technique in general, became a symbol of avant-garde, antinaturalist expression, taken up in the twentieth century by the Fauve painters Henri Matisse and André Derain, the Futurists Umberto Boccioni and Gino Severini, by František Kupka, and even, at one point after the First World War, by Pablo Picasso.

Seurat's most important legacy, however, may have been the example he set by rigorously applying theory to art. Seurat disciplined himself even in the choice and sequence of his subjects. Having perfected, for example, the painting of figures in a sun-filled landscape (*La Grande Jatte*), he painted some of these same figures indoors and undressed (*Les Poseueses*) before attempting an equally audacious rendering of a street scene at night (*La Parade*, Plate 49). He similarly counterbalanced his painting of a *Woman Powdering Herself*, an exercise in placid curves, with the *Can-Can*, an almost ecstatic study in acute angles. Realizing a strange, poetic stasis through rhythmic repetition and simplification of forms, Seurat mixed geometry, philosophy, and painting in a way that prepared the ground for the "pure plastics" and transcendental symmetry of Piet Mondrian and the artists of De Stijl.

Vincent van Gogh's last act in Paris before leaving in February 1888 for Provence, his "Japan of the South," was a visit to the studio of Georges Seurat. Only two weeks later Van Gogh wrote that what he had learned in Paris was "leaving" him, and that he was on his way to forging a new, personal style. His homage to Seurat now seems prescient —although at the time it doubtless was coincidental —and serves well as a reminder of how quickly the young Dutchman, who had not even heard of Impressionism when he had arrived in Paris two years earlier, assimilated vanguard techniques only to synthesize and expand upon them for his own particular ends: the purposeful exaggeration and distortion of form, color, and line for an expressly emotive art. Van Gogh's painting and drawing was always rooted in experience, in nature, but it also was always overladen with a record of his feelings and ideas. As much as his subject matter, Van Gogh's form, color, and line became the vehicles for the expression of his feelings and ideas. As such, his work provided the precepts, and sometimes the specific model, for much of the art of the twentieth century, which likewise relied on these fundamental elements to express emotional or spiritual content. Franz Marc and Wassily Kandinsky in Munich, Emil Nolde, Ludwig Kirchner, and Erich Heckel in Dresden, and in Paris André Derain, Henri Matisse, Chaim Soutine, Georges Rouault, and Pablo Picasso in his "Blue Period" all drew inspiration from Van Gogh's paintings. Max Pechstein even claimed him as the father of modern Expressionist art, an assertion parallel to Picasso's declaration of Cézanne's paternity of Cubism.

Van Gogh's influence in the early part of this century was diffused as much through his writings as by knowledge of his pictures. He was a great, if private, theorist. His letters, largely written to his brother, Theo, an art dealer, began to be published in French, Russian, Dutch, and German soon after Van Gogh's death in 1890. They contain not only the dramatic story of the artist's short and anguished life (told with remarkable insight despite the self-pity), but offer as well the theoretical underpinnings of the Expressionist and Symbolist art of the painters just named. Yet although he wrote of theory and technique, in his own paintings Van Gogh was too passionate to confine himself to the cool, logical development of someone like Seurat. Jealously independent yet highly susceptible to influence, he painted fitfully in his ten-year career. Just at the moment when he achieved a coherent variant of mid-century Dutch Realism in *The Potato Eaters* and related works—with their blocky drawing, coarse handling of paint, and dark, restricted palette—he moved to Paris and adopted the bright colors and broken brushstrokes of the Impressionists—witness his *Self Portrait* of 1887 (Plate 40). In *Sunflowers* (Plate 39), executed a few months later, he made extensive use of complementary colors, in this case yellow and blue, and thereby flirted with the same theories of color that Seurat employed; but the heavy impasto laid with Expressionist brushwork, not to mention the bathetic subject, was antithetical to the Neoimpressionist sensibility. *L'Arlésienne*, painted in 1888 (Plate 42), was also painted in complementary colors, but with a completely different effect: Here the brushwork is even, the planes of color are broad, and the whole is firmly bound by strong outlines, derived from Japanese prints and the "cloissonist" art, with its areas of strong, flat colors bordered in black, of Gauguin and the group of painters in Pont-Aven. Then, in *Dr. Gachet* (1889), Van Gogh countermanded with nervous drawing and animated forms the placidity of works like the portrait of Madame Ginoux, "flinging onto the canvas," as one German writer wrote, "the very essence of these cornfields and trees, people and things, as he does his own soul, satisfying an almost erotic need for self-surrender." While many painters emulated Van Gogh's style, more were emboldened by his "courage to express himself," by his ability, as Paul Klee said, "to reach down, deep, deep into his heart."

The modern tendency toward fantastic, imagined imagery and the concurrent rejection of Naturalism was older and more broadly based than the movements toward Expressionism and abstraction. Ever since the Romantic era, earlier in the nineteenth century, there had been a number of artists and writers who believed that there was more to art than the depiction or description of seen things. Men as different as Baudelaire and Wagner sought later in the century a suggestive art that could better express the inner recesses of man's soul. In the 1860s, Puvis de Chavannes and Gustave Moreau began painting visions of a mystical, classically inspired world, deeply at odds with the materialism of the Second Empire; soon thereafter Odilon Redon gave form to the weird menagerie that inhabited his imagination. These individual expressions found a name in 1886, when Jean Moréas issued the Symbolist Manifesto, group-

ing together all artists who hoped "to objectify the subjective (the externalization of an idea) instead of subjectifying the objective (nature seen through a temperament)." Other critics quickly identified Gauguin as the head of the Symbolist movement, and the 1889 exhibition at the Café Volpini, where his work hung alongside that of his followers, was thought (in Maurice Denis's words) "to inaugurate an epoch," effectively nailing the lid on the coffin of Impressionism. Moreover, said Denis, "the Symbolist crisis, which erupted a little later, facilitated the spreading of Gauguin's ideas to the point where all the applied arts, decorative painting, accessories, and the poster down to the caricature, were revitalized."

What was Gauguin's idea? "To translate thought into a medium other than literature." This he achieved with a strange, eclectic method, deliberately elusive and difficult to define. His first truly Symbolist painting, *The Vision after the Sermon—Jacob Wrestling with the Angel* (1888), was a decided departure from the tentative Impressionist technique he had learned under Pissarro's instruction. Most observers were immediately struck by the painting's strong, unnatural colors, simplified forms, and insistent outlines. But its subject and meaning were in fact far more provocative and subversive. That Gauguin was even willing to paint an angel with wings was perceived as a direct contradiction of Courbet's famous refusal to paint anything he had not personally seen: "Show me an angel and I will paint one." And of course the mystical vision that Gauguin depicts—Jacob appearing before a congregation of peasant women—gave credence to an aspect of Christian belief that was beyond empirical confirmation. Pissarro recognized in Gauguin a threat to Naturalist principles, and identified him with the Catholic revival: "I do not criticize Gauguin for having painted a rose background, nor do I object to the two struggling fighters and the Breton peasants in the foreground. What I dislike is that he copied these elements from the Japanese, the Byzantine painters, and others. I criticize him for not applying his synthesis to our modern philosophy which is absolutely social, anti-authoritarian and anti-mystical —Gauguin is not a seer, but a schemer who has sensed that the bourgeoisie are moving to the right."

Gauguin was not, in the sense Pissarro meant, a schemer, but he certainly was a dreamer. His search for a simpler, cheaper existence led him to the French colonies in the South Seas, settling finally in Tahiti. There, in 1891, he painted *Ia Orana Maria*—I Greet Thee Mary (Plate 54)—one of his most remarkable paintings. As in *The Vision after the Sermon*, Gauguin has transposed a miraculous apparition, here the Archangel Gabriel before Mary, into colloquial terms, only now the setting is tropical rather than Breton. Weaving together motifs from a Javanese relief (which he knew from a photograph) with references to Italian gold-ground painting, Western religion with local superstition, brilliant, varied color with idealized forms, Gauguin created from wide-ranging sources a true modern synthesis—a term he often used to explain his method.

Despite the heights Gauguin's painting reached in Polynesia, where he stayed, with some interruption, until his death in 1903, his life was mired in misery. True to the pattern established by his colleague Van Gogh, Gauguin died penniless just as the ramifications of his work began to reverberate among younger artists. The retrospective exhibition organized in Paris in 1906 directly affected the career of Matisse, who adopted Gauguin's sinuous line and sumptuous color; at the same time examples of Gauguin's woodcuts and zincographs reached German artists, who quickly incorporated aspects of his "primitive" imagery into their work. Gauguin's paintings and wood carvings made in Brittany had already influenced the Nabis, Bernard, Denis, and others, while Bonnard and Vuillard had also learned a great deal from Gauguin's decorative sense of composition.

Art history, particularly at the end of the nineteenth century, is largely the history of artists. While untold factors—economic, social, political, and literary—imperceptible or consciously taken up, doubtless influence the creation of any work of art, the most salient confrontations are those between an artist and the work of another artist. It is then that the one is challenged into activity by the other. The aftermath can, as we have seen, manifest itself in a variety of ways: Monet and Renoir building, in the summer of 1869, on the foundations of a new plein-air style of painting advanced by Boudin; Manet heightening his palette and moving out of doors in response to seeing Monet's work; Cézanne learning how to construct a composition under Pissarro's tutelage in Pontoise; Seurat reacting to the casual, seemingly haphazard composition of Renoir's scenes of bourgeois leisure; Van Gogh painting the plain of La Crau, outside of Arles, conscious of the fact that Cézanne was painting nearby, "not that there was much resemblance between a drawing of mine [Van Gogh] and one by Cézanne"; Picasso bringing, in *Les Demoiselles d'Avignon*, Cézanne's bathers in from a landscape and turning them into prostitutes; Kandinsky failing to recognize the subject of one of Monet's *Haystacks*, and thereafter doubting the necessity of "the object" in art; or Balthus, in *The Mountain* (Plate 126), trying to invest his painting with the same ambiguity and multivalent meaning as that of Gauguin's epic *Who Are We, Where Do We Come From, Where Are We Going*. The dizzying number of artistic interconnections led the Symbolist poet Verhaeren to exclaim (in a statement of 1891 that John Rewald later made famous): "There is no longer any school, there are scarcely any groups, and those few are constantly splitting. All these tendencies make me think of moving and kaleidoscopic geometric patterns, which clash at one moment only to unite at another, which now fuse and then separate and fly apart a little later, but which all nevertheless revolve within the same circle, that of the new art." It is this "new art"—from its foundations in the 1860s to work of the recent past—that unfolds on the following pages.

Gary Tinterow

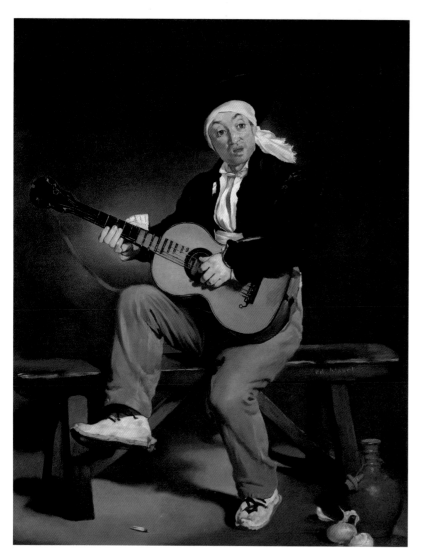

1 The Spanish Singer, 1861
Edouard Manet
French, 1832–83
Oil on canvas;
58 x 45 in. (147.3 x 114.3 cm.)
Gift of William Church Osborn,
1949 (49.58.2)

2 Mlle. V. in the Costume of an Espada,1862
Edouard Manet
French, 1832–83
Oil on canvas; 65 x 50¼ in.
(165.1 x 127.6 cm.)
Bequest of Mrs. H. O. Havemeyer, 1929,
H. O. Havemeyer Collection (29.100.53)

EDOUARD MANET

Spanish Singer and *Mlle. V. in the Costume of an Espada*

Although Edouard Manet is best known for his cool, laconic style of painting—in deliberate opposition to the rhetorical style sanctioned by the art establishment—he continued to submit his work to the official Salon. *The Spanish Singer* (Plate 1) was accepted by the Salon of 1861, along with a portrait of the artist's parents. Another work with a Spanish theme, *Mlle. V. in the Costume of an Espada* (Plate 2), was rejected by the Salon of 1863 and exhibited instead at the Salon des Refusés.

Both of these works testify to the Parisian vogue for Spanish culture and art. Yet despite the Spanish subject of the paintings, Manet has made no attempt to disguise the fact that they are counterfeits. Whereas a traditional painter would have done everything he could to make his Spanish figures authentic, and would have placed them in a rhetorical or romantic setting, Manet seems to be saying, "Why pretend? This is not a Spanish singer. This is not an *espada*, but a Parisienne whom I have dressed as one." The singer's costume, for example, is not entirely Spanish; he wears pieces of the costumes Manet kept in his studio as props. Furthermore, he is left-handed and holds a guitar strung for a right-handed player, and he is seated in a position that would make playing the instrument extremely difficult.

The authenticity of the figure of the *espada*, who stands before a background scene taken from a set of prints by Goya, is undermined first of all by the fact that she is a contemporary woman dressed as a man. She wears pieces of the same costume as the Spanish singer, and shoes that are entirely unsuitable for bull fighting. Moreover, she holds a pink cape unlike any ever seen in a bullring.

The matter-of-fact, unromantic character of these paintings derives as much from Manet's technique as from the obviously contrived figures. Especially in *Mlle. V. in the Costume of an Espada*, the painter has abandoned illusionistic perspective, in which our eye is led smoothly from foreground to background: Note the dramatic disjunction between the model and the scene behind her. He has also abandoned the smooth transition from light to shadow in favor of broad areas of freely applied color and bold, flat patterns of light and dark. Manet's delight in surprising, unconventional colors is most striking in the closely related yet clashing pinks of the *espada*'s scarf and cape, in her opalescent stockings, and in the fillip of the acid-yellow cloth in her pocket, all of which stand out so sharply against her black bolero and trousers, and which were doubtless felt as an insult to conservative taste.

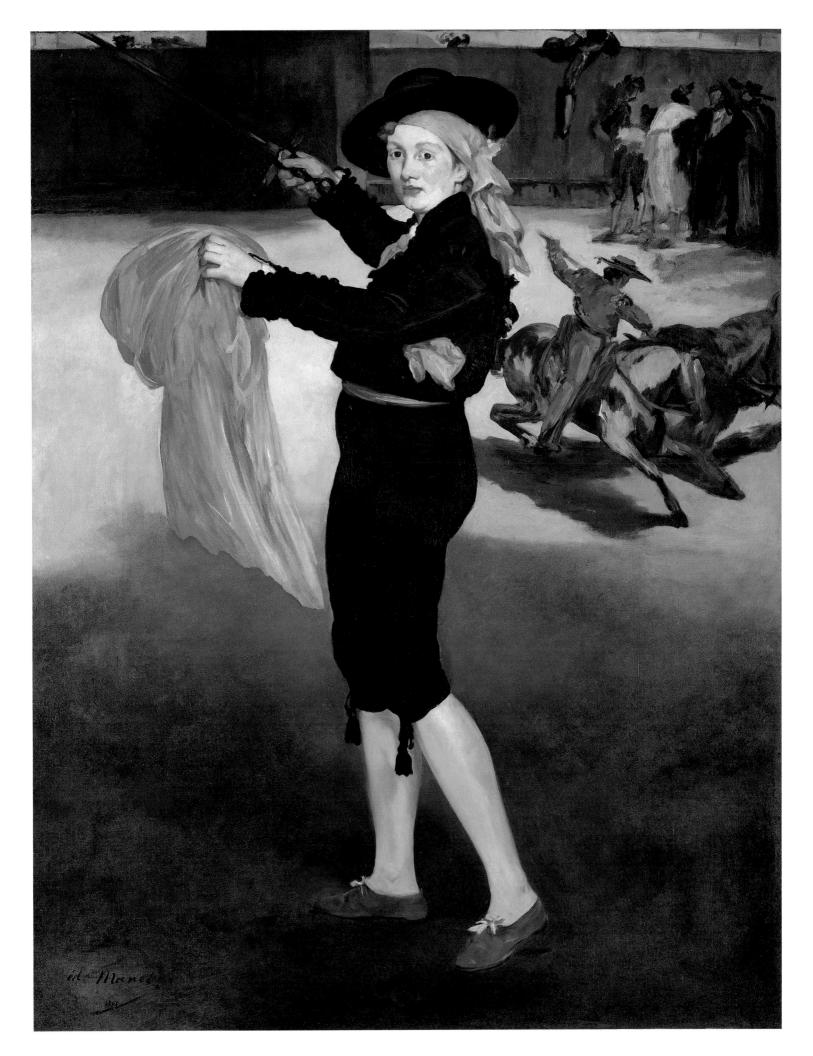

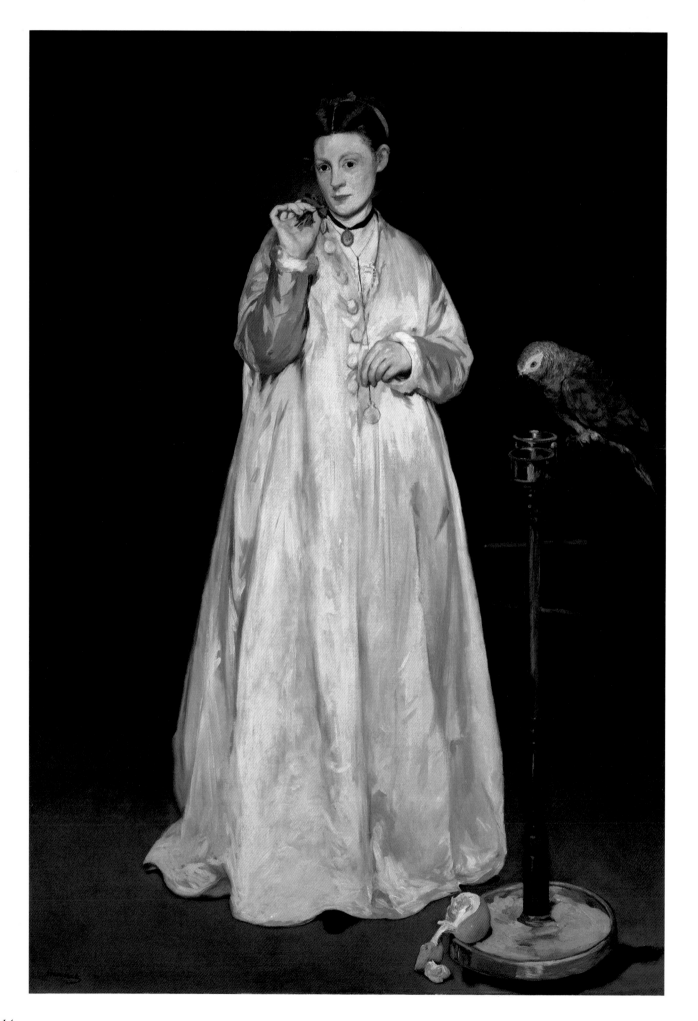

3 *Woman with a Parrot*, 1867
Edouard Manet
French, 1832–83
Oil on canvas; 72⅞ x 50⅝ in.
(185.1 x 128.6 cm.) Gift of
Erwin Davis, 1889 (89.21.3)

Right: detail

EDOUARD MANET

Woman with a Parrot

This painting seems to have been Manet's answer to Courbet's *Woman with a Parrot*, exhibited at the Salon of 1866. While Courbet's work is explicitly sexual, Manet's is cool, detached, and intellectual, striking in its simplicity and spareness. Manet has organized his composition with a strong, even light and large areas of bright color rather than with traditional modeling and perspective. The woman, with her salmon-pink gown and pale pink skin, forms a striking pattern against the gray background. The creamy pinks and whites of the figure are enlivened by the black ribbon tied round her neck and the glimpse of her foot peeking from beneath her robe. Manet has daringly clashed the pink of the figure with the orange-yellow of the half-peeled orange at the lower right, the yellow at the base of the parrot's stand, and the acid-yellow of the liquid in the bird's glass cup.

It has been posited that this picture is an allegory of the five senses: sound (the parrot), taste (the orange), touch (the finger and thumb touching), smell (the flower), and sight (the monocle). Since we know Manet to have been concerned with classical themes in art, such a traditional allegory—in such antitraditional terms—seems plausible.

The model for *Woman with a Parrot* was Victorine Meurent, who posed for *Mlle. V. in the Costume of an Espada* (Plate 2), as well as Manet's celebrated *Olympia* (Plate 4) and *Déjeuner sur l'Herbe*, both painted in 1863, and both now in the Musée d'Orsay, Paris.

EDOUARD MANET
Olympia

At the Salon of 1865, Manet caused a tremendous scandal with his painting *Olympia,* which is now perhaps his best-known work. This picture confronted the Parisian public not with an ideal, classical reclining nude, but with a woman distinctly of the here and now, a contemporary courtesan who, wearing nothing but a black ribbon round her neck, a bracelet, a flower in her hair, and one slipper, stares directly at the viewer as if to implicate him in her world. Behind her a servant displays a lush bouquet of flowers presumably sent by a client, and at the foot of her bed a black cat arches its back.

Manet etched two reproductions of his *Olympia.* The second, smaller version, shown here, was made for a pamphlet written by Emile Zola, one of the artist's staunchest and most articulate supporters. With minor variations, the composition of the etching is the same as that of the painting. The most notable differences are that in the print the background is only faintly articulated, and Olympia wears a curl on her forehead, whereas in the painting her hair is pulled taut from her face.

At the bottom of the example shown here is an inscription to Zola from Manet, reading, "A mon cher ami, ed. Manet." The year after this print was made, Manet painted a portrait of his friend Zola in which his pamphlet and its etched illustration of the *Olympia* appear.

EDOUARD MANET
Man on Crutches

The subject of this drawing is a local character in the quartier de l'Europe, where Manet lived. He was most likely a victim of the Franco-Prussian War, during which Manet himself had enlisted in the National Guard and served as a volunteer gunner in the artillery. Paris had suffered bitterly in the war, both from the German siege and from the public rebellion (the "Commune") against the government that was installed after the war.

This figure appears in a painting of 1878 by Manet, *The Rue Mosnier with Flags,* in which he forms an ironic foil to the joyful nationalism expressed by the display of flags honoring the Exposition Universelle. In the painting he is seen from behind; here he is depicted full face, wearing a worker's blouse and visored cap. Manet's drawing is void of picturesque or narrative detail. Rendered with a strong, concise line, it projects a forceful, even monumental, image of the disabled man.

5 Man on Crutches, ca. 1878
Edouard Manet
French, 1832–83
Brush and black ink on tan paper;
10⅝ x 7¾ in. (27 x 19.7 cm.)
Harris Brisbane Dick Fund, 1948
(48.10.2)

4 Olympia, 1867
Edouard Manet
French, 1832–83
Etching and aquatint; 3½ x 7 in.
(8.9 x 17.8 cm.)
The Elisha Whittelsey Collection,
The Elisha Whittelsey Fund, 1983
(1983.1093)

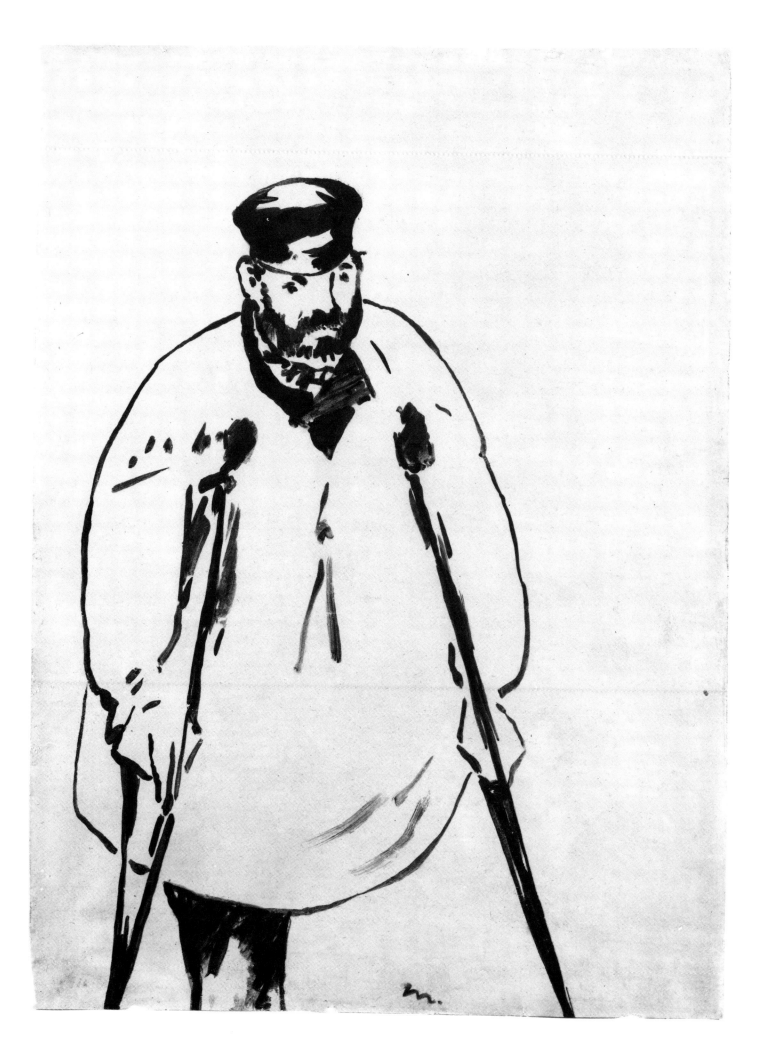

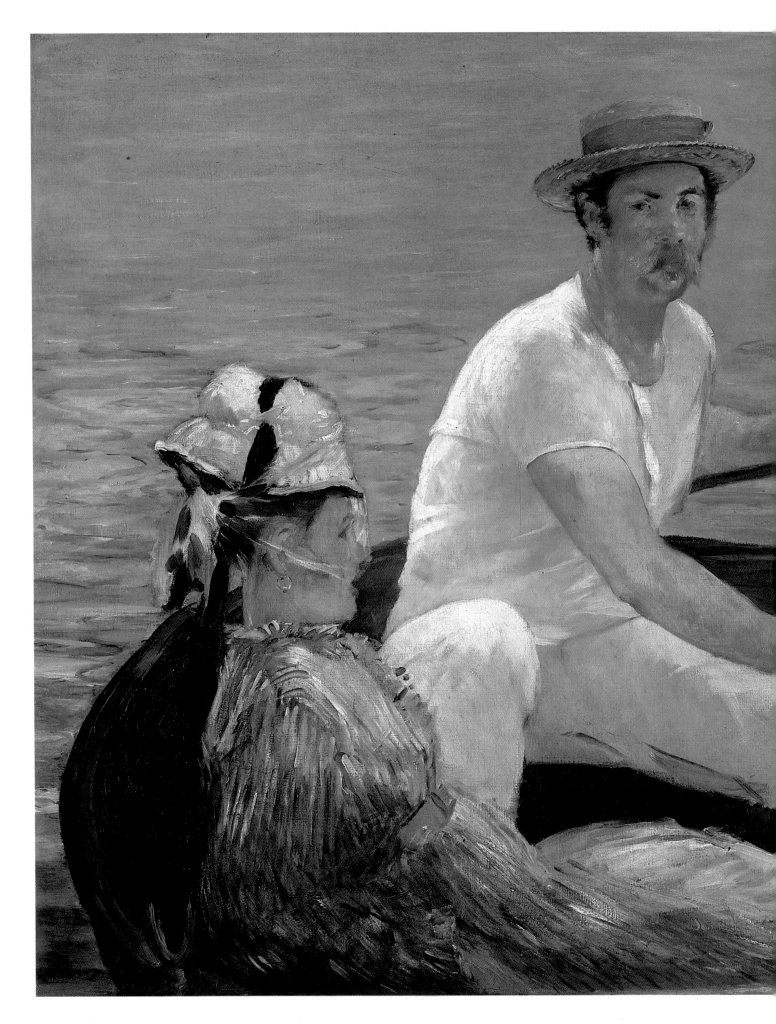

6 *Boating*, 1874
Edouard Manet
French, 1832–83
Oil on canvas; 38¼ x 51¼ in. (97.2 x 130.2 cm.)
Bequest of Mrs. H. O. Havemeyer, 1929,
H. O. Havemeyer Collection (29.100.115)

Page 20: text

EDOUARD MANET

Boating

(Pages 18–19)

By 1874 Manet was committed to naturalism, painting the middle class pursuing their everyday pleasures, the favorite subject of the Impressionists. *Boating* depicts a rather fashionable couple—the man is dressed in leisure clothes, the woman in a stylish summer dress—getting away from the city on an excursion on the Seine. It was painted during the summer of 1874 in Argenteuil, a suburb of Paris where Monet lived in a house across the river from Manet's family home in Gennevilliers. Manet, Monet, and Renoir painted together frequently that summer, and the work of the young painters affected Manet's.

If Manet's subject matter shifted toward that of the Impressionists, so did his colors—his dark, Spanish palette gave way to the brighter, more high-keyed hues we see in *Boating*. He also painted pictures in which the denial of deep space was greater than in his earlier work. The high viewpoint of *Boating* causes the water's surface to rise up as a backdrop, blocking our view into the distance. And while the boat angles into space, the sail, the boom, and the rope are all parallel to the picture plane. This flattened composition, as well as the way the forms are cut off at the edges of the canvas, reflect Manet's interest—shared with the Impressionists—in Japanese prints.

EDGAR DEGAS

A Woman with Chrysanthemums

Even in so traditional a format as portraiture, Degas departed from convention and painted his subjects in informal poses. The woman depicted here, with her hand raised to her mouth and her gaze directed out of the picture, is seen in a private, unguarded moment of thought, typical of Degas's portraits. Carefully drawn, with an exquisitely modeled face, she is seated next to a table on which a large bouquet of flowers rests. The flowers, which occupy the central portion of the canvas, are brighter in color and more freely executed than the woman, and vie with her for our attention.

In fact, this canvas was originally a flower painting completed in 1858, and was probably influenced by Delacroix's flower pictures of 1848–49. Degas repainted his picture in 1865, and added the figure of the woman. Thus *A Woman with Chrysanthemums* represents an accumulation of ideas and observations over a long period. Degas himself once said, "I assure you that no art was ever less spontaneous than mine. What I do is the result of reflection and study of the great masters; of inspiration, spontaneity, temperament."

7 *A Woman with Chrysanthemums*, 1858/65
Edgar Degas
French, 1834–1917
Oil on canvas; 29 x 36½ in.
(73.7 x 92.7 cm.)
Bequest of Mrs. H. O. Havemeyer, 1929,
H. O. Havemeyer Collection (29.100.128)

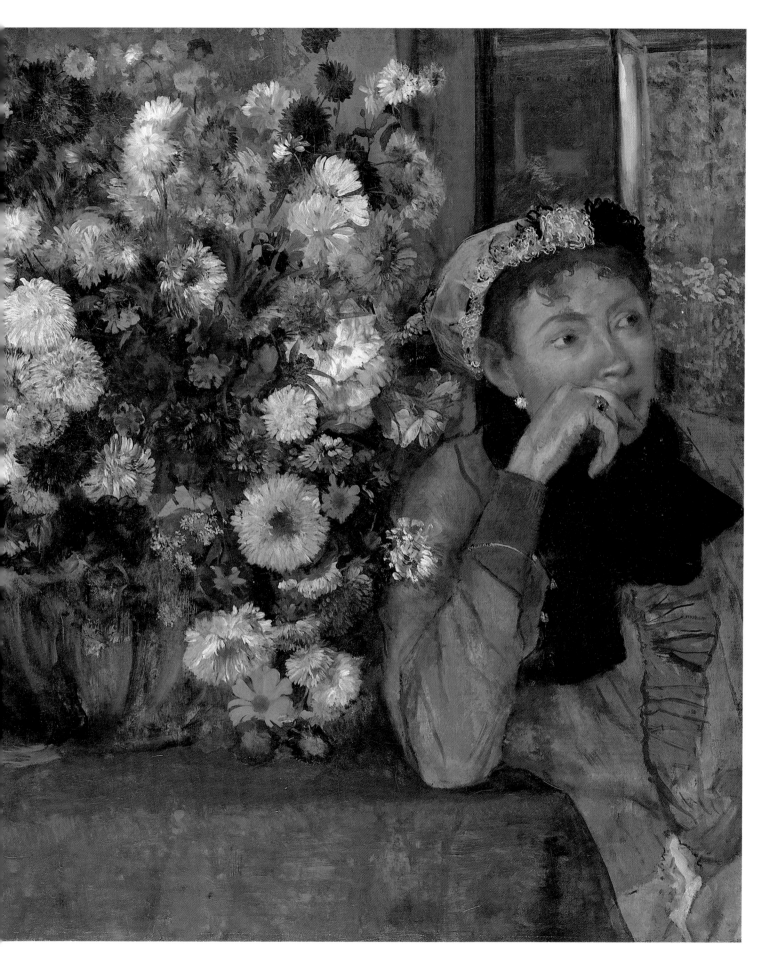

8 *Dancers Practicing at the Bar*, 1876–77
Edgar Degas
French, 1834–1917
Oil colors mixed with turpentine, on
canvas; 29¾ x 32 in. (75.6 x 81.3 cm.)
Bequest of Mrs. H. O. Havemeyer, 1929,
H. O. Havemeyer Collection (29.100.34)

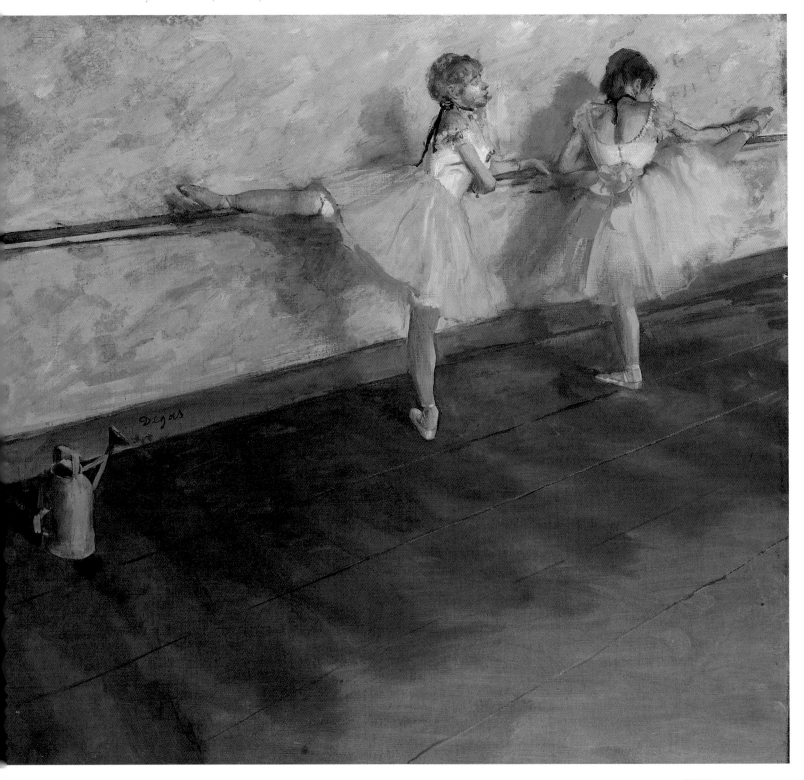

9 *Little Fourteen-Year-Old Dancer*, 1880–81
Edgar Degas
French, 1834–1917
Bronze with tulle skirt and satin hair
ribbon, wood base; H. 39 in. (99.1 cm.)
Bequest of Mrs. H. O. Havemeyer, 1929,
H. O. Havemeyer Collection (29.100.370)

Right: three views

EDGAR DEGAS
Dancers Practicing at the Bar

This painting appears to give a random glance through an open door into a dance studio. Far from being self-consciously posed, the two ballerinas are spied practicing at the bar, unaware of our existence. Yet though the dancers appear to be casually observed, the composition was meticulously worked out and is an example of the artist's fascination with form and structure. Degas has created a witty analogy between the watering can (used to lay dust on the studio floor) and the dancer on the right. The handle on the side imitates the dancer's left arm, the handle at the top mimics her head, and the spout approximates her right arm and raised leg. After the work was complete, Degas was not sure if he liked this visual pun and asked the owner, his friend Henri Rouart, if he could take the picture back to rework it. Rouart refused, since he knew that Degas sometimes ruined works by making too many revisions.

EDGAR DEGAS
Little Fourteen-Year-Old Dancer

It is thought that until Degas executed the tinted-wax original from which this bronze was cast, his sculpture was largely confined to statuettes of horses. Here, however, he turned to the human figure, which had preoccupied him in his paintings. In fact, Degas aimed to change sculpture as he had changed painting, turning to real life for inspiration, and experimenting with new materials and techniques in order to gain his desired effect. The use of materials of everyday reality was one of the most revolutionary aspects of *Little Dancer*. The original wax statue had, in addition to the gauze skirt and silk hair ribbon seen here, a painted linen bodice, satin slippers, red lips, and even real hair. The expression on her face is strained, showing the difficulties of holding her pose. The extreme realism of *Little Dancer* —far from the idealized figures of other sculptors—repelled many viewers, who found the work brutal and coarse.

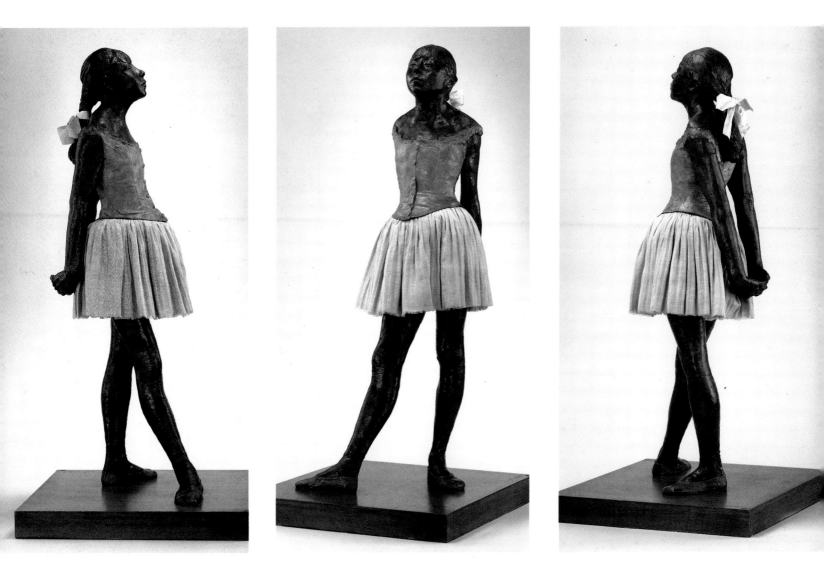

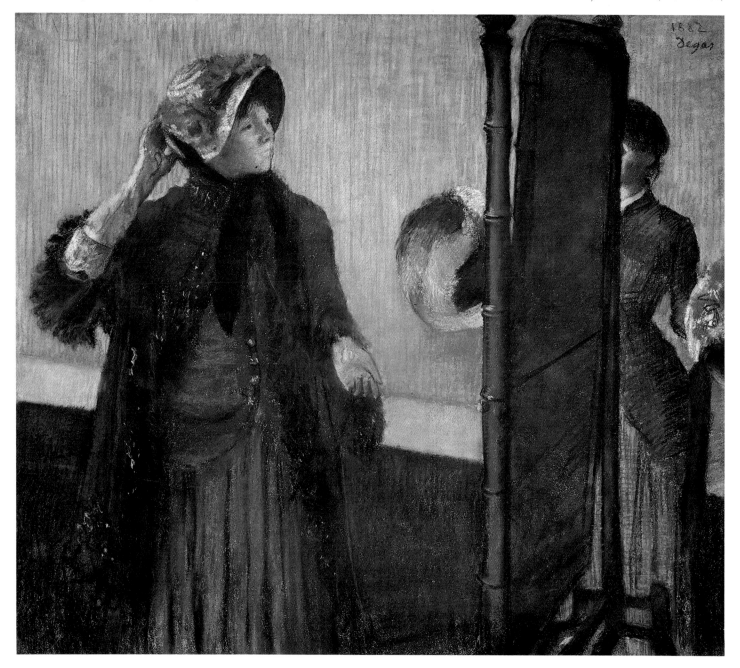

EDGAR DEGAS

At the Milliner's

In the early 1880s, Degas's search for authentic details of modern Parisian life led him to accompany women friends to milliners, excursions that resulted in several pastels of women trying on hats. Rather than detailed pictures of a milliner's shop, which might have included counters, wares, and so on, Degas's pastels are condensed and incisive, and show only a few telling gestures. Here a young woman stands before a mirror. She cocks her head and touches the back of the bonnet she is trying on in a gesture that we recognize today. The shopgirl stands at the ready, a hat in each hand waiting to be tried. The relative social positions of the two figures are wittily expressed in the prominence of the client and the way the shopgirl, who is barely more important to the customer than the mirror, is half hidden by the glass.

In *Confessions of a Young Man* George Moore said the customer in *At the Milliner's* was "as typical of the nineteenth century as Fragonard's ladies are of the Court of Louis XV." The model for the customer may have been Mary Cassatt.

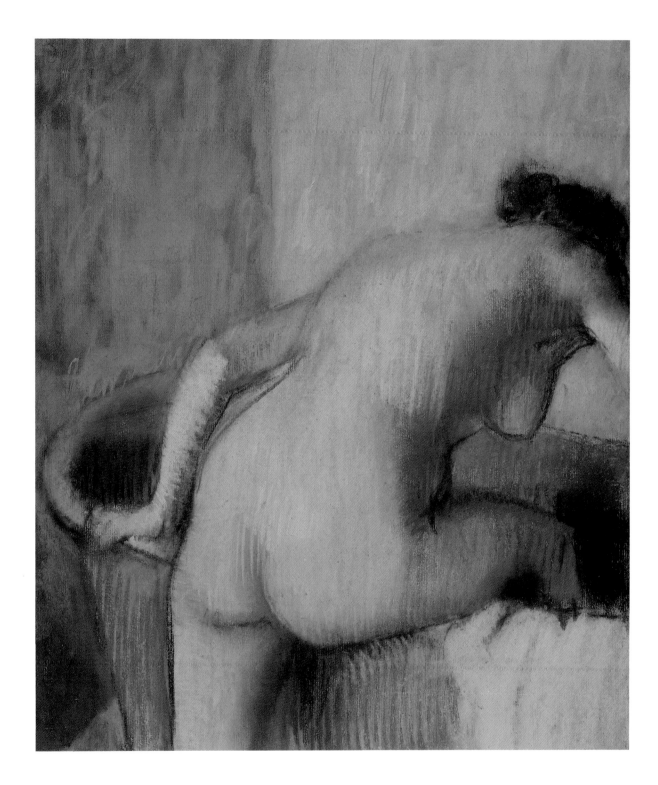

EDGAR DEGAS
The Bather

In the 1880s and 90s Degas executed several pictures of women bathing, combing their hair, or drying themselves. The effect of these images, in which the women are engrossed in a private activity, unaware of any onlooker, is at once intimate and impersonal: It is as if the scene were being viewed secretly. This is, in fact, the effect intended by Degas, who wrote, "Hitherto . . . the nude has always been represented in poses which presuppose an audience, but these women of mine are honest, simple folk, unconcerned by any other interests than those involved in their physical condition. . . . It is as if you looked through a keyhole."

The Bather belongs to a group of pastels, drawings, monotypes, and one painting that are usually dated about 1890. Degas evidently first used the pose depicted here in a pastel of 1883 that belonged to the art dealer Ambroise Vollard. The softness of the execution and the vertically striated application of the pastel relate them to a number of pictures by the artist of the late 1880s.

EDGAR DEGAS
Sulking

This picture is one of Degas's most suggestive and ambiguous paintings. Neither the figures, their relationship, nor even their setting is immediately clear. The decor and furnishings—the window counter with opaque glass at the left, the rack filled with ledgers at the upper right, and the table piled high with papers in the center—suggest that the scene is a small bank; it may even be the one on the rue de la Victoire owned by Degas's father. But this is clearly more than a realistic depiction of a banker's office. As in so much of Degas's work, it is as if we have suddenly interrupted a private scene. The woman turns her head to look directly at us; the man sullenly—perhaps somewhat angrily—raises his head and peers at us from beneath his knitted brow. The

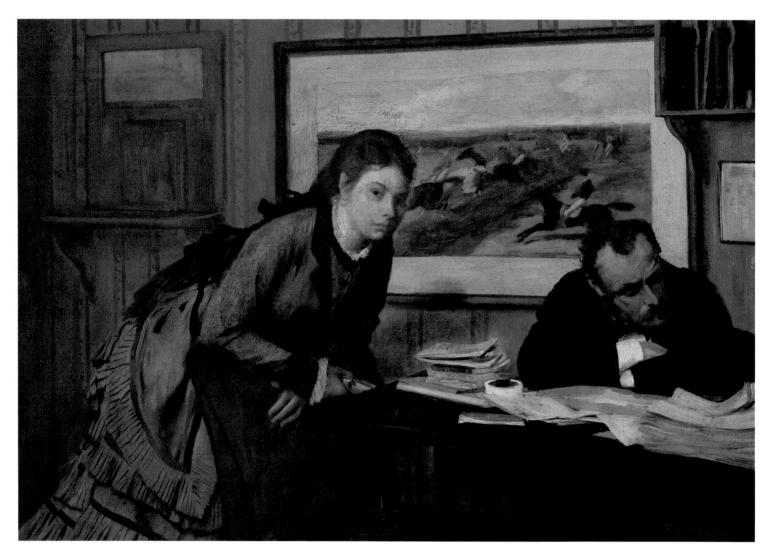

12 Sulking (The Banker), 1869–71
Edgar Degas
French, 1834–1917
Oil on canvas; 12¾ x 18¼ in.
(32.4 x 46.4 cm.)
Bequest of Mrs. H. O. Havemeyer,
1929, H. O. Havemeyer Collection
(29.100.43)

poses and facial expressions of the figures show that the moment is charged with tension. Neither figure touches nor looks at the other. She leans towards him, resting against the back of a chair with a glum expression on her face; he turns away from her, arms folded and shoulders hunched.

This work may be the result of a project Degas proposed in a notebook of 1869, in which he mentioned transforming the exaggerated physiognomic expressions of rhetorical art into more subtle expressions of modern life.

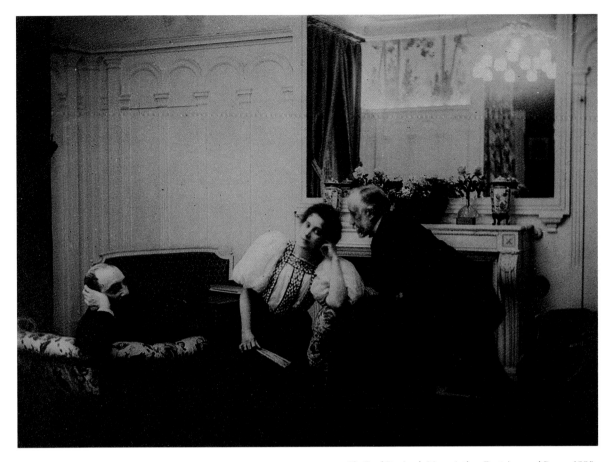

13 Paul Poujaud, Mme. Arthur Fontaine; and Degas, 1895
Edgar Degas
French, 1834–1917
Gelatin-silver print; 11⁹⁄₁₆ x 15⅞ in. (29.4 x 40.5 cm.)
The Elisha Whittelsey Collection,
The Elisha Whittelsey Fund, 1983 (1983.1092)

EDGAR DEGAS
Paul Poujaud, Mme. Arthur Fontaine, and Degas

By the late 1870s the procedures and compositions of photography were standardized and the medium was being exploited for its commercial potential. Degas, always interested in new techniques to expand his range of expression, was one of a small group of painters who turned to photography and broke with accepted methods to make photographs that were personal and expressive in their points of view.

This photograph was made one evening in 1895 when Degas was dining at the house of composer Ernest Chausson. After the meal, Degas posed with two of the other guests, Paul Poujaud and Madame Arthur Fontaine, in the drawing room. Guillaumé Lerolle, Madame Fontaine's brother, snapped the shutter when signaled by Degas.

Degas was as great an experimenter in his photographs as he was in his graphic work and sculpture, attempting to stretch his materials to do more than their mechanics permitted. This photograph, for example, was taken under lighting conditions that made correct exposure of the negative nearly impossible. Furthermore, the negative was enlarged several times more than was customary for the period, when great enlargements led to loss of resolution and detail: Degas was willing to accept these losses for the sake of experimentation.

Degas's interest in telling gestures and postures, seen in paintings such as *Sulking* (Plate 12), is evident in this photograph. Poujaud and Mme. Fontaine are in relaxed poses, each resting his or her head on one hand, and with contemplative expressions. Degas—the artist and observer—leans toward his friends and looks directly at them with an alert and penetrating gaze.

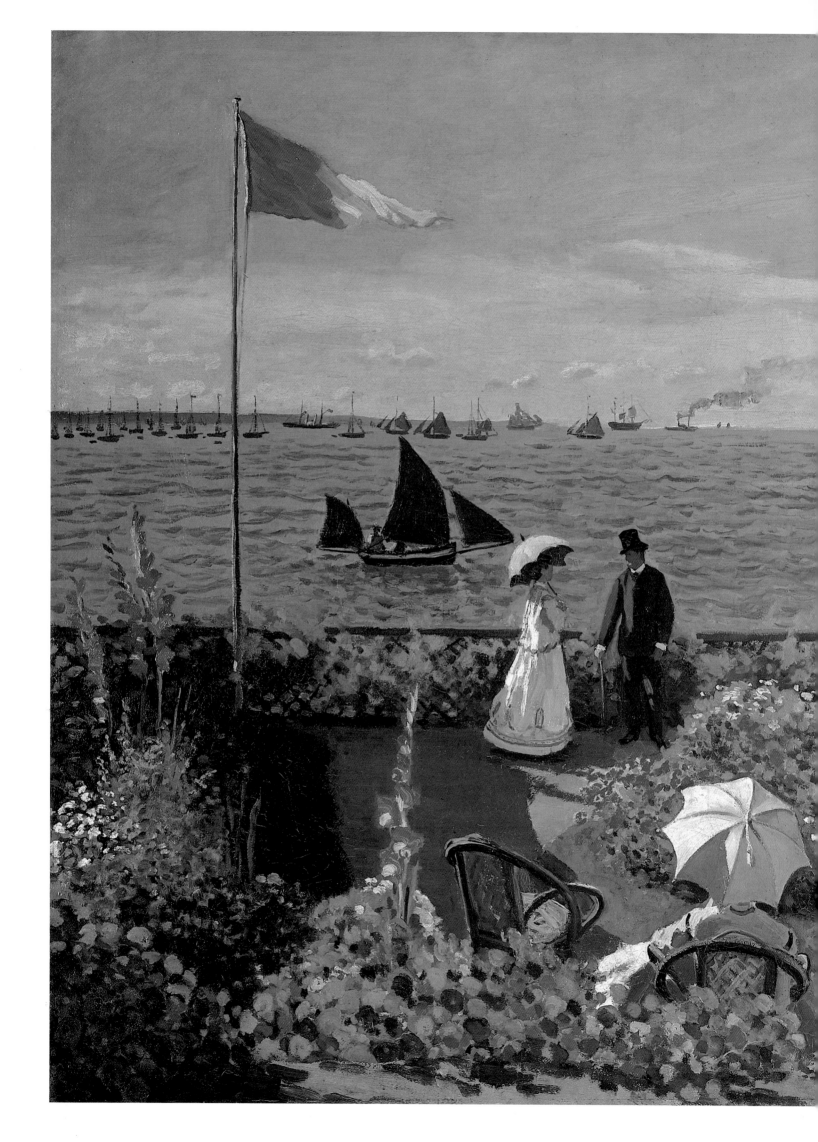

Claude Monet

14 *Terrace at Sainte-Adresse*, 1867
Claude Monet
French, 1840–1926
Oil on canvas; 38⅝ x 51⅛ in.
(98.1 x 129.9 cm.) Purchased with
special contributions and purchase
funds given or bequeathed by friends
of the Museum, 1967 (67.241)

Page 30: text

29

CLAUDE MONET

Terrace at Sainte-Adresse

In 1867 Monet was forced by financial circumstances to live with his family in the small seacoast town of Sainte-Adresse, about two and a half miles northwest of Le Havre. It was here that Monet painted this picture, in which his father, Adolphe, and his aunt, Sophie Lecadre, are seated in the foreground facing the sea. His cousin Jeanne Marguerite Lecadre is seen standing with an unidentified gentleman in the middle ground. The direction of the sun, from the region of Le Havre (visible in the distance to the left), tells us that it is the middle of the forenoon; the gladiolas tell us that it is the middle of August, when these flowers usually bloom.

The raised vantage point of Monet's picture divides the composition into three horizontal registers that appear to rise parallel to the surface of the canvas rather than recede into space. The flagpoles, which extend into all three registers, serve to flatten the picture still further, as do the touches of red on the boat at the right, echoing the red in the foreground. The tension between illusionism and the two-dimensional nature of the canvas remained an important characteristic of Monet's art throughout his career.

CLAUDE MONET

Beach at Sainte-Adresse

On June 25, 1867, when Monet was staying with his family in Sainte-Adresse, he wrote to his colleague Bazille about his work there. In the letter he refers to a group of paintings that appears to include this example, "Among the seascapes, I am doing the regattas of Le Havre with many figures on the beach and the outer harbor covered with small sails." The sweeping, wide-angle distortion of the coast in *Beach at Sainte-Adresse* is daring, and like *Terrace at Sainte-Adresse* (Plate 14), this work has many characteristics of the style that seven years later would be dubbed "Impressionism" by a hostile critic. Monet's subject matter—vacationers in the outdoors —would become one of the most popular among the Impressionists, as would his close attention to the appearance of the landscape. The variety of blues and greens in the water, the blue shadows behind the figures in the left foreground, and the different blues in the hull of the boat on the beach all testify to the young painter's increasing concern with color, light, and specific atmospheric conditions.

15 *Beach at Sainte-Adresse*, 1867
Claude Monet
French, 1840–1926
Oil on canvas; 29⅝ x 40 in. (75.3 x 101.6 cm.)
Bequest of William Church Osborn, 1951
(51.30.4)

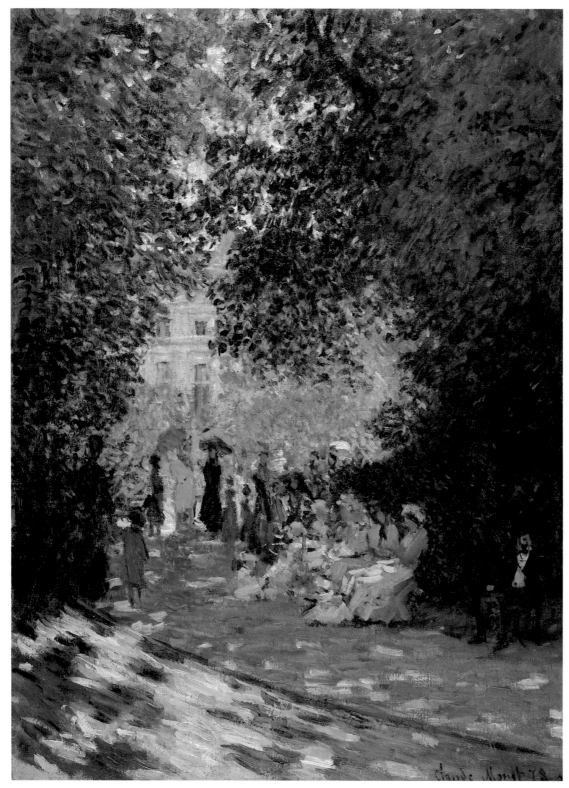

16 *Parisians Enjoying the Parc Monceau*, 1878
Claude Monet
French, 1840–1926
Oil on canvas; 28⅞ x 21⅜ in. (72.7 x 54.3 cm.)
The Mr. and Mrs. Henry Ittleson, Jr. Purchase
Fund, 1959 (59.142)

CLAUDE MONET
Parisians Enjoying the Parc Monceau

The subject of this painting—middle-class Parisians at lei-
sure in the outdoors—is quintessentially Impressionist. Yet
the cheerfulness of the sun-dappled scene, which is domi-
nated by women and children, contrasts with the poverty
and despair that was rife in Monet's life in 1878. Indeed,
the second half of the 1870s was a very difficult period for
Monet. Impressionism was under attack, his second son was
born amid dire financial distress, and his wife's health was
rapidly deteriorating.

CLAUDE MONET
Sunflowers

In 1881 Monet painted four views of the steps descending to the garden behind his house in Vétheuil, a suburb of Paris. Each painting includes sunflowers growing on both sides of the steps. The flowers depicted here were probably cut from his garden on a day when poor weather made it impossible for him to work outside. Although the sunflowers were arranged by hand and painted indoors, Monet has captured the exuberance of the outdoors in this luxuriant still life. The flowers are painted with a strong, direct brush-stroke; their writhing stalks cause the blossoms to twist and turn in the Japanese vase in which the artist has placed them. Filling the canvas, the sunflowers stand out especially strongly against the background of contrasting color.

Van Gogh, whose paintings of sunflowers are so well known, wrote to his brother, Theo, in 1888, saying, "Gauguin was telling me the other day that he had seen a picture by Claude Monet of sunflowers in a large Japanese vase, very fine, but—he likes mine better. I don't agree."

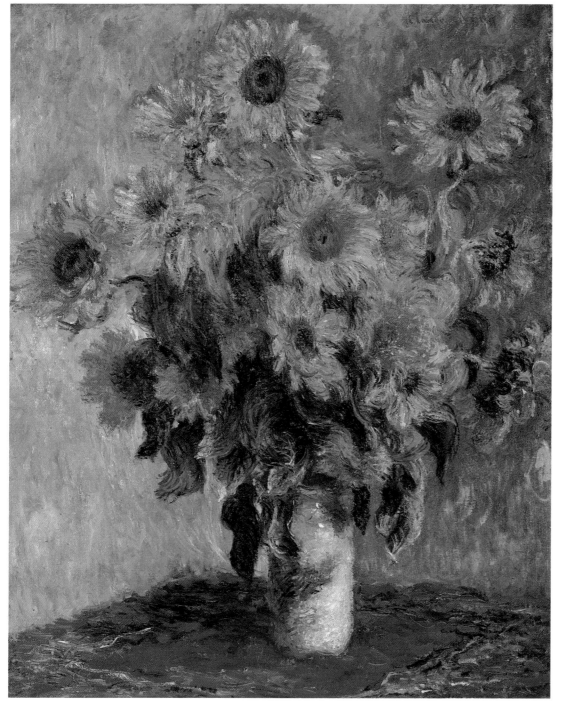

17 *Sunflowers*, 1881
Claude Monet
French, 1840–1926
Oil on canvas; 39¾ x 32 in.
(101 x 81.3 cm.)
Bequest of Mrs. H. O. Havemeyer,
1929, H. O. Havemeyer Collection
(29.100.107)

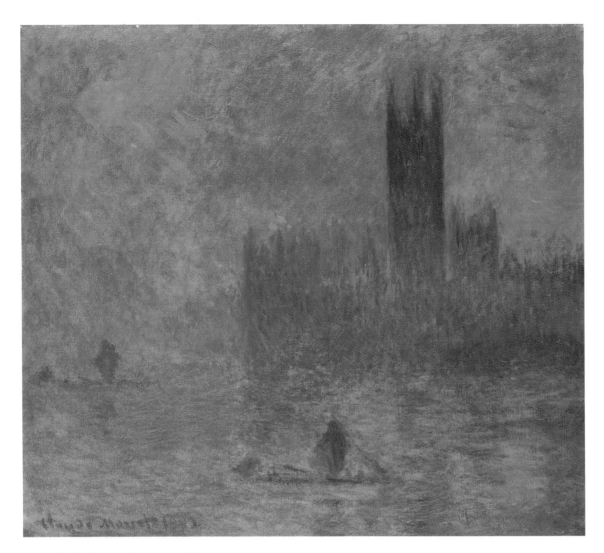

19 Rouen Cathedral, 1894
Claude Monet
French, 1840–1926
Oil on canvas; 39¼ x 25⅞ in.
(99.7 x 65.7 cm.)
Theodore M. Davis Collection,
Bequest of Theodore M. Davis,
1915 (30.95.250)

18 The Houses of Parliament, 1903
Claude Monet
French, 1840–1926
Oil on canvas; 32 x 36⅜ in.
(81.3 x 92.4 cm.) Bequest of
Julia W. Emmons, 1956 (56.135.6)

CLAUDE MONET
The Houses of Parliament

In London, in the fall of 1899, Monet began a series of pictures of structures along the River Thames, comprising views of Waterloo Bridge, Charing Cross Bridge, and the Houses of Parliament. He returned to Giverny in November, but in February 1900 he was in London once again, where he continued to work on the Thames series until April. Monet would work on a canvas until the light changed, at which point he would turn to another. This picture, painted from Saint Thomas's Hospital on the south side of the river directly across from the Houses of Parliament, was painted in a thick fog, an atmosphere that adds a sense of quiet mystery to the scene, softening the massive Gothic buildings into a muted silhouette, and transforming the boats into ghostly presences.

CLAUDE MONET
Rouen Cathedral

During February–April 1892 and February–March 1893, Monet painted more than thirty views of Rouen Cathedral. The character of the cathedral changed hourly as the light moved over its sculptured facade. Moving from one canvas to another as the day progressed, Monet painted the facade with highly textured brushstrokes that both convey the aspect of carved stone and make the atmosphere and light palpable.

The Rouen Cathedral pictures are more than a record of the cathedral's appearance at different times of the day; they are the record of the artist's very subjective experience of light, atmosphere, and a great building. Indeed, Monet, giving the lie to his reputation as a completely spontaneous painter, finished the works in his studio in Giverny, carefully adjusting the pictures both independently and in relation to each other.

In 1895 Monet exhibited twenty of the cathedral pictures at Durand-Ruel's gallery. This one was called *Le Portail (Soleil)*, or *The Portal (Sunlight)*. The paintings quickly sold for 15,000 francs apiece, which was then a great deal of money. A day after the exhibition closed, Camille Pissarro wrote to his son Lucien, "I would have so much wanted you to see it in its ensemble, because I find a superb unity that I have so often sought."

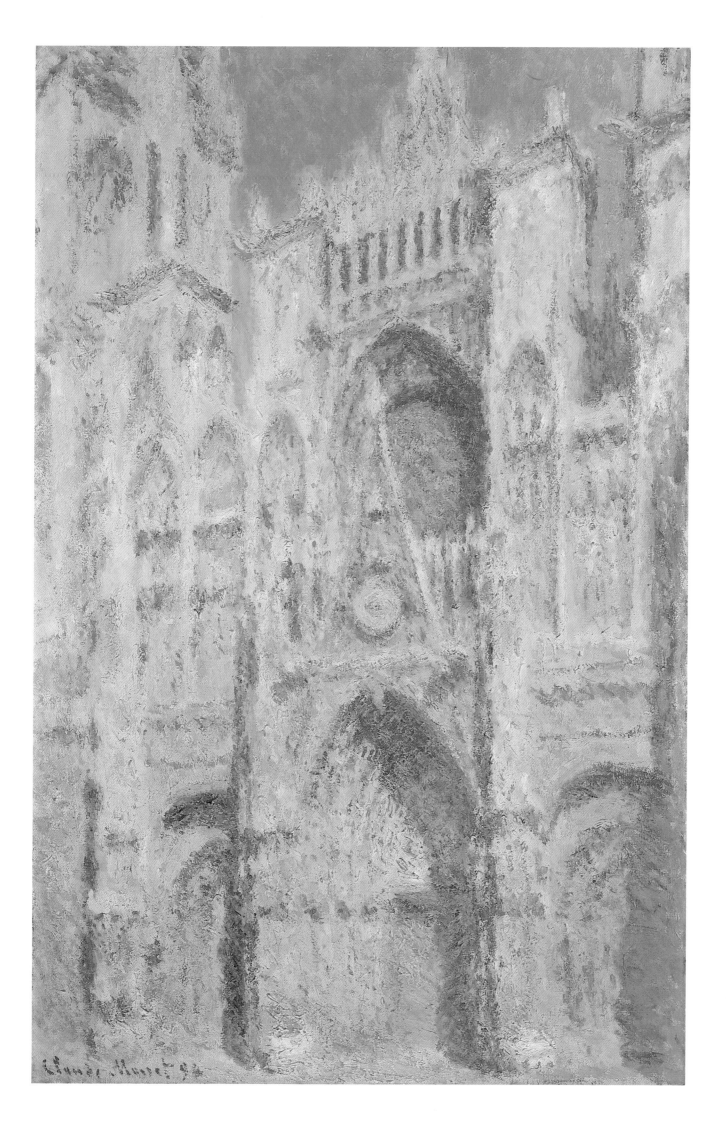

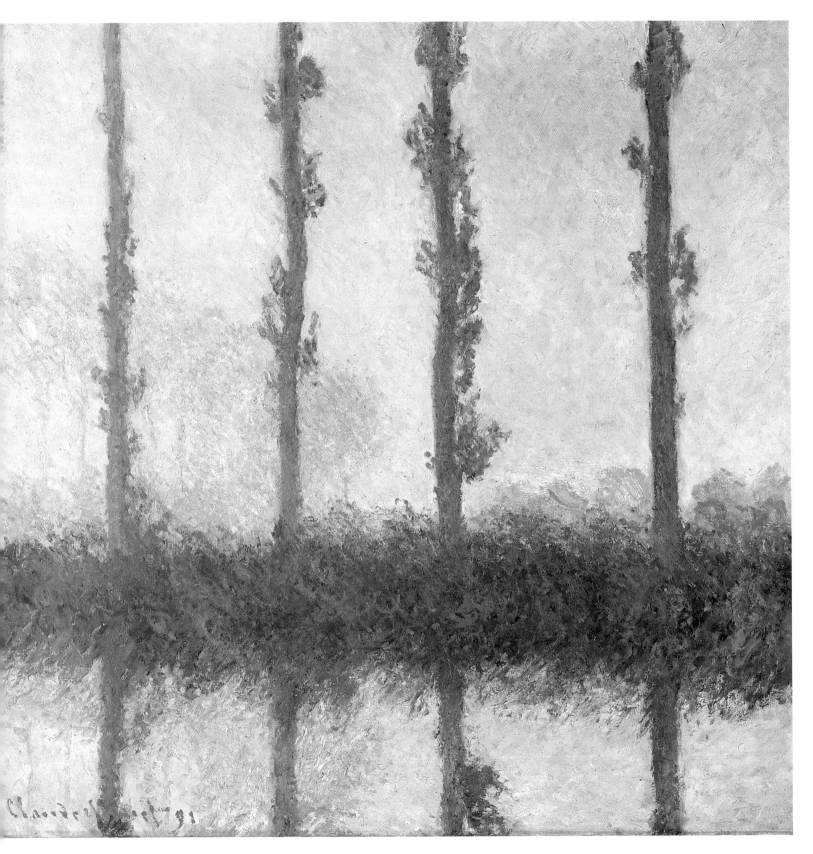

20 Poplars, 1891
Claude Monet
French, 1840–1926
Oil on canvas;
32¼ x 32⅛ in. (81.9 x 81.6 cm.)
Bequest of Mrs. H. O. Havemeyer,
1929, H. O. Havemeyer Collection
(29.100.110)

36

CLAUDE MONET
Poplars

Monet settled in Giverny, about forty miles northwest of Paris, in 1883. Although he took frequent trips, venturing as far as London and Venice, it was the landscape within a two-mile radius of his home that captured his attention for the rest of his life. With his famous *Haystacks* pictures, begun in 1890, Monet began to paint in series, often working on several canvases at once in order to capture the scene in changing light and weather conditions.

During the summer and fall of 1891, he painted a series of canvases depicting the poplars along the Epte River, about a mile from his house in Giverny. In the picture shown here, the radically simplified composition typical of Monet's late work is stated in terms of simple vertical and horizontal elements. Because he painted the poplars not from the distance of the opposite bank but from a boat in the middle of the river, we cannot see the tops of the four trees nearest us, but only the vertical lines of their slender trunks. Furthermore, were it not for the horizontal of the river bank, the tree trunks would be indistinguishable from their reflection in the water. The poplars in the background are depicted almost as a yellow-pink haze.

Monet's picture is evocative rather than representational; he has so abstracted the trees that they here become solemn, totemic icons. As a series, the works are both a record of changing light and atmosphere, and metaphors for the artist's changing moods.

CLAUDE MONET
Bridge over a Pool of Water Lilies
and Water Lilies (Pages 38–39)

21 *Bridge over a Pool of Water Lilies*, 1899
Claude Monet
French, 1840–1926
Oil on canvas;
36½ x 29 in. (92.7 x 73.7 cm.)
Bequest of Mrs. H. O. Havemeyer, 1929,
H. O. Havemeyer Collection (29.100.113)

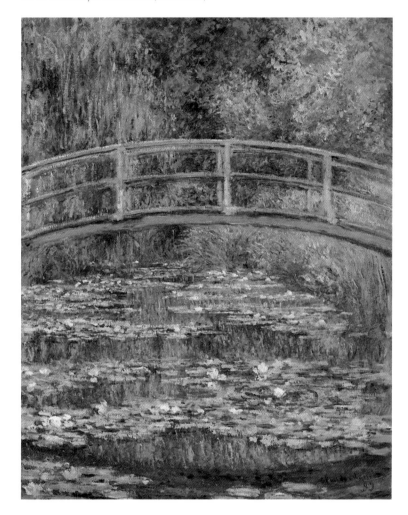

Water lilies, the subject most closely identified in the public mind with Monet, totally preoccupied the artist at the end of his career. As part of his extensive gardening plans at Giverny, Monet had a new pond dug out and planted with water lilies in 1893. But he did not adopt the motif for his painting until the summer of 1899. From that moment on he sensed that he had finally found a subject that equalled—and sometimes exceeded—the enormous ambitions he harbored for his art: In a large-scale, decorative series he worked continuously for more than twenty years to capture in paint every observation, impression, and reflection of the flowers and water. His early pictures of this subject, such as the one

in Plate 21, follow closely in harmony and texture his well-known series of paintings of the 1880s and 1890s, such as the pictures of haystacks, poplars, Rouen Cathedral, and mornings on the Seine (see Plates 19, 20). By the mid-teens of the twentieth century, however, he had pushed himself into a completely new, fluid, and often audacious style of painting in which the water-lily pond eventually became only the point of departure for an almost abstract art. This painting, begun by Monet sometime in the late teens and kept in his studio until his death, is one of the most complete and confidently executed pictures of the late series; its palette of violet, lapis blue, and deep viridian green is especially striking.

Overleaf

22 *Water Lilies*
Claude Monet
French, 1840–1926
Oil on canvas; 51¼ x 79 in. (130.2 x 200.7 cm.)
Jointly owned by The Metropolitan Museum of
Art and Mrs. Bertram Smith, 1983 (1983.532)

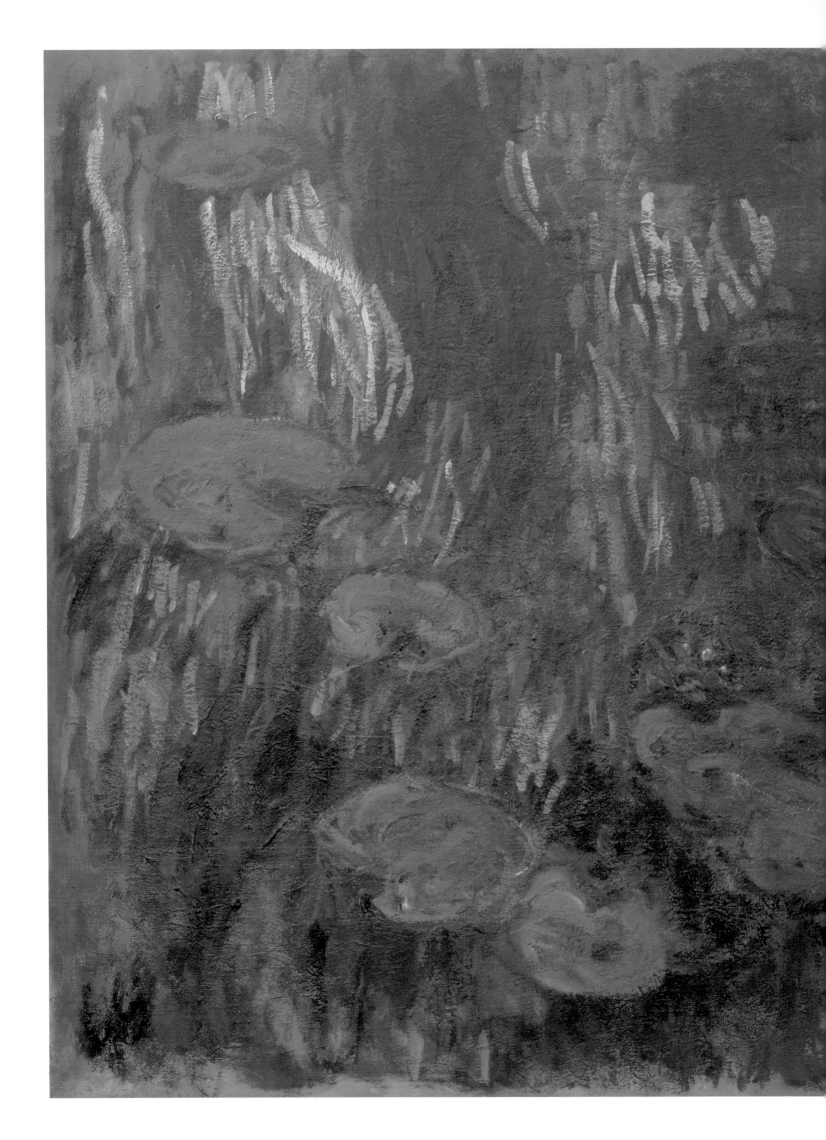

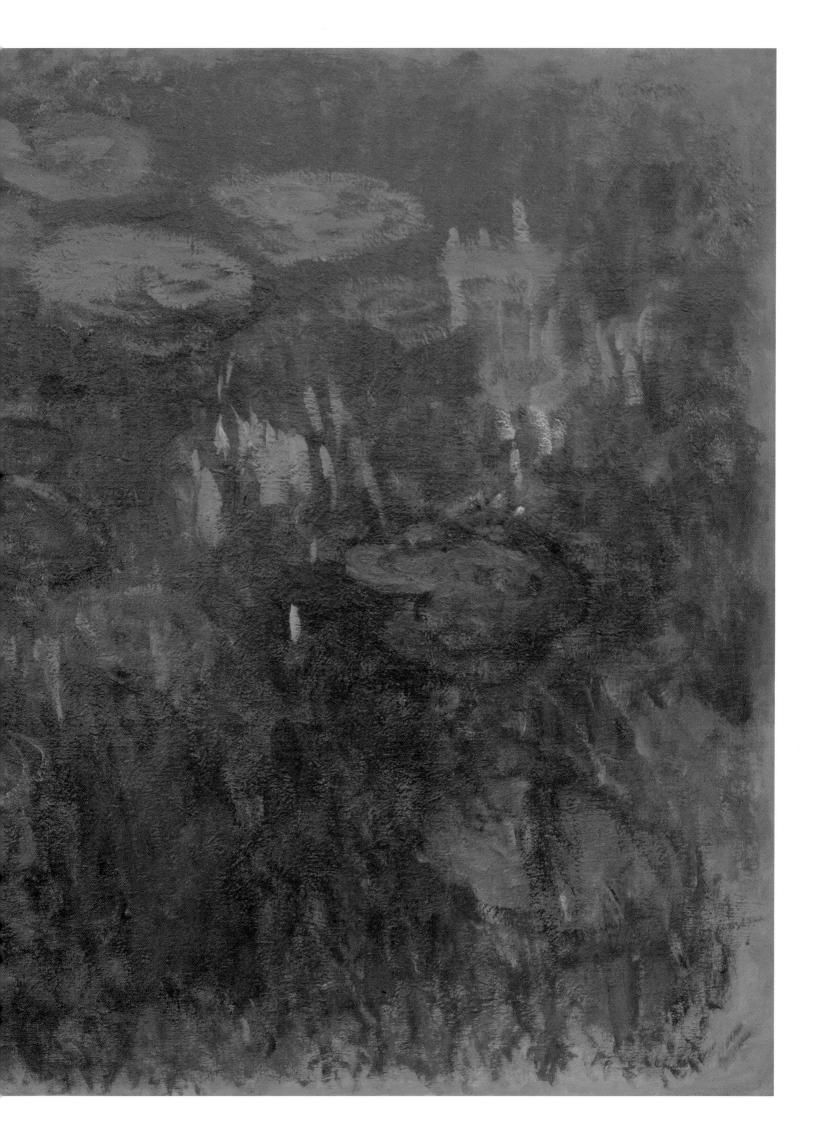

23 *Madame Georges Charpentier (Marguerite Lemonnier) and Her Children, Georgette and Paul*, 1878
Pierre Auguste Renoir
French, 1841–1919
Oil on canvas; 60½ x 74⅞ in. (153.7 x 190.2 cm.)
Wolfe Fund, Catharine Lorillard Wolfe Collection,
1907 (07.122)

Opposite: detail

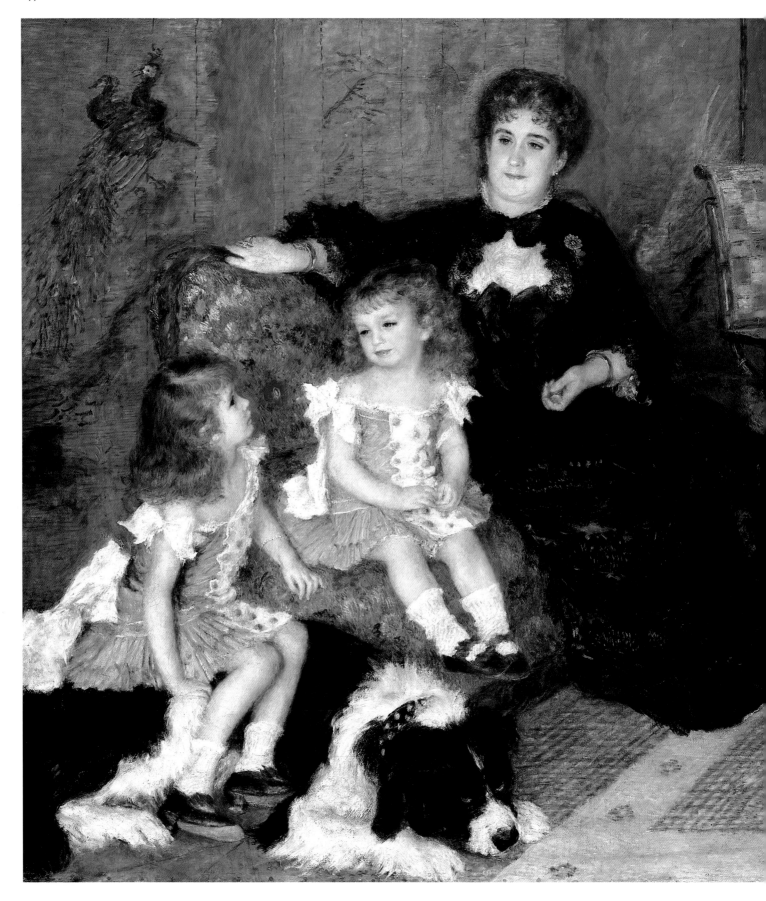

PIERRE AUGUSTE RENOIR
Madame Georges Charpentier and Her Children

The well-known publisher Georges Charpentier and his wife were important figures in the intellectual life of Paris. On Friday evenings they entertained political, literary, and artistic notables, including Renoir, at a salon in their house. Monsieur Charpentier paid Renoir a handsome sum to paint this large picture of his wife and children.

Renoir has given us a vivid description of the opulent surroundings in which the Charpentiers lived. The well-dressed figures—Madame Charpentier wears a Worth gown and the children wear matching blue outfits—are almost as decorative as the objects adorning the red-and-gold Japanese-style drawing room. Indeed, Renoir seems to have been more interested in conveying the luxurious and stylish atmosphere of the Charpentier household than in capturing the personalities of his sitters. Consequently, the portrait is closer in spirit to works by Rubens and Fragonard than to the penetrating portraits of his colleague Degas.

The elaborate detail in this painting signals the beginnings of Renoir's break with classic Impressionism. In fact, Renoir decided not to exhibit in the fourth Impressionist exhibition, and submitted this work to the official Salon. It was accepted and, thanks to Madame Charpentier's influence, hung in a prominent position.

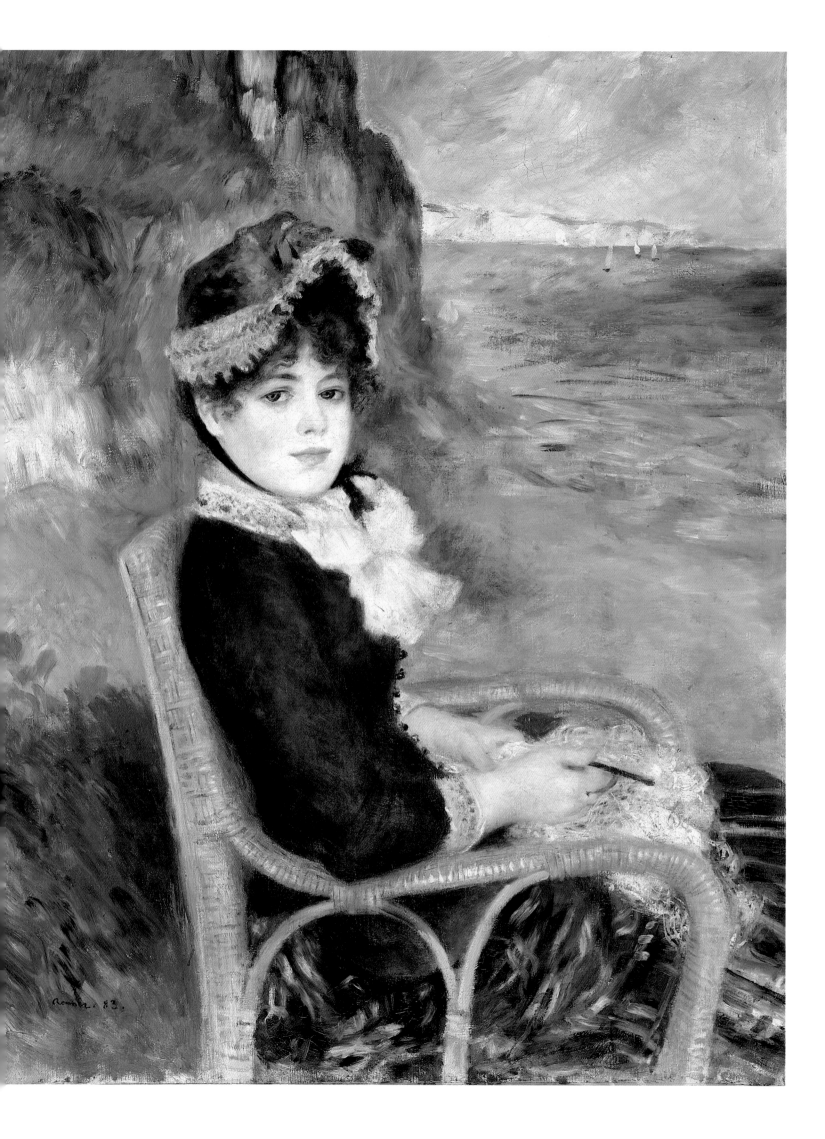

24 *By the Seashore*, 1892
Pierre Auguste Renoir
French, 1841–1919
Oil on canvas; 36¼ x 28½ in.
(92.1 x 72.4 cm.) Bequest of
Mrs. H. O. Havemeyer, 1929,
H. O. Havemeyer Collection
(29.100.125)

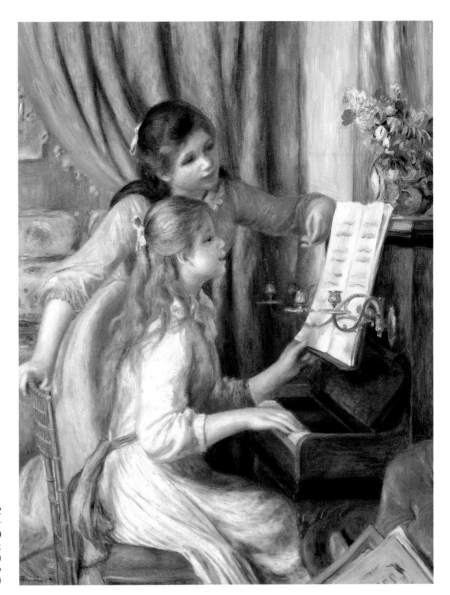

25 *Two Young Girls at the Piano*, 1892
Pierre Auguste Renoir
French, 1841–1919
Oil on canvas;
44 x 34 in. (111.8 x 86.4 cm.)
Robert Lehman Collection, 1975
(1975.1.201)

PIERRE AUGUSTE RENOIR

By the Seashore

On a trip to Italy in 1881 Renoir fell under the influence of the great Renaissance painter Raphael. This inspiration, coupled with the artist's growing dissatisfaction with the tenets of pure Impressionism, led him to break from the Impressionists for a time. In pursuit of the simplicity and grandeur of the ancient painters, Renoir determined to discipline his work by creating more classical compositions, exercising greater precision in drawing, and using a more even brushstroke. He later referred to the style he developed during this period as his "sour" or "dry" manner. In *By the Seashore* the new style is evident in the large, fully modeled figure, and in the porcelain smoothness of her face, painted almost without shadows. The rainbow of quick strokes in the background on the left, however, shows that Renoir had not yet completely abandoned the Impressionist method. The scene may be set on the Channel Island of Guernsey, where Renoir stayed in September 1883.

PIERRE AUGUSTE RENOIR

Two Young Girls at the Piano

Renoir painted three other variations of this composition in oil and one in pastel. Known by the artist as *répétitions*, they were executed to fulfill commissions from dealers and collectors. Pissarro and Monet routinely painted series of variations on a single theme, but their works were intended to be shown together to chronicle the effects of light and atmosphere, while Renoir's *répétitions* were independent essays in composition.

Renoir did realize, though, that originality in art did not depend wholly upon the invention of compositions. As his son explained:

> He told me one day that he regretted not having painted the same picture—he meant the same subject—all his life. In that way he would have been able to devote himself entirely to what constituted creation in his painting: the relation between form and color, which has an infinite variation in a single motif, and which can better be grasped when there is no further need to concentrate on the motif.

Camille Pissarro
Jallais Hill, Pontoise

Pissarro lived in Pontoise, a village on the Oise River north-west of Paris, from 1866 to 1869. Here he painted a group of pictures of the village lanes, farm buildings, hillsides, and fields that are among his most important early works. The paintings are firmly structured in composition and are characterized by strong brushstrokes and broad, flat areas of color that owe much to the work of Courbet and Corot, whose paintings were on view in large exhibitions in Paris.

Pissarro exhibited *Jallais Hill, Pontoise*, along with another landscape, in the Salon of 1868. Emile Zola praised them in an article in *L'Evénement illustré* devoted to Pissarro's work, saying of *Jallais Hill*, "There is the modern countryside. One feels that man has passed, turning and cutting the earth.... And this valley, this hillside embody a simplicity and heroic freedom. Nothing could be so banal were it not so great. From ordinary reality the painter's temperament has produced a rare poem of life and strength."

Although this work predates Impressionism, it has many characteristics of that style: There is little precise detail, and the grass, figures, road, and foliage in the foreground are treated broadly, foreshadowing the Impressionists' interest in the generalized appearance of things. In fact, Pissarro included *Jallais Hill, Pontoise* in the sixth Impressionist exhibition in 1881.

26 Jallais Hill, Pontoise, 1867
Camille Pissarro
French, 1830–1903
Oil on canvas; 34¼ x 45¼ in. (87 x 114.9 cm.)
Bequest of William Church Osborn, 1951 (51.30.2)

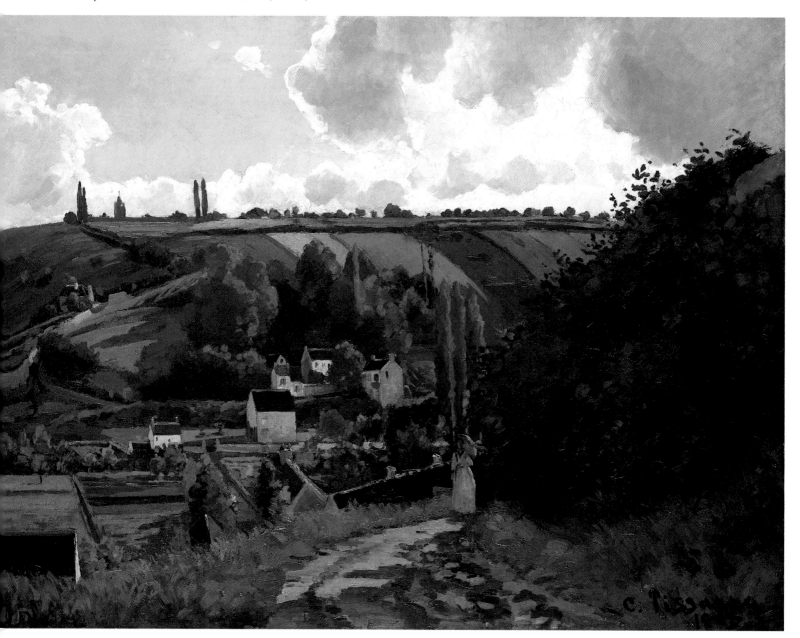

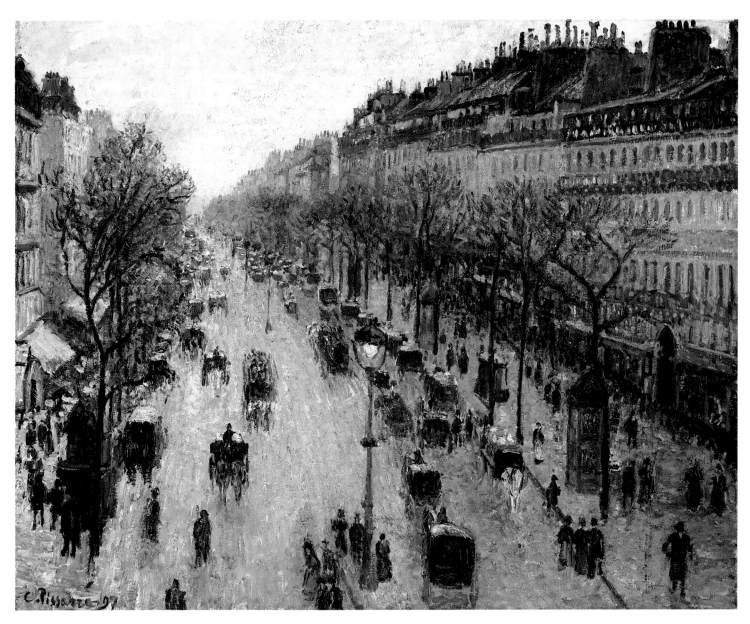

27 *The Boulevard Montmartre on a Winter
Morning*, 1897
Camille Pissarro
French, 1830–1903
Oil on canvas; 25½ x 32 in. (64.8 x 81.3 cm.)
Gift of Katrin S. Vietor, in loving memory of
Ernest G. Vietor, 1960 (60.174)

CAMILLE PISSARRO

The Boulevard Montmartre on a Winter Morning

Pissarro greatly admired Monet's series of pictures of hay-stacks and poplars when they were exhibited at Durand-Ruel's gallery in 1891 and 1892. Several years later he, too, decided to paint a series of pictures of a single subject at different times of day and under different atmospheric conditions. In February 1897 he arrived in Paris from Eragny and took a room at the Grand Hôtel de Russie, where he painted a series of pictures of the boulevard Montmartre. All the paintings in the series are slightly different in detail and point of view, like Monet's pictures. Yet Pissarro's works, although late, recall the classic Impressionism of the 1870s both in subject—the effects of light and atmosphere—and in style—especially the small, rapid brushstrokes with which figures and objects are generalized rather than represented in detail.

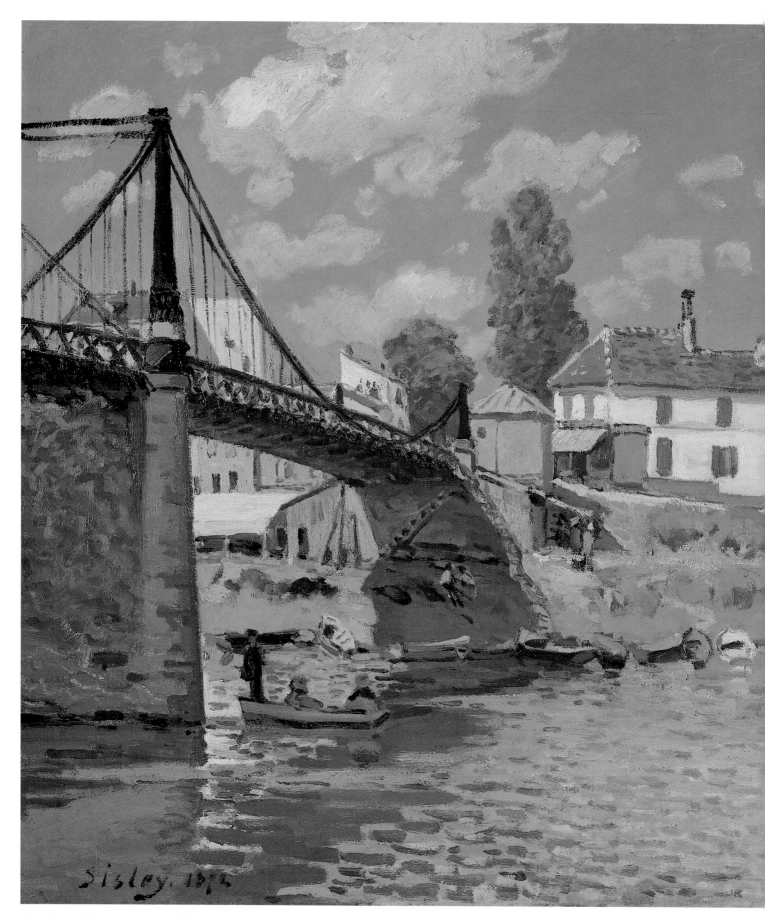

28 *Bridge at Villeneuve-la-Garenne*, 1872
Alfred Sisley
British, 1838–99
Oil on canvas; 19½ x 25¾ in.
(49.5 x 65.4 cm.)
Gift of Mr. and Mrs. Henry Ittleson, Jr.,
1964 (64.287)

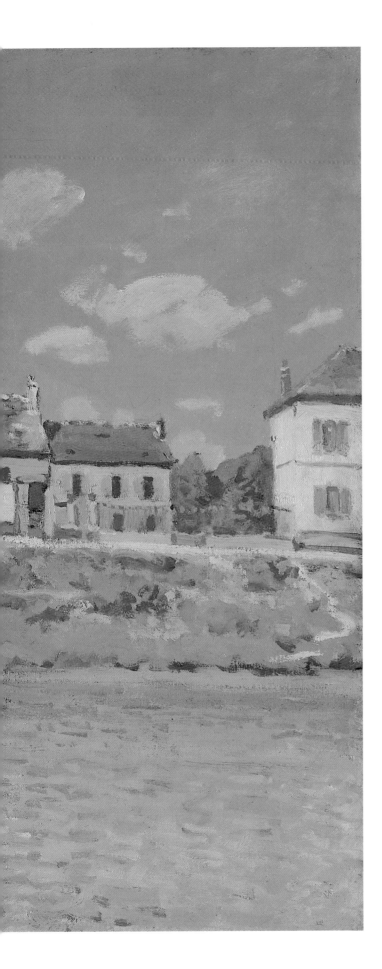

ALFRED SISLEY
Bridge at Villeneuve-la-Garenne

As a young man, Alfred Sisley, the son of a wealthy English family living in Paris, joined the studio of Charles Gleyre, where Monet and Renoir were also students. After Gleyre retired in 1864, the three would occasionally paint landscapes side by side. It may have been this contact that encouraged Sisley to adopt the basic elements of the style that came to be known as Impressionism. In *Bridge at Villeneuve-la-Garenne*, painted in 1872, we already see the fresh, high-keyed color and short, staccato brushstrokes approximating the effects of shimmering light that we associate with Impressionism. Above all, the scene depicted—life in one of the small towns near the Seine on the outskirts of Paris —was perhaps the quintessential subject for the Impressionists in the 70s.

PAUL CÉZANNE
Mont Sainte-Victoire

Cézanne exhibited with the Impressionists in 1874, and though he shared their plein-air approach, he was preoccupied by other aims. While they sought to capture the fleeting impression of a casual glance, he tried to explain the forms and patterns that build the structure of a scene. Cézanne sought to reveal the inner geometry of nature, "to make of Impressionism something solid and durable, like the art of museums."

The distinctive silhouette of Mont Sainte-Victoire rises above the Arc River valley near the town of Aix-en-Provence. The prospect was much loved by Cézanne, who made repeated use of its dramatic form in his work. The picture illustrated here is one of four the artist made in the mid-1880s. It was painted from the little hill at Bellevue, the estate of his brother-in-law, Maxime Conil. During this period Mont Sainte-Victoire was studied in its relationship to the artist's immediate surroundings; in later works it came to dominate the entire scene.

29 Mont Sainte-Victoire, mid-1880s
Paul Cézanne
French, 1839–1906
Oil on canvas;
25¾ x 32⅛ in. (65.4 x 81.6 cm.)
Bequest of Mrs. H. O. Havemeyer,
1929, H. O. Havemeyer Collection
(29.100.64)

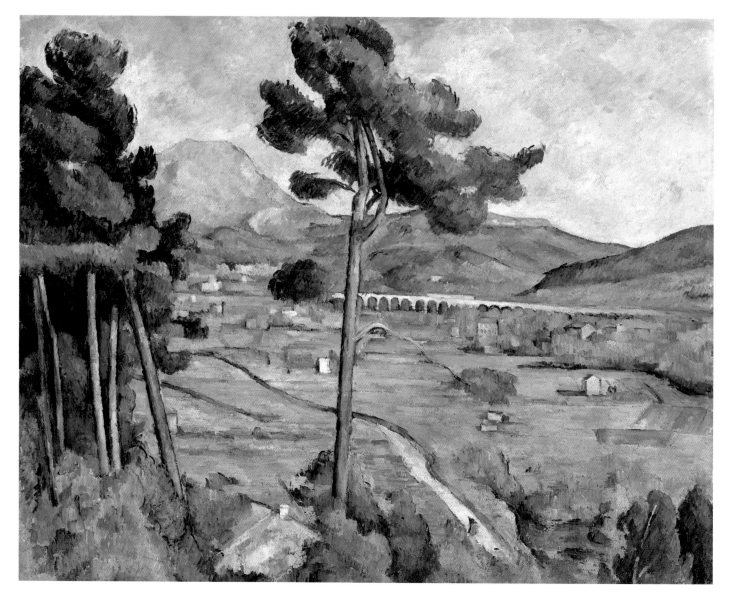

Paul Cezanne
The Gulf of Marseilles Seen from L'Estaque

Though he studied in Paris from 1862 to 1870—during which time he became good friends with Pissarro—Cézanne preferred to live in the calm isolation and beauty of the landscape around Aix-en-Provence, the town in the south of France in which he was born to wealthy middle-class parents.

In the 1880s Cézanne executed more than a dozen closely related pictures of the panoramic view from the Provençal town of L'Estaque toward a low range of mountains across the Gulf of Marseilles. Pissarro and Monet adopted similar working methods in their series paintings, but while their purpose was to record the shifting effects of sunlight and shadow, Cézanne was interested in the variations in composition that result from a change of vantage point or angle of vision.

In this painting, executed around 1878–82, Cézanne contrasts the closely packed geometric forms of buildings in the foreground with the more scattered and irregularly shaped mountains. The composition is intriguing: From the elevated position the scale is distorted, and the nearby buildings seem comparable to the mountains in size.

*30 The Gulf of Marseilles
Seen from L'Estaque*, 1878–82
Paul Cézanne
French, 1839–1906
Oil on canvas;
28¾ x 39½ in. (73 x 100.4 cm.)
Bequest of Mrs. H. O. Havemeyer, 1929,
H. O. Havemeyer Collection (29.100.67)

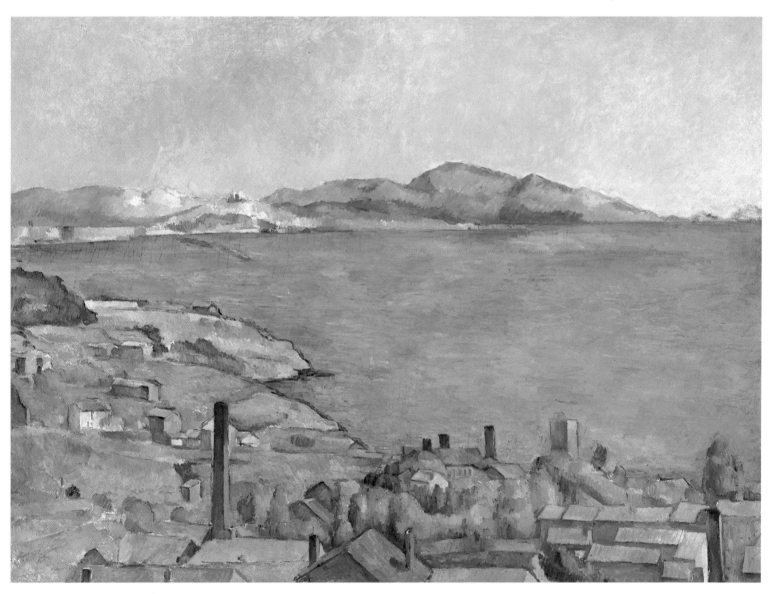

PAUL CEZANNE

Still Life with a Ginger Jar and Eggplants

Cézanne's still lifes are a starting point for complex meditations about mass and space. In them, the artist abandoned the limits of traditional one-point perspective and explored the variety of angles that compose the volume of a three-dimensional object.

In *Still Life with a Ginger Jar and Eggplants*, painted around 1890, Cézanne added a number of new objects to an established repertoire that included the table and green crockery jar seen here. They include the heavy blue curtain decorated in a bold abstract floral pattern, the dark wine bottle with raffia lacing, and the round ginger jar, also bound with raffia lacing. Cézanne introduced these elements into a composition that is more elaborate than his previous still lifes. Indeed the whole tableau seems predicated on pictorial needs rather than on the demands of ordinary vision. Every shape and contour is overlapped by another. Even the artist's vantage point changes to suit the picture: The height of the table in the background indicates that the arrangement is set very close to the floor, but the objects in the foreground do not seem to be observed from such a high perspective.

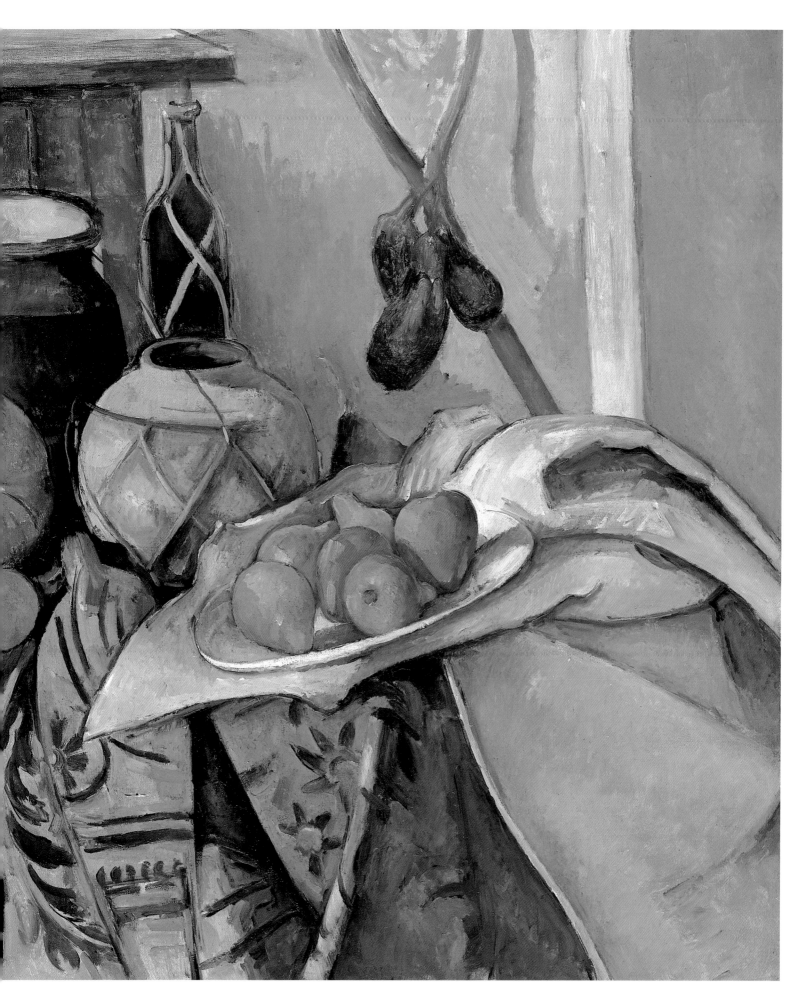

32 *Madame Cézanne in the Conservatory*, 1891
Paul Cézanne
French, 1839–1906
Oil on canvas; 36¼ x 28¾ in. (92.1 x 73.0 cm.)
Bequest of Stephen C. Clark, 1960 (61.101.2)

33 *The Card Players*, early 1890s
Paul Cézanne
French, 1839–1906
Oil on canvas; 25¾ x 32¼ in. (65.4 x 81.9 cm.)
Bequest of Stephen C. Clark, 1960 (61.101.1)

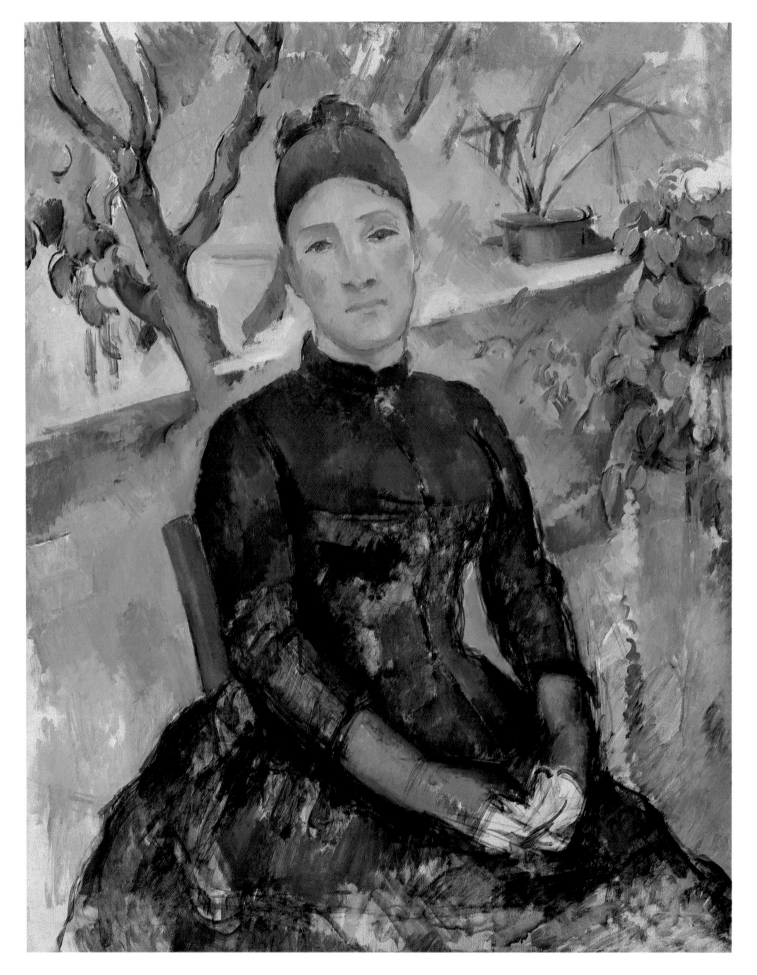

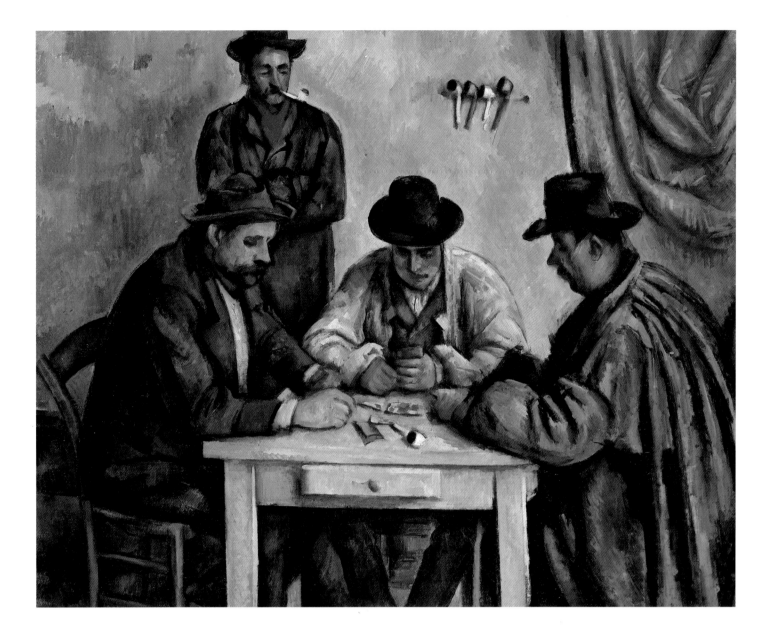

Paul Cezanne
Madame Cézanne in the Conservatory

Hortense Fiquet was a professional model whom Cézanne met in Paris in 1869. They had a son in 1872 and married in 1886, though she continued to live in Paris and he in Aix-en-Provence. Madame Cézanne was known for her ability to hold herself in a single pose for hours, and Cézanne made use of her talent, painting her portrait at least twenty-seven times.

This picture was made in 1891 on one of Hortense's visits to the Cézanne family estate at the Jas de Bouffan. The artist shows her in the conservatory amidst flowering plants. Though his preoccupation with geometric volumes is evident in the perfect oval of her head and the cylinder that forms her torso, there is a sympathy in this portrayal of Hortense that is uncharacteristic of Cézanne. His wife, however, returns his compliment with the stoic gaze of one resigned to a lifetime of posing.

Paul Cezanne
The Card Players

This still-life arrangement of peasants playing cards was made in the early 1890s and was probably inspired by a work of Mathieu le Nain in the local museum at Aix. Genre subjects are unusual in the work of Cézanne. He is known for his landscapes, still lifes, and portraits, and has here treated his subject as if similarly static. The figures, stoic pyramids hunched over their cards, could almost be the same man turned round. They are placed for study—as if they were elements in a *nature morte*—before a billow of golden cloth, their eyes downcast, vacant of personality. Four pipes hang on the wall, serving to balance the composition as well as to suggest a peasant interior.

Typically, Cézanne made a series of paintings of this subject over a five-year period. This is thought to be the second one. As he pared away extraneous details in each of the five successive versions, Cézanne's psychological characterization of the event became more penetrating. In the final paintings, he dispensed with everything except the figures of two players starkly confronting one another across the table.

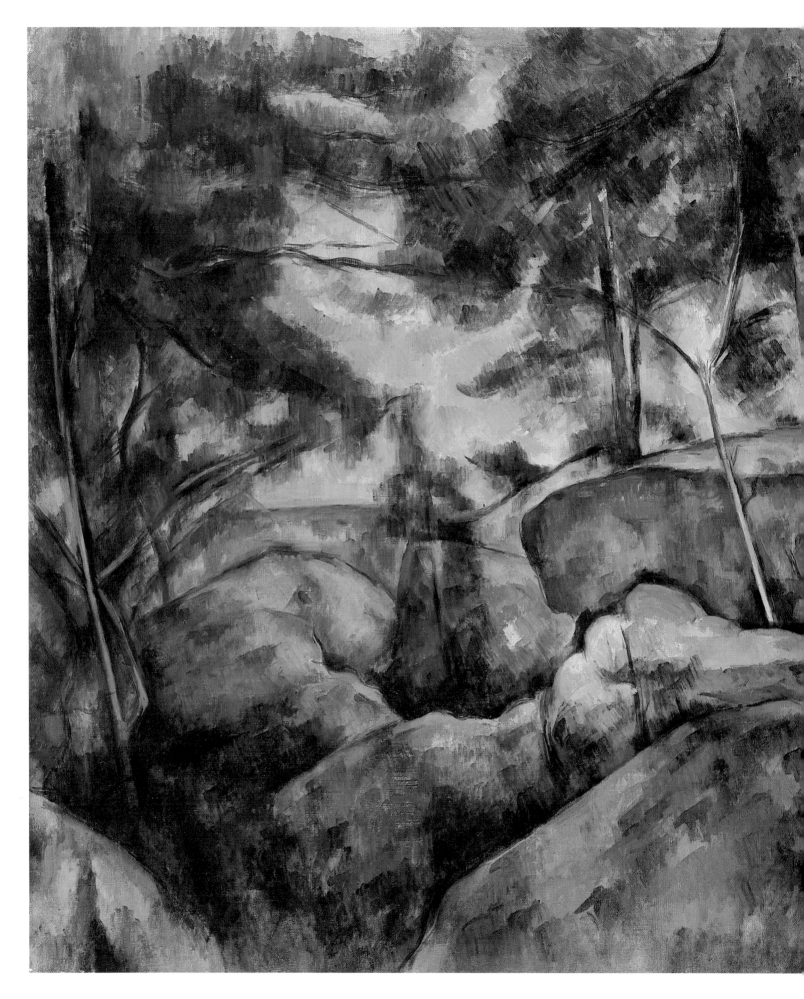

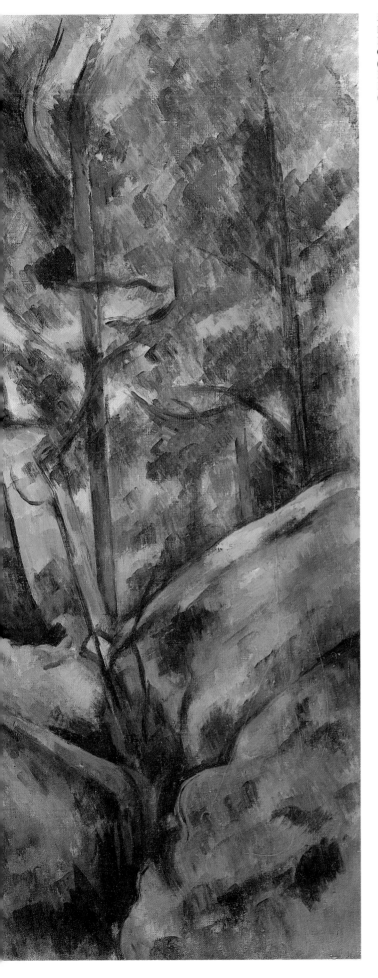

34 *Rocks in the Forest*, ca. 1893
Paul Cézanne
French, 1839–1906
Oil on canvas; 28⅞ x 36⅜ in.
(73.3 x 92.4 cm.) Bequest of
Mrs. H. O. Havemeyer, 1929,
H. O. Havemeyer Collection
(29.100.194)

PAUL CEZANNE
Rocks in the Forest

This scene showing rocks in a forest is thought to have been observed during one of Cézanne's working trips to the forest of Fontainebleau, sometime around 1893. Characteristic of his work at this time are the purplish-gray tone of the painting and the thin layers of pigment applied in a manner reminiscent of watercolor technique.

The art historian Meyer Schapiro compared the painting to a passage (set in the Fontainebleau forest) from Flaubert's novel *L'Education sentimentale:*

> The light... subdued in the foreground planes as if at sundown, cast in the distance violet vapors, a white luminosity.... The rocks filled the entire landscape,... cubic like houses, flat like slabs of cut stone, supporting each other, overhanging in confusion, like the unrecognizable and monstrous ruins of some vanished city. But the fury of their chaos makes one think rather of volcanos, deluges and great forgotten cataclysms.

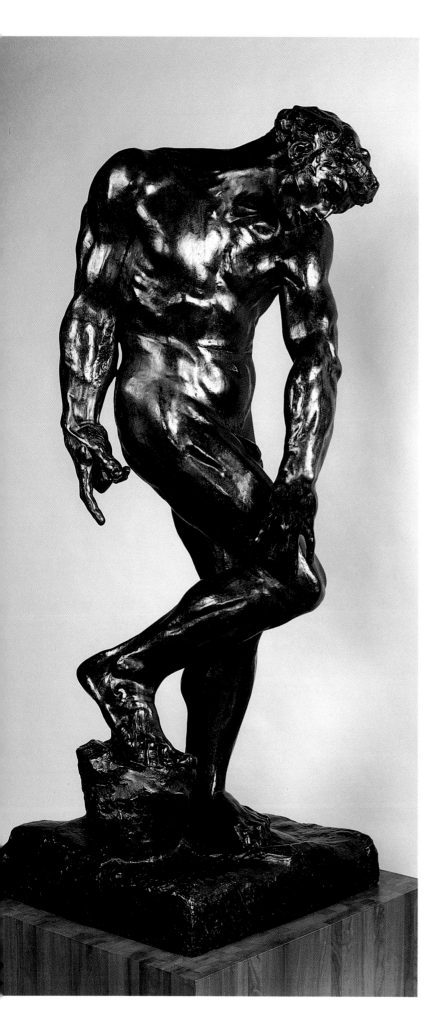

35 Adam
Auguste Rodin
French, 1840–1917
Bronze, modeled 1880, cast 1910;
H. 76¼ in. (193.7 cm.)
Gift of Thomas F. Ryan, 1910
(11.173.1)

AUGUSTE RODIN
Adam

Auguste Rodin is probably the best-known sculptor of the nineteenth century. Even in his own day he was immensely popular; on his death in 1917, in addition to his funeral in Meudon, France, memorial services were held in England and Germany, despite the world war. Rodin's passionate exploration of the human body and psyche endowed works so small as to be measured in inches with vibrant, lifesize energy.

On a trip to Italy in 1875, Rodin was deeply impressed by the work of Michelangelo. The Renaissance master's Sistine Chapel frescoes were a direct source of inspiration for *Adam*, which shows the first man being raised to life slowly and with difficulty. In this work, Rodin combined elements from the *Creation of Man* in the Sistine Chapel and from the Christ of Michelangelo's *Pietà* in the Duomo in Florence. *Adam* was originally modeled in 1880, and for a time Rodin intended to incorporate the figure into his design for *The Gates of Hell*, the portal planned for a building, designed to house the Musée des Arts Décoratifs in Paris, that was never constructed. The Metropolitan Museum of Art commissioned this bronze from Rodin in 1910.

AUGUSTE RODIN
Orpheus and Eurydice

The mythological subject of Orpheus and Eurydice was the subject of a large marble executed in 1893. When Orpheus's wife Eurydice was killed, the poet-musician went to the underworld to bring her back. By the power of his lyre he persuaded Pluto to allow Eurydice to follow him to earth if he did not turn to look at her until they reached their destination. He did turn, however, and Eurydice vanished forever. Rodin shows the young couple making their way to earth, Orpheus covering his eyes. Here, too, Michelangelo's influence may be felt, in the way the figures emerge from the marble block. For Rodin, however, unlike for Michelangelo, such an effect is an integral part of the finished piece and not a stage in its execution. The way in which the marble block stands for the netherworld through which the figures travel was revolutionary.

36 Orpheus and Eurydice, 1893
Auguste Rodin
French, 1840–1917
Marble; H. 50 in. (127 cm.)
Gift of Thomas F. Ryan, 1910
(10.63.2)

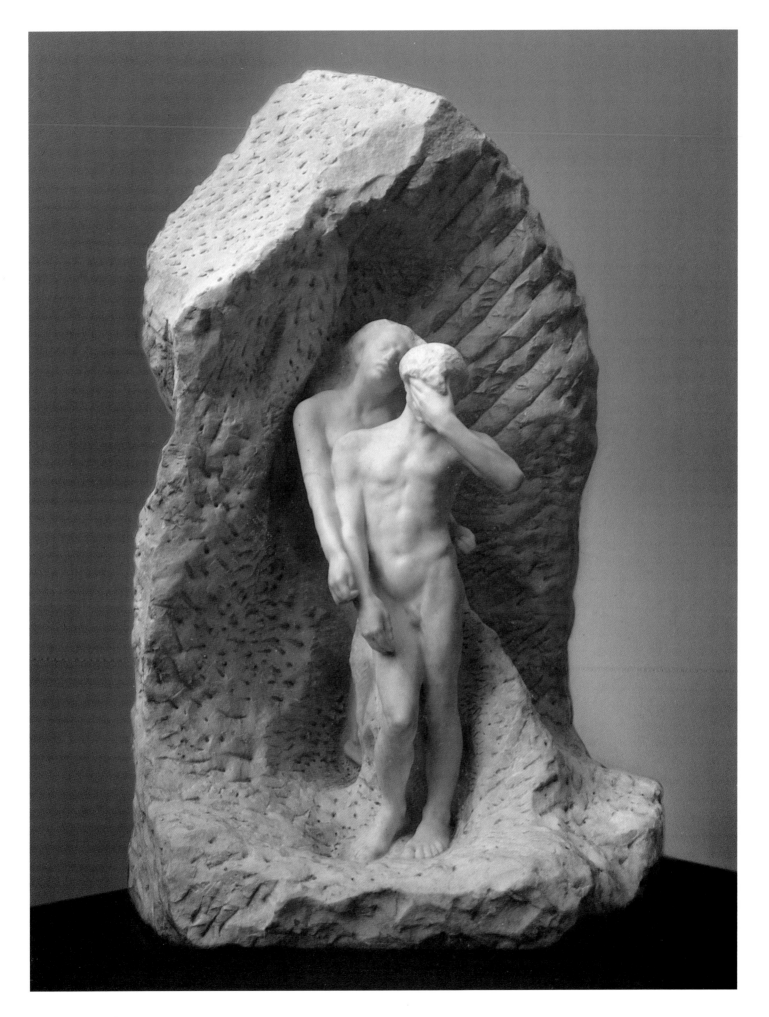

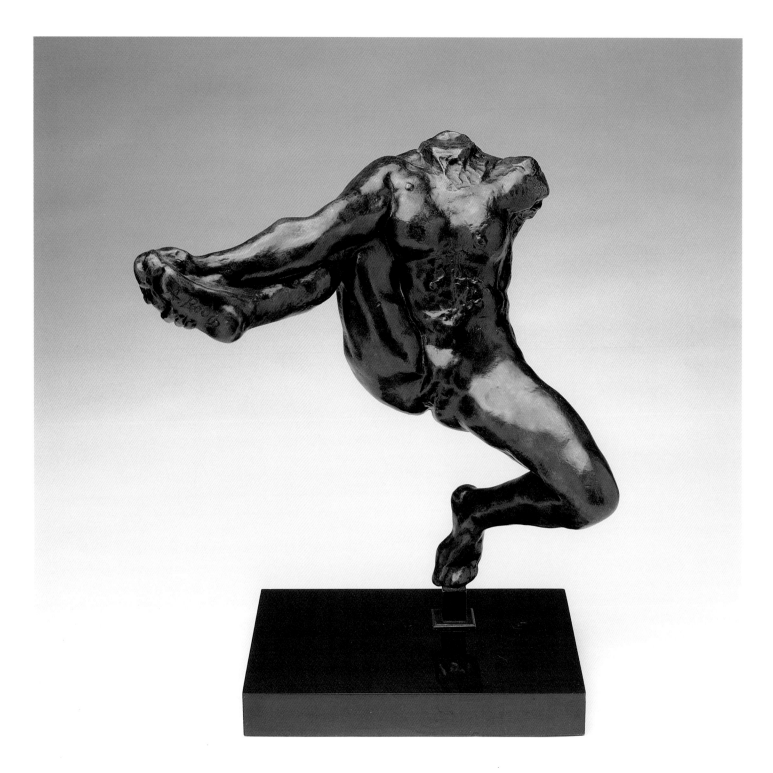

Auguste Rodin
Iris, Messenger of the Gods

Iris, Messenger of the Gods is remarkable for the way in which it captures movement. This figure of a woman, headless and without a left arm, is unabashedly sexual and energetic and was probably inspired by Rodin's growing interest in dance. Freestanding and separated from any narrative or anecdotal context, *Iris, Messenger of the Gods* is an image of tremendous vitality.

Auguste Rodin
Birth of the Greek Vase

In this drawing executed in old age, Rodin permitted himself a witty but profound reflection upon the origins of art itself, speculating that the Greeks derived the shapes of their vessels from natural forms; the drawing is inscribed *Naissance du vase grec*. Rodin's kneeling woman-amphora has shoulders and hips of equal width, which he claimed was the essence of Greek proportion.

VINCENT VAN GOGH
Sunflowers

Sunflowers were a favorite subject of Van Gogh's and they recur with regularity in his work. This picture is one of three that he made of sunflowers during the summer of 1887 in Paris. In this work the artist fills the canvas with the great lolling heads of the sunflowers and imparts a pathos to their fate that seems almost human. Severed from their lifeline stalks, the flowers are going to seed—withering and dying. Sharp, flamelike petals, which seem to lick the perimeter of the buds, stand out against stark blue. The swirling brush-strokes that compose the background are charged with an autonomous energy similar to that in the artist's *Self-Portrait with a Straw Hat* (Plate 40).

Gauguin admired Van Gogh's sunflower paintings and paid homage to the artist in his Arles portrait *Van Gogh Painting Sunflowers*.

39 *Sunflowers*, 1887
Vincent van Gogh
Dutch, 1853–90
Oil on canvas; 17 x 24 in.
(43.2 x 61 cm.)
Rogers Fund, 1949 (49.41)

40 Self-Portrait with a Straw Hat, 1887
Vincent van Gogh
Dutch, 1853–90
Oil on canvas; 16 x 12½ in. (40.6 x 31.8 cm.)
Bequest of Miss Adelaide Milton de Groot
(1876–1967), 1967 (67.187.70a)

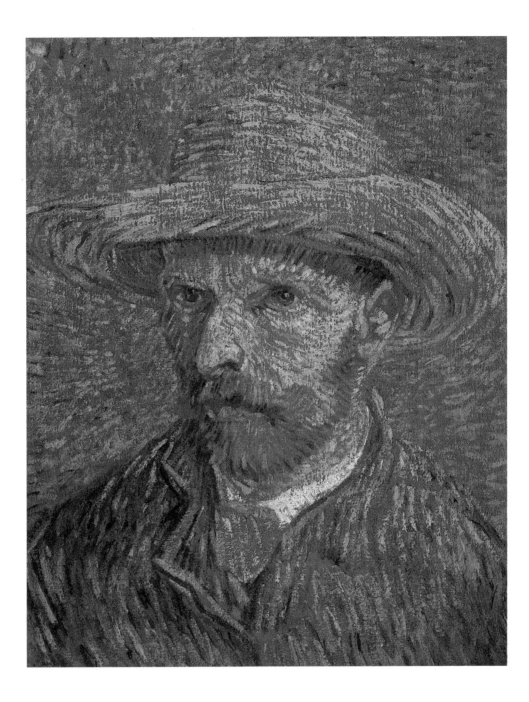

VINCENT VAN GOGH

Self-Portrait with a Straw Hat

In the last five years of his life Van Gogh painted thirty-seven self-portraits. Seven of them show him wearing a straw hat. This picture is thought to date from the final months of Van Gogh's two-year stay in Paris from March 1886 to February 1888. During this period Van Gogh experimented with color theory, brushstroke, and a variety of techniques then popular in Paris. Both the palette and brushstrokes of this particular work show the influence of divisionism, as it was practiced by Seurat and Signac. But where these artists used the technique to achieve a more objective and "scien-

tific" rendering of color, Van Gogh used the short, staccato dabs and slashes to evoke a personality. Though he neither dated the self-portraits nor mentioned them in his letters, the artist seems to have described his objective in a note to his brother from December 1885:

> I prefer painting people's eyes to cathedrals, for there is something in the eyes that is not in the cathedral, however solemn and imposing the latter may be—a human soul, be it that of a poor streetwalker, is more interesting to me.

FELIX BRACQUEMOND
Plate

Félix Bracquemond was a painter and printmaker who began decorating ceramics in the 1850s. This plate was designed while Bracquemond was employed as the director of the Paris decorating studio of Haviland et Cie., a porcelain factory in Limoges. The decorative ribbon and medallions, which were impressed from a relief cast from an etched metal plate, are bold in shape and asymmetrically disposed, evidence of Bracquemond's debt to Japanese art—a debt he shared with many artists, including Van Gogh.

41 Plate, 1872–80
Félix Bracquemond
French, 1833–1914
Porcelain with gilding;
D. 9½ in. (24.1 cm.)
Gift of George Haviland,
1923 (23.31.21)

VINCENT VAN GOGH
L'Arlésienne: Madame Ginoux

From February 1888 to May 1889 Van Gogh lived in the town of Arles in Provence. During that period the artist produced some two hundred paintings, among them this portrait of the *patronne* of a local café, Madame Ginoux. The picture was painted during the period of Gauguin's visit to Arles from late October to December 1888. Both artists cajoled Madame Ginoux into posing for them by inviting her to share coffee with them. They sat on either side of her and made rapid sketches. Apparently, Gauguin encouraged Madame Ginoux's patience by telling her, "Madame Ginoux, Madame Ginoux, your portrait will be placed in the Louvre in Paris."

Van Gogh wrote to his brother, Theo, in the week of November 11, 1888:

> I have an Arlésienne at last . . . a figure slashed on in an hour, background pale citron, the face gray, the clothes black, black, black, with perfectly raw Prussian blue. She is leaning on a green table and seated in an armchair of orange wood.

Madame Ginoux wears the distinctive cap of women from this region of Provence. The large areas of single color and the bold contours of the figure reflect the influence of Japanese prints and medieval cloisonné enamels. Even the bit of ribbon that dangles from the cap is treated as a solid element, its edges sculptured in paint. Van Gogh made two versions of this portrait, of which this is probably the second. The one referred to in the letter is likely to be a paler version made rapidly at the first sitting. True to Gauguin's words, that version now belongs to the Louvre.

42 L'Arlésienne: Madame Ginoux, 1888
Vincent van Gogh
Dutch, 1853–90
Oil on canvas;
36 x 29 in. (91.4 x 73.7 cm.)
Bequest of Sam A. Lewisohn, 1951
(51.112.3)

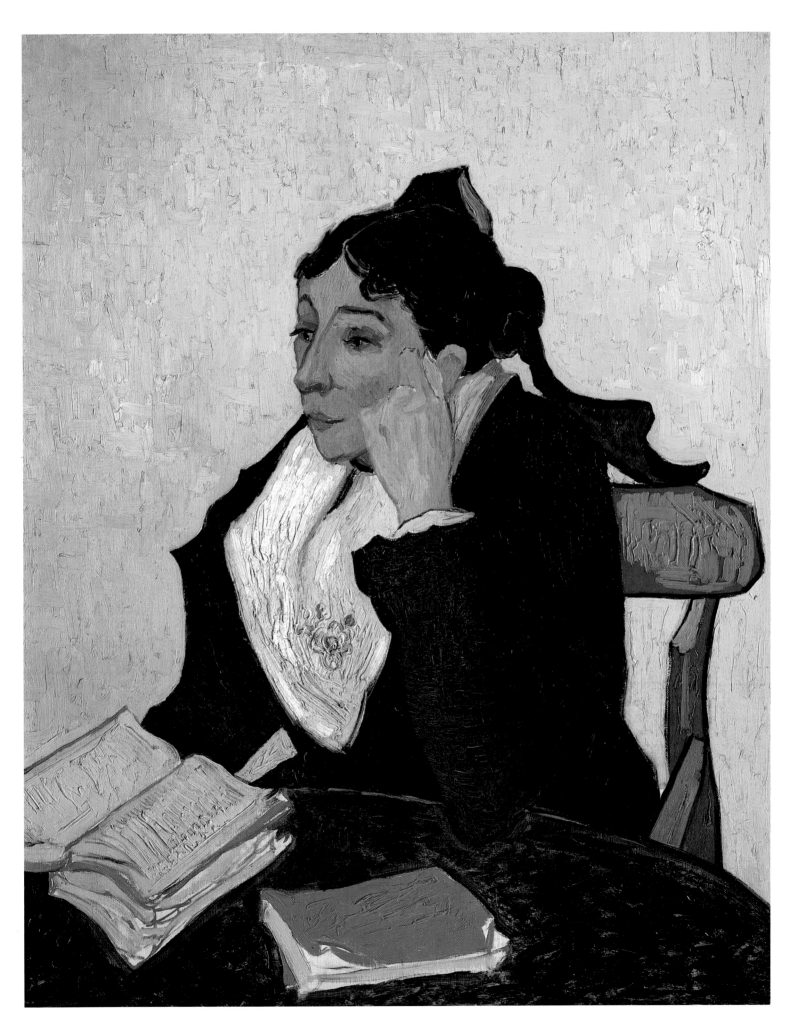

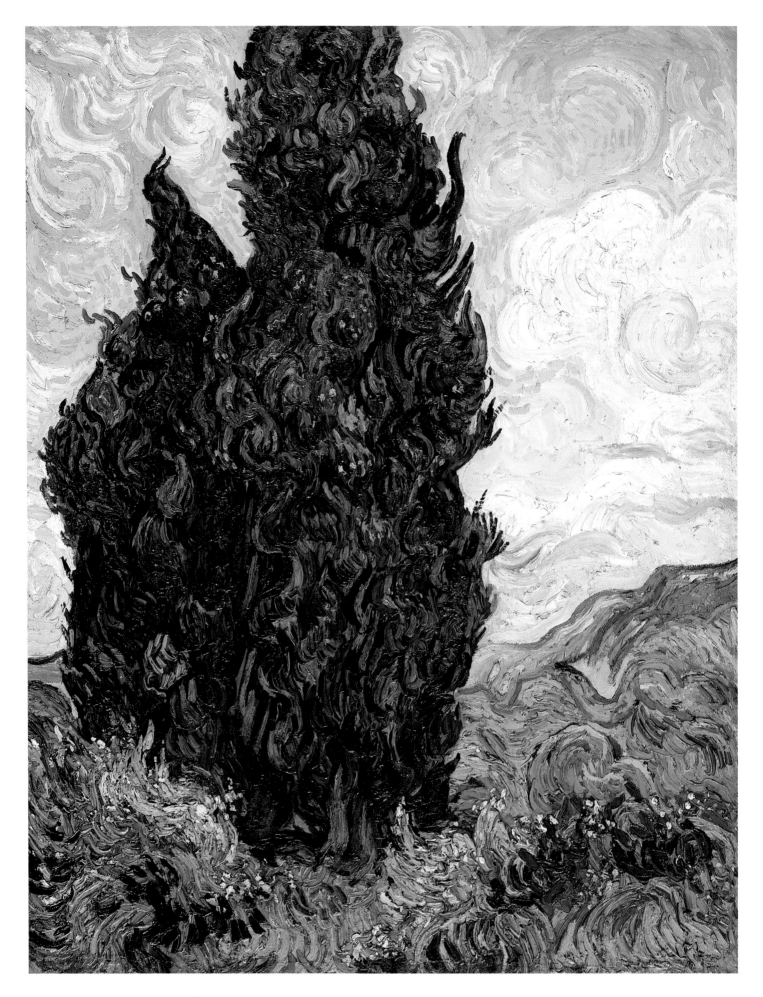

VINCENT VAN GOGH
Cypresses

Van Gogh painted *Cypresses* in June of 1889, not long after the beginning of his year-long voluntary confinement at the asylum of Saint Paul in Saint-Rémy. The cypress represented a kind of perfect natural architecture in Van Gogh's canon of pantheism. On June 25 the artist wrote to his brother, "It is as beautiful of line and proportion as an Egyptian obelisk."

The loaded brushstrokes and the swirling, undulating forms are typical of Van Gogh's late work: The thick, flame-like strokes that create the cypresses curl upward in a restless convection, as if consuming the forms they compose. The mountains flame purple, the sky blue and pink, and a crescent moon fills the daylight sky, repeating the patterns of the clouds. The subject posed an extraordinary technical problem for the artist, especially with regard to realizing the deep, rich green of the tree: "It is a splash of *black* in a sunny landscape, but it is one of the most interesting black notes, and the most difficult to hit off that I can imagine."

43 Cypresses, 1889
Vincent van Gogh
Dutch, 1853–90
Oil on canvas; 36¾ x 29⅛ in.
(93.3 x 74 cm.)
Rogers Fund, 1949 (49.30)

Right: detail

44 Portrait of the Artist's Mother, ca. 1883
Georges Seurat
French, 1859–91
Conté crayon on Ingres paper;
12⅝ x 9⁷⁄₁₆ in. (31.3 x 24 cm.)
Purchase, Joseph Pulitzer Bequest, 1955
(55.21.1)

45 Portrait of Edmond-François Aman-Jean, 1883
Georges Seurat
French, 1859–91
Conté crayon on Ingres paper; 24½ x 18¾ in.
(62.2 x 47.6 cm.) Bequest of Stephen C. Clark,
1960 (61.101.16)

GEORGES SEURAT

The Artist's Mother and *Edmond-François Aman-Jean*

The marriage of conté crayon and Ingres paper helped make Seurat's drawing style one of the most distinctive of his century. Conté crayon, a medium-hard, waxy crayon, does not smudge and gives especially opaque, velvety blacks that are unattainable with charcoal. Ingres paper is highly textured, and when the conté crayon is applied gently, to yield a light gray, the tufts of paper catch it occasionally, leaving the lower areas untouched. The result is a light that shimmers—a light that, in fact, comes from the white paper left untouched by the crayon. Indeed, the figures in Seurat's drawings are defined in terms of light and dark rather than by line. In the portrait of the artist's mother (Plate 44), for example, the bow at her neck is "drawn" with the blank paper.

Seurat was close to his mother, with whom he lived until he died. Her sober, hardworking nature is expressed in the solid, massive form of the drawing. Her body has been greatly simplified into a pyramid shape; her head is almost a perfect oval. In its simplicity and geometry, combined with the delicate, almost magical light, Seurat's drawing endows his mother, as well as the prosaic task in which she is engaged, with both dignity and reverence.

The painter Aman-Jean (Plate 45) was an intimate friend of Seurat's from their student days, and in 1879 they shared a studio. Like the figure of Seurat's mother, Aman-Jean is depicted with a simple dignity. The solidity of his form derives partly from what Seurat called "irradiation," in which light and dark are juxtaposed: As the background nears a darker area, for example, it lightens, as seen in the halo around Aman-Jean's head. The deep, lustrous black of the sitter's body and hair and the shimmering light that radiates from the background and models his head and hand make this one of Seurat's most magical drawings. This portrait is Seurat's largest drawing and his first work to figure in a public exhibition: It was shown in the Salon of 1883.

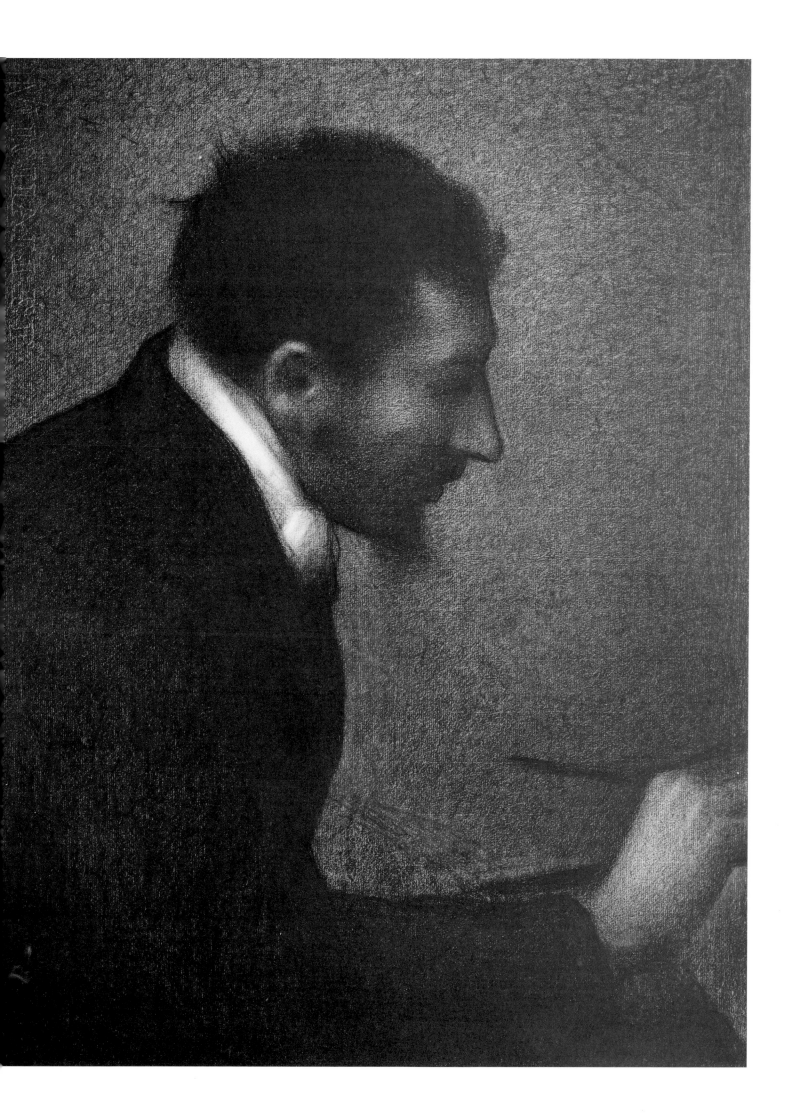

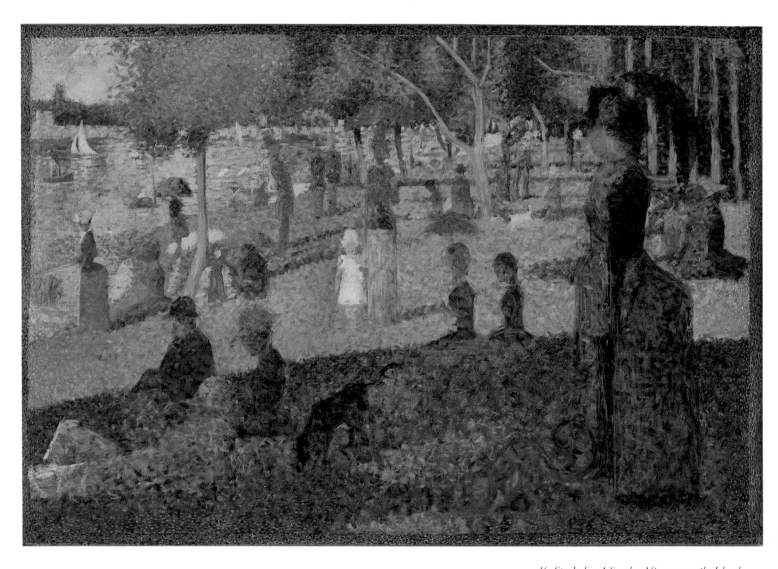

46 Study for *A Sunday Afternoon on the Island of La Grande Jatte*, 1884
Georges Seurat
French, 1859–91
Oil on canvas; 27¾ x 41 in. (70.5 x 104.1 cm.)
Bequest of Sam A. Lewisohn, 1951 (51.112.6)

GEORGES SEURAT
Studies for *A Sunday Afternoon on La Grande Jatte*

Seurat, who wanted to make the art of painting objective and systematic, made at least thirty-two preparatory drawings and oil sketches for his monumental picture (now in the Art Institute of Chicago) of Parisians enjoying their day off on an island in the Seine. In the work illustrated in Plate 46, his final sketch, Seurat juxtaposed contrasting pigments, depending on optical mixture—the phenomenon that causes two tones seen at a distance to form a single hue—to create his desired effect. Although there are only minor differences in compositional detail between this study and the final work, the pictures represent distinct stages in the development of Seurat's color theory. For the study he prepared the canvas with a red ground, upon which he applied layers of saturated colors in hatched strokes. He may have begun the larger version in a similar fashion, but eventually he chose a white ground and applied his paints in the small, discrete dabs for which his technique—pointillism—was named.

In the study illustrated in Plate 47, Seurat used the same small, patchy brushstrokes as in his final sketch. Here, however, the scene is nearly uninhabited. The sketch shows us that it was through trial and error and careful consideration that Seurat worked out the placement of figures in his composition. The five figures all appear in the final work, but in slightly different poses or in different areas of the picture. Note, for example, how the woman in profile in the background of Plate 47 stands in the foreground of the final study. Indeed, although Seurat's subject is Impressionist, his composition does not have the casual appearance of Impressionist painting but is as preconceived as his color. Seurat often made small, painted sketches such as this to work out the color and composition of his large works.

Seurat worked out the individual figures of his paintings in separate drawings, such as the crayon study for the woman fishing in Plate 48. The figure is rendered with very little interior modeling, and the contrast between her extremely thin torso and her enormous bustle transforms her into an abstract shape. Unlike Seurat's earlier, independent drawings, as seen in Plates 44 and 45, this figure is placed against a pale background, an effect that highlights the simple geometry of her form. Her face is obscured by her fashionably tilted white hat, emphasizing Seurat's preference for the general over the individual.

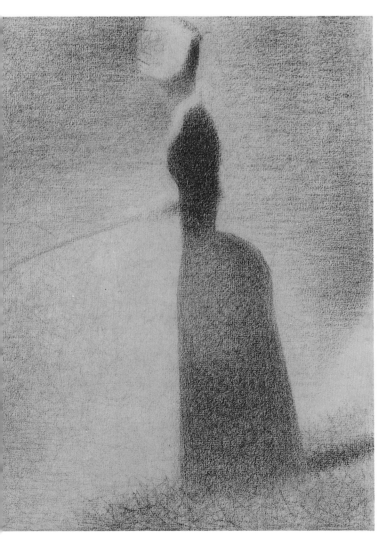

OVERLEAF:

GEORGES SEURAT (Pages 70–71)
La Parade

In the mid-1880s, the depictions of suburban pleasures favored by the Impressionists gave way to pictures of urban entertainment, as writers, poets, and songwriters turned to acrobats, clowns, and café singers for their subject matter. Seurat's interest in urban entertainment culminated in *La Parade*.

Depicted is the popular *Cirque Corvi*. The scene is a small performance given on the street to lure passersby into purchasing tickets to the circus. But far from a gay and festive show, guaranteed to entice an audience, this performance is mysteriously quiet and melancholy. Seurat's musicians—a trombonist isolated on a platform and four additional musicians lined up on a catwalk—are almost featureless; they are eerily regular geometric forms that stand alienated from each other as well as from the animated audience. The artificial light created by the row of gas jets at the top casts a gloomy, mysterious glow over the scene. A single, barren tree at the left of the composition adds to this sense of gloom.

In *Parade* Seurat has put into practice the theories of Charles Henry, a scientist who believed that certain lines and colors evoke specific emotional responses in the viewer, and that patterns created according to set proportions achieve the effect of harmony and serenity. Seurat's composition forms a gridlike pattern created by both figures and architecture. In a letter of 1890 he said that the form of the gas lamps at the top of the picture, with their upward diagonals, is meant to evoke a feeling of gaiety. It is a feeling that is in telling contrast to the sadness of the scene below.

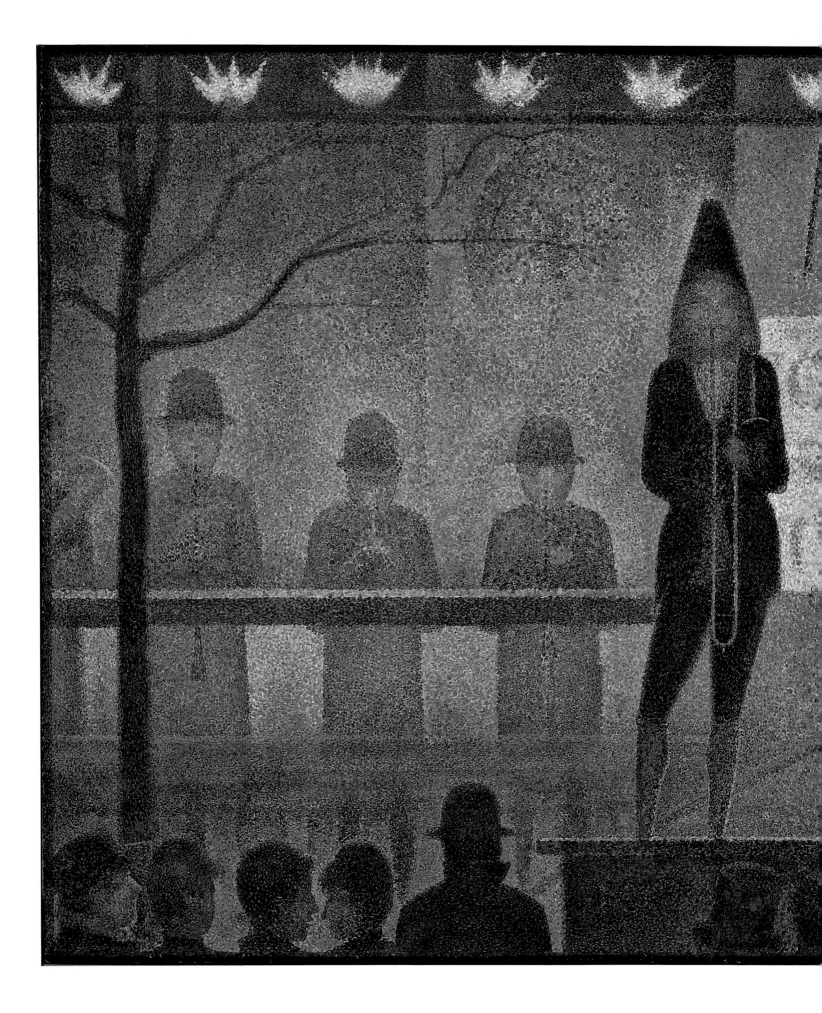

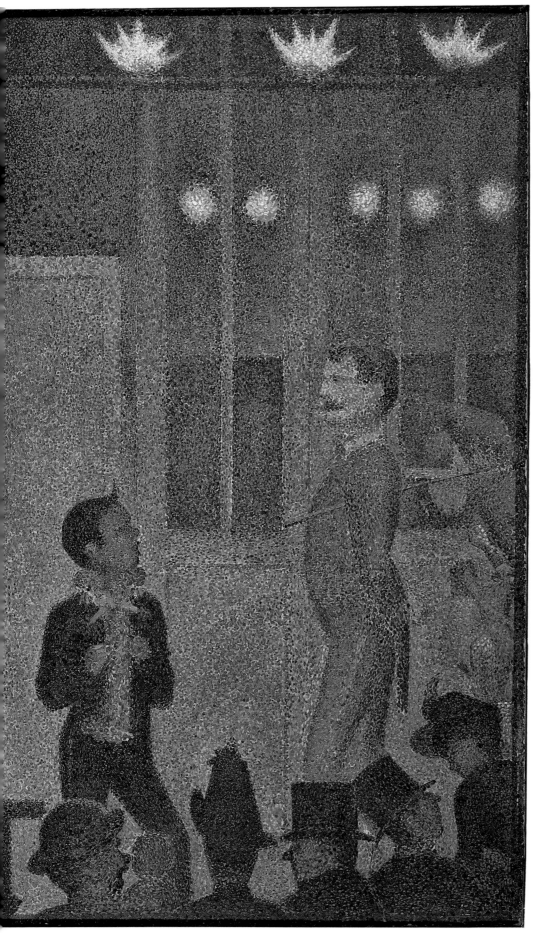

49 *Invitation to the Sideshow* (*La Parade*),
1887–88
Georges Seurat
French, 1859–91
Oil on canvas; 39¼ x 59 in. (99.7 x 149.9 cm.)
Bequest of Stephen C. Clark, 1960 (61.101.17)

Page 69: text

Henri de Toulouse-Lautrec
The Englishman at the Moulin Rouge

Born into one of France's oldest aristocratic families, Henri de Toulouse-Lautrec was never oppressed by poverty. Due to congenital defects, however, his growth was truncated at adolescence, and physical deformities kept him from a normal life. Perhaps because of this, he began to draw at an early age, and soon concentrated most of his energy on his painting and on documenting the lives of other Parisian outcasts. In 1886, Lautrec moved to the district of Montmartre, where he executed a series of pictures of the cafés and dance halls frequented by prostitutes and their clients.

The Englishman at the Moulin Rouge is the preparatory study for a color lithograph commissioned by the Boussod & Valadon Gallery in 1892. The influence of Degas and Japanese prints can be seen in the odd perspective the artist chose, in the vibrancy of the color, and in the strong descriptive line. Lautrec chose a vantage point close to the shoulder of a seated woman with bright orange hair who wears a black choker and long black gloves. Her right hand is placed on the thigh of a top-hatted gentleman whose chair has been pulled up to hers. He regards her advances with smug expectation, while a second woman watches the open sexual play. Lautrec drew this woman's eyes in an exaggerated slant, like a cat's, and colored green the lock of hair falling over her brow, evoking the luridly gaslit interior of the Moulin Rouge, as well as the passions of lust and jealousy that bind the three figures together. The model for the man was William Tom Warrener, an artist and friend of Lautrec's.

50 *The Englishman at the Moulin Rouge*, 1892
Henri de Toulouse-Lautrec
French, 1864–1901
Oil and gouache on cardboard;
33¼ x 26 in. (84.5 x 66 cm.)
Bequest of Miss Adelaide Milton de Groot
(1876–1967), 1967 (67.187.108)

Henri de Toulouse-Lautrec
The Seated Clowness

In 1896 Lautrec produced a series of ten lithographs and a frontispiece. The series, called *Elles*, was intended to document life in the brothels and to show that prostitutes were not damned but led sad and sympathetic lives. The artist chose his title because it was a general term that applied to all women without differentiation.

In most of the scenes Lautrec shows the women posed in the intimate surroundings of their rooms: washing, dressing, and lying in bed. Here he shows an exhausted performer resting from the din of a dance hall. She is seated on a dark orange couch, her white hair tied up in a bright yellow bow that matches the broad clown's-collar. Her black-stockinged legs are spread apart, with her hands clasped between them in the gesture of a male athlete on the bench. Her look of fatigue and resigned distaste is in poignant contrast to the glitter and apparent merriment visible off to the left.

OVERLEAF:

Henri de Toulouse-Lautrec *(Pages 74–75)*
The Sofa

Intrigued by erotic Japanese prints, as well as by Degas's small monotypes of brothel scenes (which were not intended for public exhibition), Lautrec set out to document the lives of prostitutes in a series of pictures executed between 1892 and 1896. Himself a social outcast because of his physical deformities, Toulouse-Lautrec was accepted by the prostitutes, and he keenly apprehended the dreary sadness of their lives. Since they were accustomed to being observed, these women made unaffected models, never compromising Toulouse-Lautrec's commitment to utter candor. At first he made sketches in the brothels; hampered by the insufficient lighting, however, he eventually had his models pose in his studio on a large divan.

The prostitutes often fell in love with one another, and Toulouse-Lautrec was sympathetic to lesbianism. Although the sexual attraction between the women is evident in this picture, their attentive affection is equally striking.

51 *The Seated Clowness*, 1896
Henri de Toulouse-Lautrec
French, 1864–1901
Lithograph printed in five colors;
20½ x 15¾ in. (52.1 x 40 cm.)
Alfred Stieglitz Collection,
1949 (49.55.50)

52 *The Sofa*, 1892–96
Henri de Toulouse-Lautrec
French, 1864–1901
Oil on cardboard;
24¾ x 31⅞ in. (62.9 x 81 cm.)
Rogers Fund, 1951 (51.33.2)

Page 73: text

53 Two Tahitian Women, 1899
Paul Gauguin
French, 1848–1903
Oil on canvas; 37 x 28½ in.
(94 x 72.4 cm.) Gift of
William Church Osborn, 1949
(49.58.1)

54 Ia Orana Maria, 1891
Paul Gauguin
French, 1848–1903
Oil on canvas; 44¾ x 34½ in.
(113.7 x 87.6 cm.)
Bequest of Sam A. Lewisohn,
1951 (51.112.2)

Page 78: text

Paul Gauguin

Two Tahitian Women

Gauguin's first stay in Tahiti, from 1891 to 1893, was curtailed by financial considerations. In 1895, however, after spending two years in Paris, he returned to the islands and remained there until his death in 1903. This picture of two women dates from 1899. Unlike the figures in many of Gauguin's Tahitian pictures, these dignified, statuesque women are not part of a Christian or Tahitian mythological scene. They confront us in an unaffected and graceful manner, emblems of the uncorrupted society Gauguin found there.

This natural, untainted way of life is expressed not only in Gauguin's subject matter but also in his style of painting, characterized by broad areas of a single color and greatly simplified forms.

The woman on the left has been identified as Gauguin's mistress, Pahura. The pose of the other woman appears in several works that Gauguin painted between 1896 and 1899; the position of her hands derives from carvings on the Javanese temple of Borobudur.

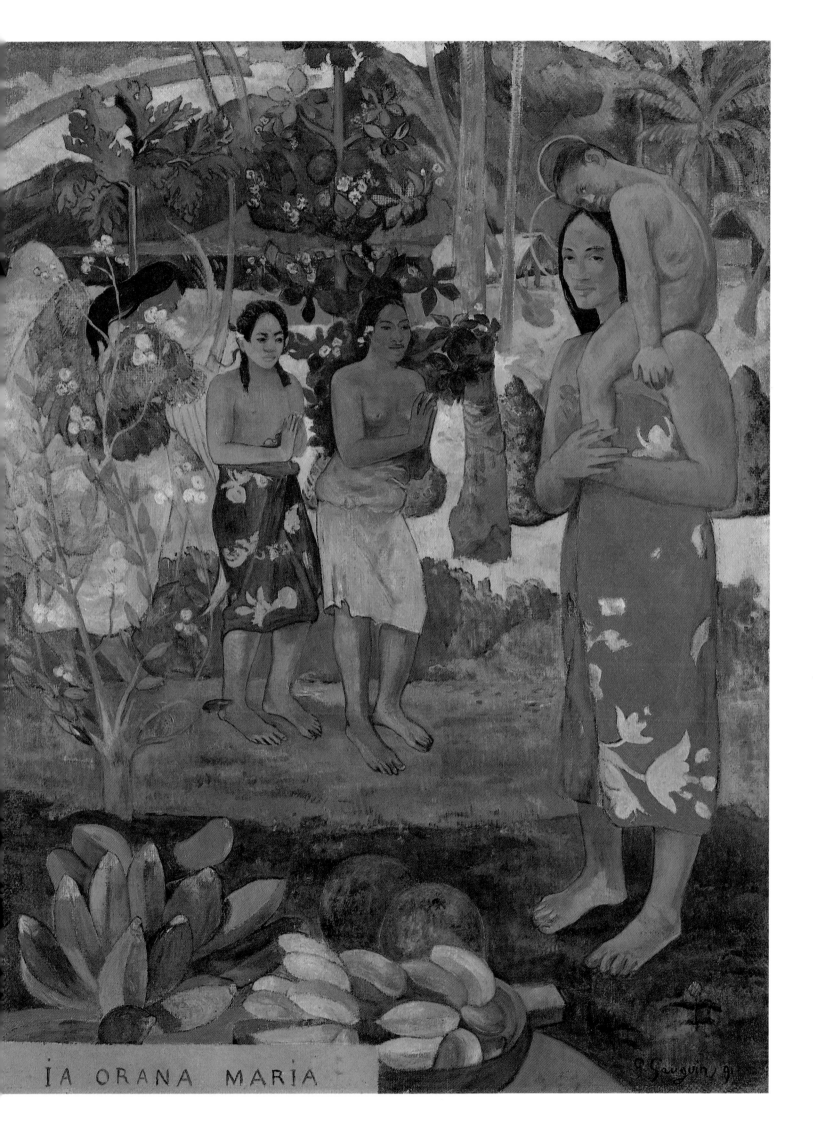

IA ORANA MARIA P Gauguin 9

55 *Pygmalion and Galatea*, ca. 1881
Jean Léon Gérôme
French, 1824–1904
Oil on canvas; 35 x 27 in.
(88.9 x 68.6 cm.) Gift of
Louis C. Raegner, 1927 (27.200)

56 *The Shepherd's Song*, 1891
Pierre Puvis de Chavannes
French, 1824–98
Oil on canvas; 41⅛ x 43¼ in.
(104.5 x 109.9 cm.)
Rogers Fund, 1906 (06.177)

PAUL GAUGUIN (Page 77)
Ia Orana Maria

In 1883 Paul Gauguin gave up a successful career as a stock-broker to become a painter. From 1886 to about 1891 he lived in Pont Aven, in Brittany, hoping to find in native Breton culture a people close to nature, unfettered by the complications and sophistication of modern civilization. In 1891 he made his first trip to Tahiti, in search of a still more "natural" world, a kind of Polynesian Garden of Eden.

In his Breton canvases, Gauguin used the vernacular art and customs of Brittany to express Christian themes; in his South Pacific pictures he expressed these themes in Tahitian terms. The title of this work—the most important one Gauguin painted during this trip—is native dialect for "I hail thee, Mary," the angel Gabriel's first words to the Virgin Mary at the Annunciation. The only elements taken from traditional representations of the Annunciation are the angel, the salutation, and the halos around the heads of the Virgin and Child. Everything else is Tahitian except the composition, which was adapted from a bas-relief in the Javanese temple of Borobudur. Gauguin had a photograph of the bas-relief with him in Tahiti.

JEAN LEON GEROME
Pygmalion and Galatea

While the Impressionists were busy recording transient scenes from everyday life, Jean Léon Gérôme perpetuated the style and subject matter of the academic painters of the first part of the nineteenth century.

In the story from Ovid's *Metamorphoses*, the sculptor Pygmalion is so enamored of the statue he has created that he prays to Venus that he might have a wife as beautiful. In answer to his prayers, the goddess brings the statue to life.

For his picture *Pygmalion and Galatea* Gérôme has chosen both the most dramatic moment in the story and the one in which he can best display his technical skill: the moment Venus grants Pygmalion's wish. Gérôme sets the scene in the sculptor's studio. At the center of the composition is the beautiful Galatea. Pygmalion, dressed in antique garb, reaches up to the stony beauty and she responds. Her figure slowly comes to life. Her head now bears a pile of chestnut-brown hair, her arms, still statuesque, extend to caress their maker, while the pink of life suffuses her torso and highlights the contours of her hips. Only Galatea's feet and calves remain bound in stone.

Pierre Puvis de Chavannes

The Shepherd's Song

While the Impressionists were painting the leisure-time pursuits of the urban middle class, Pierre Puvis de Chavannes was concentrating on a different kind of theme. His pictures, such as *The Shepherd's Song*, are inhabited by figures from a remote, arcadian world. These figures are detached, tranquil, and serene, rather than active and ephemeral; the compositions are classical and balanced, and are marked by broad areas of color and stylized drawing, unlike the Impressionists' asymmetrical compositions and figures that dissolve under shimmering light.

Puvis's style was appreciated by both his contemporaries and younger painters. Seurat, for example, attracted by Puvis's calm, austere compositions, updated the older artist's classical scenes to create pictures of a modern Arcadia,

such as the monumental *Sunday Afternoon on the Island of La Grande Jatte* (see Plates 46–48). Gauguin not only admired Puvis's vision of a world unsullied by modern urban civilization, but also found a parallel with his own work in Puvis's stylized drawing and flat areas of color.

The figures and composition of *The Shepherd's Song* derive in large part from Puvis's *A Vision of Antiquity —Symbol of Form*, which was part of a triptych made in 1884–86 for the Palais des Arts in Lyons. In 1896 *The Shepherd's Song* was exhibited in the United States, at the first annual exhibition of the Carnegie Institute in Pittsburgh, Pennsylvania. His work had already been shown in New York by his dealer Durand-Ruel in 1887, and in 1891 he won a commission for a group of paintings for the Boston Public Library.

PABLO PICASSO
Jardin de Paris

Throughout his career, Picasso was fascinated by the theatrical spectacle—whether it was the bull ring, the music hall, the circus, or the cabaret. The drawing reproduced here, a design for a theatrical poster, is not yet marked by the social criticism that would characterize Picasso's Blue-period pictures of theatrical performers (see Plate 88); instead, it is imbued with the gaiety and excitement of the club it advertises. In its asymmetrical composition, sweeping movement, and bold lettering, it is reminiscent of posters by Toulouse-Lautrec. And as Lautrec would have done, so Picasso has portrayed nocturnal Paris with a blend of admiration and satire. He gives us a glimpse of the prosaic reality behind the brilliant display by showing that the faces of the dancers are heavily made up, and that not all of them wear happy, relaxed expressions.

No posters were ever printed from Picasso's design, leaving unclear the exact reason for its creation. However, the popularity of poster art at the time, both in Paris and Barcelona, could not have escaped him.

57 *Jardin de Paris*, 1901
Pablo Picasso
Spanish, 1881–1973
Brush, ink, and watercolor on paper;
25½ x 19½ in. (64.8 x 49.5 cm.)
Gift of Raymonde Paul, in memory
of her brother, C. Michael Paul, 1982
(1982.179.17)

PIERRE BONNARD
The Laundry Maid

The acceptance of color lithography by fine artists owes a great deal to the advent of the advertising poster, and especially to the work in that field of Jules Chéret. In 1866 Chéret began producing some of the most imaginative, eye-catching posters in Europe. Advertisements for theaters, music halls, cigarettes, and champagne, these large posters attracted artists by their bold and colorful design.

Pierre Bonnard was one of the first artists to make use of the technical advances wrought in the commercial production of color lithographs. The example illustrated here was made for the *Album des peintres-gravures*, a portfolio of works by painter-printmakers, published by Ambroise Vollard in 1896. Bonnard was clearly interested in the decorative potential of the medium, and he designed a richly patterned composition. The little laundress and the dog stand out as flat abstract shapes in a space which seems to rise up to the surface of the page rather than receding into depth. The contrast of the black costume with the clean white laundry is striking, while the spots on the dog present a playful pattern. The scene is arbitrarily cut off by the edges of the

58 *The Laundry Maid*, 1896
Pierre Bonnard
French, 1867–1947
Lithograph printed in five colors;
11¾ x 7½ in. (30 x 19 cm.)
Harris Brisbane Dick Fund, 1939
(39.102.3)

picture, and is dominated by bold diagonals which, along with the stylized forms, contribute to the immediacy of the image.

While the decorative aspects of Bonnard's composition owe a debt to Japanese prints, its subject is typically Parisian. Bonnard was constantly on the alert for the picturesque in French daily life.

Pierre Bonnard
The Terrace at Vernon

Bonnard's interest in color, light, and pattern causes much of his work to tread the line between realism and abstraction. In *The Terrace at Vernon*, for example, we read the tree trunk that defines the foreground as a beautiful violet stripe as well as a tree, and the foliage and landscape in the background merge into a tapestry of color.

The Terrace at Vernon includes many articles of a comfortable, bourgeois life: fruit, wine, guests, even good weather. Yet Bonnard has extracted mystery and nuance from this everyday scene. The gaze of the central figure is rather enigmatic, as is the gesture of the woman on the right. The major figures concentrate on their inner world rather than on their companions or the tasks in which they themselves are engaged.

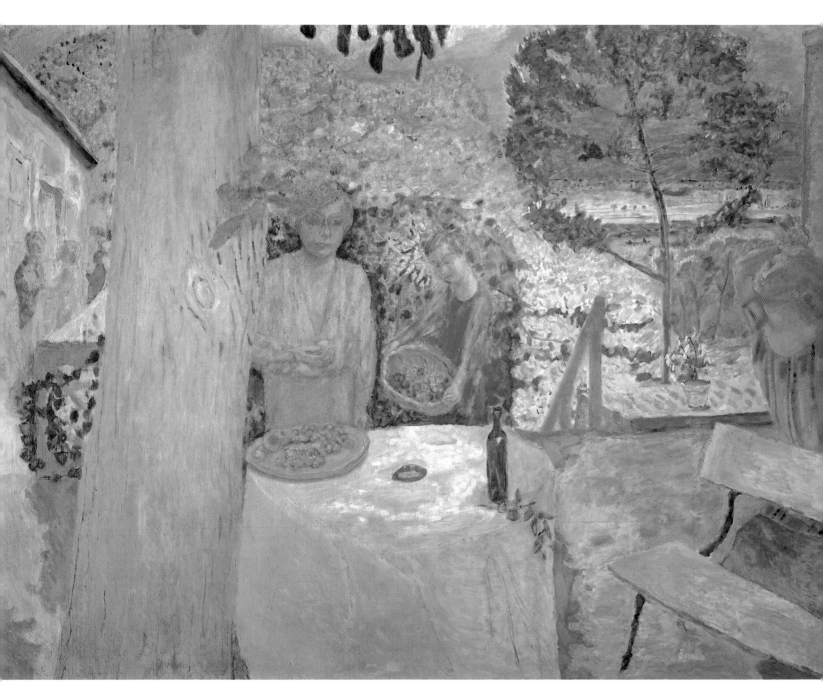

59 *The Terrace at Vernon*, 1939
Pierre Bonnard
French, 1867–1947
Oil on canvas; 58¼ x 76¾ in.
(148 x 194.9 cm.)
Gift of Mrs. Frank Jay Gould,
1968 (68.1)

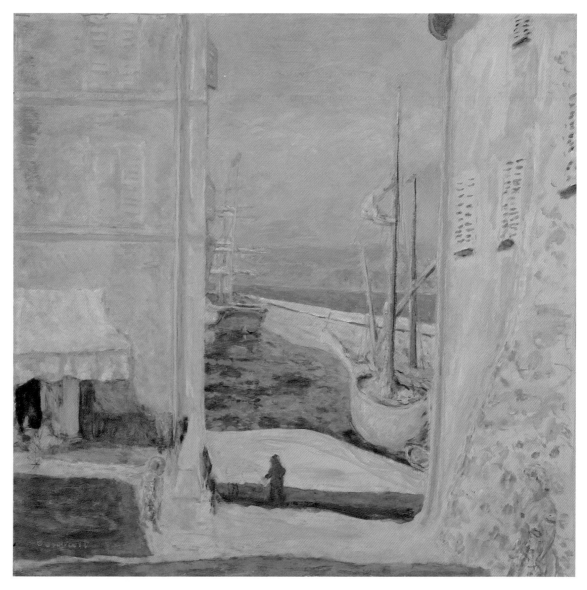

60 Saint-Tropez, 1911
Pierre Bonnard
French, 1867–1947
Oil on canvas, 33 x 34 in.
(83.8 x 86.4 cm.)
Bequest of Scofield Thayer,
1982 (1984.433.1)

PIERRE BONNARD

Saint-Tropez

Bonnard's painterly eye occasionally extended beyond the home setting. In *Saint-Tropez* he depicts a street along the harbor of this Mediterranean coastal town, which he visited frequently between 1909 and 1920. Bonnard's warm, bright colors evoke the strong light of the Mediterranean. His paint is thinned to a transparent wash and applied to the surface with little or no impasto, creating the illusion that solid form is dissolved by the bright light.

The painting is divided vertically into thirds, with shuttered buildings occupying the right and left portions. The open space between them is thus viewed as if through a window. The water and sky in the distance are brought right up to the foreground, as the natural meets the man-made.

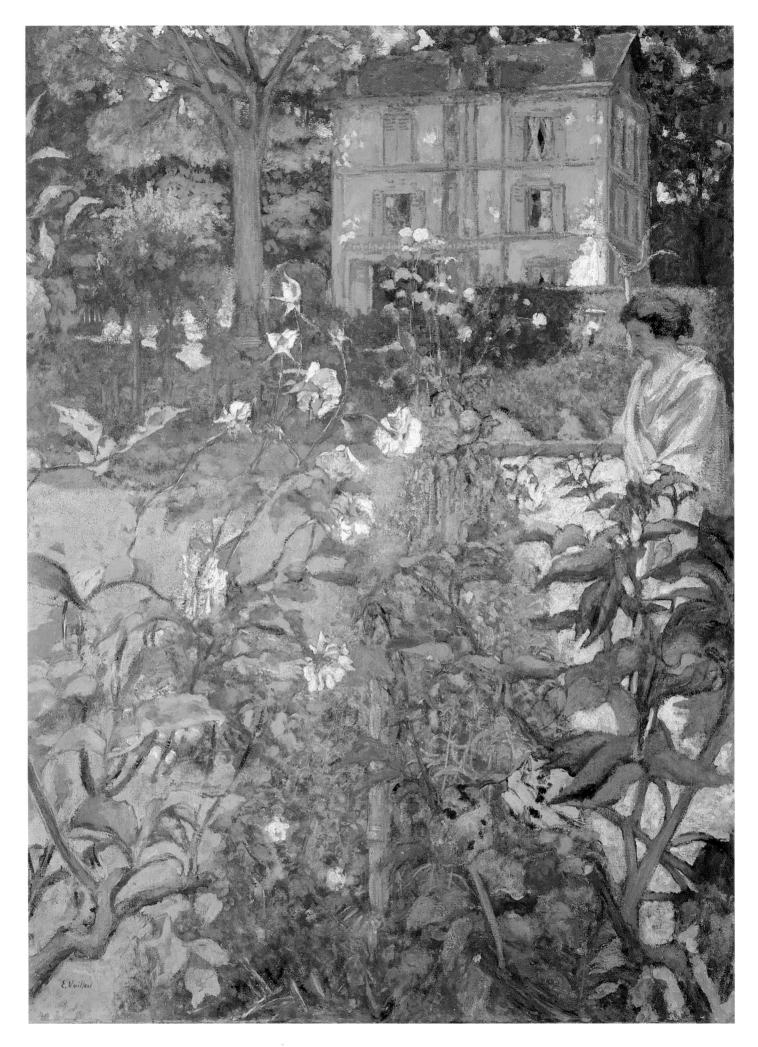

EDOUARD VUILLARD
Figure Seated by a Curtained Window

The unidentified figure who sits by the curtained window in this picture may be Vuillard's mother, with whom the bachelor artist lived until her death in 1928. Vuillard referred to her as his "muse," and she appears as an anonymous figure in many of his compositions. Madame Vuillard opened a corsetmaking business to support her family after her husband's death, and the gaily patterned fabrics and wallpaper of her studio were also frequently represented in the artist's compositions.

The influence of Gauguin is evident in the dominant single color of this composition, which is employed here to express both the quality of light suffused through a curtain and the internal mood of the seated figure.

61 Garden at Vaucresson, 1937
Edouard Vuillard
French, 1868–1940
Tempera on canvas; 59½ x 43⅝ in.
(151.2 x 110.8 cm.)
Wolfe Fund, Catharine Lorillard Wolfe
Collection, 1952 (52.183)

62 Figure Seated by a Curtained Window
Edouard Vuillard
French, 1868–1940
Oil on canvas; 12¼ x 8¼ in.
(31 x 21 cm.)
Robert Lehman Collection, 1975
(1975.1.222)

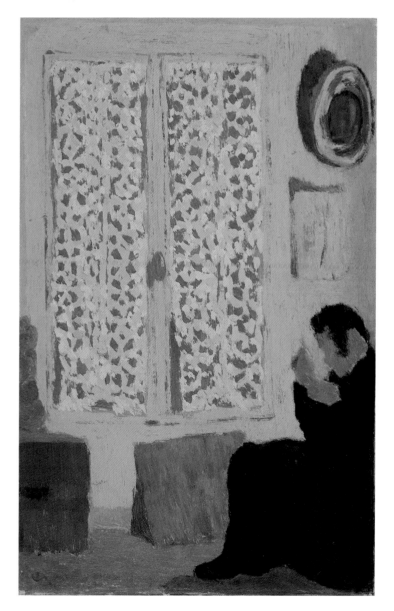

EDOUARD VUILLARD
Garden at Vaucresson

Edouard Vuillard shared some of the same qualities with his friend Pierre Bonnard that later earned them both the title of "Intimists." He used simple scenes from domestic life as a starting point for compositions that are as much an exploration of form and color as a description of an actual place.

In *Garden at Vaucresson*, Vuillard shows the house and garden of a friend near Paris. The property belonged to Jos Hessel, a Paris art dealer, who called it *Clos Cézanne* (the Cézanne Garden) as he acquired it in exchange for a picture by Cézanne. The influence of Japanese prints and of the work of Henri de Toulouse-Lautrec is evident in the dramatic vantage point Vuillard chooses: We survey the garden and the house from the low perspective of one of the lilies clinging to the fence. The entire foreground is filled with the bobbing heads of a variety of flowers that form a patterned frieze through which we see the house in the distance. On the right is a woman dressed in a loose, rose-colored kimono, her hair tied up in a chignon. Her posture is akin to that of a garden statue, and she blends so well with the floral scene that we are not immediately sure whether her presence is human or ethereal.

85

63 *Flowers in a Chinese Vase*, before 1906
Odilon Redon
French, 1840–1916
Oil on canvas; 28⅝ x 21¼ in.
(72.7 x 54 cm.) Bequest of
Mabel Choate, in memory of her father,
Joseph Hodges Choate, 1958 (59.16.3)

Page 88: text

64 *Pandora*, ca. 1910
Odilon Redon
French, 1840–1916
Oil on canvas; 56½ x 24½ in.
(143.5 x 62.2 cm.)
Bequest of Alexander M. Bing,
1959 (60.19.1)

Page 88: text

ODILON REDON \qquad *(Pages 86, 87)*
Flowers in a Chinese Vase and *Pandora*

The Symbolist artists retreated from the objective, empirical vision of Impressionism and Post-Impressionism. Concentrating on the realities of the imagination—fantasy, dreams, and revery—rather than on the material facts of everyday life, they sought to create an art of suggestion rather than *réportage*.

The Symbolist Odilon Redon is well known for his pictures of flowers and of imaginary creatures: spiders and flowers with faces; floating, disembodied eyes; and so on. His flower paintings (Plate 63) show us that his evocative, dreamlike world is, paradoxically, grounded in the observation of nature. Redon apparently owned a number of vases, such as this one of delicately patterned porcelain, in which Madame Redon would arrange bouquets that formed the subject of his flower paintings. Here is a profusion of velvety flowers whose colors are of a depth and intensity seen only in dreams and fantasy.

Redon also painted mythological figures. Pandora (Plate 64) was an exquisitely beautiful woman who was fashioned from clay by Vulcan and sent to earth by Jupiter. When she opened her box, she released all the evils that have plagued mankind since then, thereby bringing the Golden Age to an end. There is nothing in Redon's picture to suggest Pandora's story. Rather, the delicately drawn figure stands poised in the midst of a profusion of exquisite flowers, clutching what may be the yet-unopened box. This absence of explicit setting is typical of Redon's mythological pictures, in which the figures are a vehicle for the evocation of his dreamworld.

EDVARD MUNCH
Tree Stump in Moonlight

About 1898 the Norwegian artist Edvard Munch began to experiment with pure landscape. Though the results are often abstract, they were grounded in places and experiences familiar to the artist, and the same forms and themes occur with regularity.

The subject of this colored woodcut is not immediately recognizable. A form that resembles a dotted "i" floats amid horizontal lines, and two asymmetrical masses occupy the foreground plane. Munch has abstracted the salient components of a landscape scene familiar to him and has colored them with a pale green suggestive of melancholy and twilight.

Tree Stump in Moonlight represents the view from the back of Munch's summer cottage in Asgardstrand. The rocky shoreline and the moon's reflection trailing across the water were images beloved by Munch, and whether he was working in Germany or in Norway, they reappear as landscape elements in his paintings.

65 *Tree Stump in Moonlight*, 1899
Edvard Munch
Norwegian, 1863–1944
Woodcut printed in two colors;
14⁹⁄₁₆ x 22⁹⁄₁₆ in. (37 x 57.3 cm.)
Bequest of Scofield Thayer, 1982
(1984.1203.9)

66 *The Scream*, 1895
Edvard Munch
Norwegian, 1863–1944
Lithograph, Schiefler 32;
sheet 20¼ x 15⅝ in. (51.4 x 39.7 cm.)
Bequest of Scofield Thayer, 1982
(1984.1203.1)

EDVARD MUNCH

The Scream

The Scream is perhaps Munch's best-known image. The artist lived a life haunted by sickness and death and was himself a victim of tremendous anxiety, paranoia, alcoholism, and neurosis. Munch wrote of his life, "The black angels of disease and insanity were on guard at my cradle . . . I always felt that I was treated unjustly, without a mother, sick and threatened with punishment in Hell."

With his lithograph *The Scream*, Munch expresses the concentrated volume of his anxiety with one resounding shriek that seems to echo through the landscape, touching off ripples in earth, water, and sky.

As was typical of his working method, the image was adapted from an earlier painting. However, for the printed medium, Munch has drained the color of the earlier work and left the stark and simple contrasts of black and white. The absence of color intensifies the contours of his lines and makes the entire image appear to pulsate. The artist described the occasion that inspired this scene: "I walked along the road with two friends. The sun went down—the sky was blood red—and I felt a breath of sadness—I stood still tired unto death—over the blue-black fjord and city lay blood and tongues of fire. My friends continued on—I remained—trembling from fear. I felt the great infinite scream through nature."

JOSEF HOFFMANN
Bowl

In 1903 Josef Hoffmann co-founded the Wiener Werkstätte, an important crafts workshop dedicated to raising the level of the applied arts in Austria. The Wiener Werkstätte style followed an independent course, and the rigorous geometry of early works gave way in the teens to a baroque extravagance. While Hoffmann was affected by this decorative exuberance, this bowl shows the master retaining his rational control of proportion. Although the handles loop in sweeping, energetic curves, and the base and lip are flared, it is a subtle and refined piece.

GUSTAV KLIMT
Mäda Primavesi

Gustav Klimt was a leading artist in Vienna at the turn of the century. In 1897 he helped found the Vienna Secession, an independent association of artists dedicated to reforming art in the Austrian capital.

Klimt painted this portrait of Mäda Primavesi in 1912. Born in 1903, Mäda was the daughter of Otto Primavesi, a banker and financial backer of the Wiener Werkstätte (see Plate 67). Mäda's mother, Eugenia, was an actress, whose portrait Klimt painted in 1913. Although she is only nine years old, Mäda looks at us with a sophisticated and self-confident expression.

Klimt's interest in the decorative aspect of painting is evident in the flowers that have been freely disposed on the back wall and that find their counterparts in the carpet and on Mäda's dress, where the flowers on the flounce seem to have dropped from the band across her chest. The silhouette of the dress, with its billowing waist and ruffled flounce, adds a further decorative note, which is enhanced by the way in which the edges of the flounce echo the scalloped edges of the design in the carpet. In fact, these scalloped edges form perspective lines which blend with the flounce as they converge.

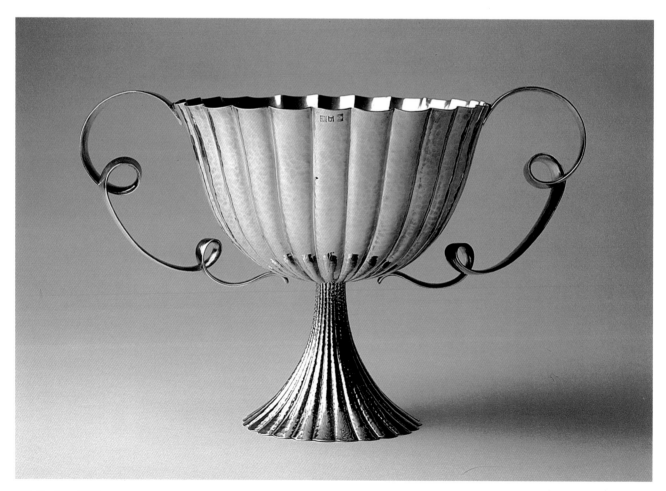

67 Bowl, ca. 1920
Josef Hoffmann
Austrian, 1870–1956
Silver; H. 7½ in. (19.1 cm.)
Gift of Jennifer Johnson Gregg,
1976 (1976.415)

68 Mäda Primavesi, 1912
Gustav Klimt
Austrian, 1862–1918
Oil on canvas; 59 x 43½ in. (150 x 110.5 cm.)
Gift of Andre and Clara Mertens, in memory
of her mother, Jenny Pulitzer Steiner, 1964
(64.148)

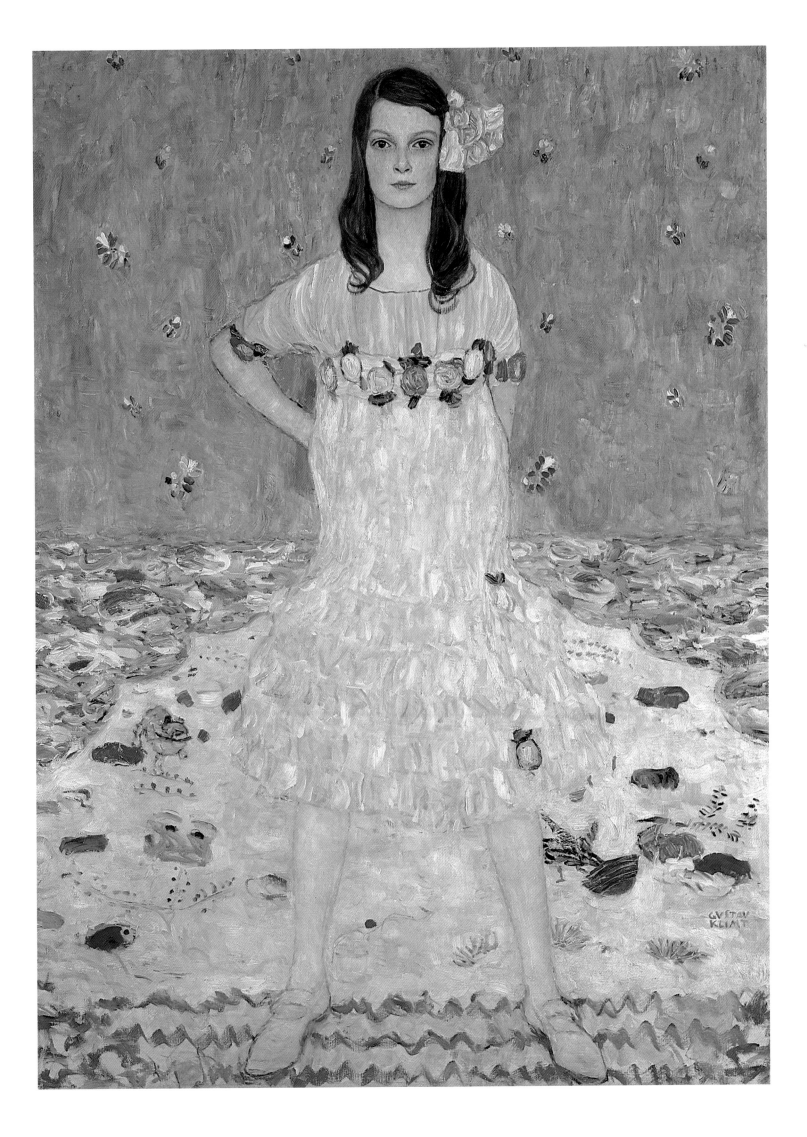

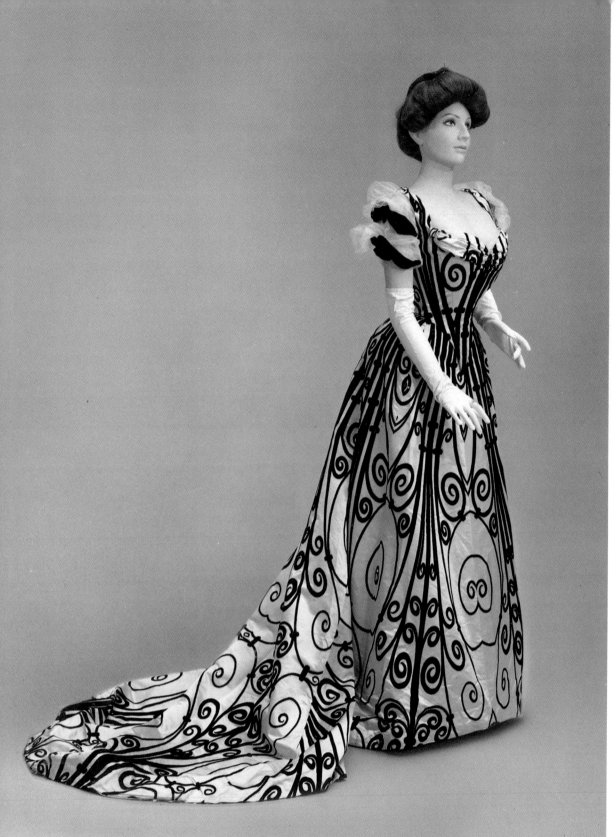

69 *Evening Gown*, ca. 1898–1900
House of Worth
French
Silk, satin, and velvet
Gift of Eva Drexel Dahlgren, 1976
(1976.258.1ab)

HOUSE OF WORTH

Evening Gown

Few garments better demonstrate the relationship of haute couture to a major artistic movement than does this Worth evening gown, fashioned at the turn of the century. The dynamic linear motion associated with Art Nouveau is clearly evident in the design of the fabric as well as in the curvilinear volumes of the silhouette. The luxury of the gown, made of heavy white silk voided with black velvet in an Art Nouveau scroll design, exemplifies the elegance of the late 1890s. The House of Worth was the first of the great couture houses of Paris. Under its founder, Charles Frederick Worth (1825–95), it was known for the high quality of its design and craftsmanship. These standards were maintained by Worth's sons, Jean Philippe and Gaston, after the death of their father.

Georges de Feure
Vase

Art Nouveau emerged in France in the 1890s to challenge the historicism of revival styles that held sway at the time. Its advocates drew on the forms and forces of nature and looked to Japan for aesthetic direction. In Paris the new style was named and popularized by the art dealer Samuel Bing, who in 1895 reopened his gallery of Japanese art as the "Salon de l'Art Nouveau." Bing's triumph, and that of the new style, came at the Exposition Universelle of 1900, where the "Art Nouveau Bing" pavilion contained a room by Georges de Feure.

On the vase by de Feure shown here, made in about 1900, the arch of a swan's neck echoes the emphatic sweep of a flower stem. His use of empty space accords with Bing's advocacy of the principles of Japanese art.

70 Vase, ca. 1900
Georges de Feure
French, 1868–1928
Porcelain; H. 12½ in. (31.8 cm.)
Purchase, Edward C. Moore, Jr.
Gift, 1926 (22.228.9)

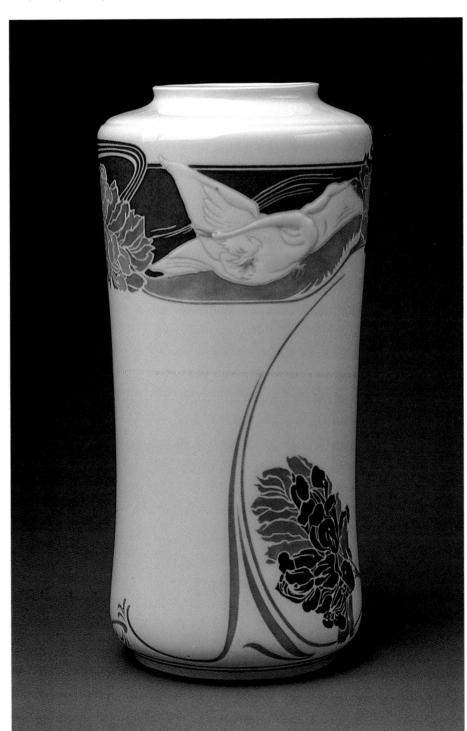

ARISTIDE MAILLOL
Night and *Torso of "Chained Action"*

When his sight began to fail in the mid-1890s, Maillol turned from painting to sculpture. He was self-taught as a sculptor, and it took him a few years of work to find his own style. The monumental figure of *Night* (Plate 71) was first exhibited in the 1909 Salon d'Automne in Paris, but the essential elements of the work were already present in a terra-cotta sketch model of the subject believed to have been made as early as 1902. The architectural quality of its carefully balanced structure and the generous, symmetrical volumes of the figure were to be characteristic of Maillol's sculpture throughout the remainder of his life.

The torso in Plate 72 is a study for the heroic figure of *Chained Action*, designed as a monument to Louis Auguste Blanqui (1805–51), a republican and revolutionary who suffered repeated persecution and imprisonment for his political views under successive French regimes. Maillol received the commission for the monument in 1905 and completed the torso in the same year. The square-shouldered and well-developed but heavy-set torso is that of Maillol's Catalan wife, Clotilde, who is recognizable as the model for many of Maillol's earlier sculptures, including *Night*. The mood of placid self-containment of *Night* is to be found in the majority of Maillol's sculptures, but the vibrant energy of *Chained Action* is quite exceptional. With a twist of the torso, a forward thrust of the thigh, and pulled-back shoulders, Maillol has suggested movement held in check by forcible restraint.

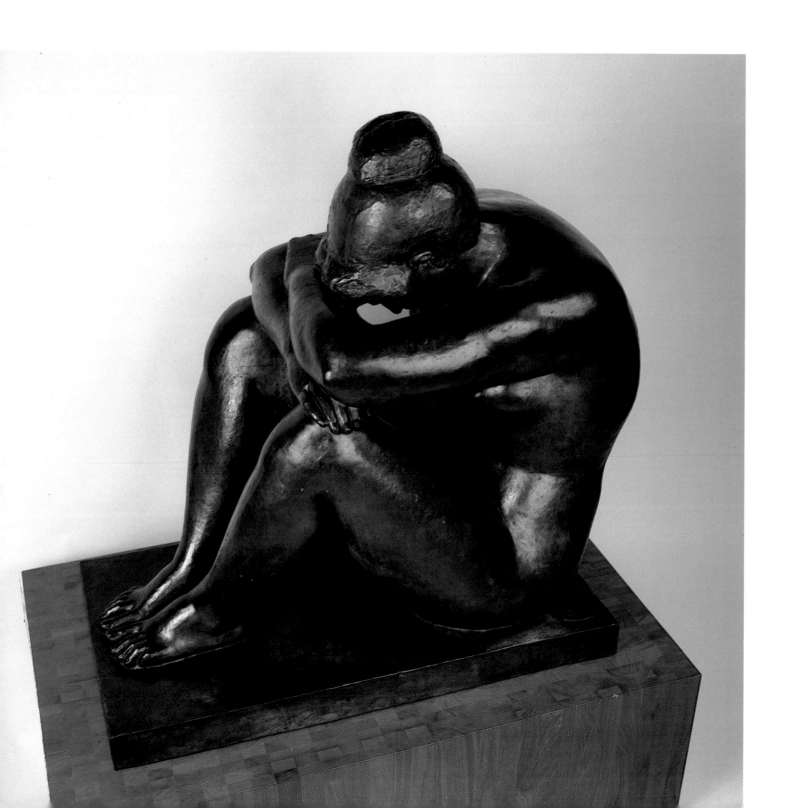

72 *Torso of "Chained Action"*
Aristide Maillol
French, 1861–1944
Bronze, modeled 1905,
cast 1929; H. 47 in. (119.4 cm.)
Fletcher Fund, 1929 (29.138)

71 *Night,* 1902
Aristide Maillol
French, 1861–1944
Bronze; H. 41¼ in. (104.8 cm.)
Gift of Maurice Wertheim, 1950
(50.100)

O V E R L E A F :

HENRI ROUSSEAU ("LE DOUANIER") *(Pages 96–97)*
The Repast of the Lion

Neither a folk artist nor a "Sunday painter," Henri Rousseau (whose nickname derives from his job as a customs official) defies classification. He was self-taught, and his work, which is characterized by great simplification of form, an emphasis on pattern, and distortions of perspective and scale, was admired by avant-garde writers and painters.

By 1891 Rousseau had begun to paint imaginary scenes set in the jungle, such as this 1907 picture of a lion devouring a jaguar. Although the vegetation in his jungle paintings was apparently based on exotic plants that the artist had studied at the botanical garden in Paris, they were subjected to Rousseau's unique vision, and they dwarf the jungle inhabitants. This unreal perspective and scale, as well as the full moon beyond the hill in the background, help create the dreamlike quality that was so admired by Rousseau's fellow artists.

73 *The Repast of the Lion*, 1907
Henri Rousseau ("Le Douanier")
French, 1844–1910
Oil on canvas;
44¾ x 63 in. (113.7 x 160 cm.)
Bequest of Sam A. Lewisohn,
1951 (51.112.5)

Page 95: text

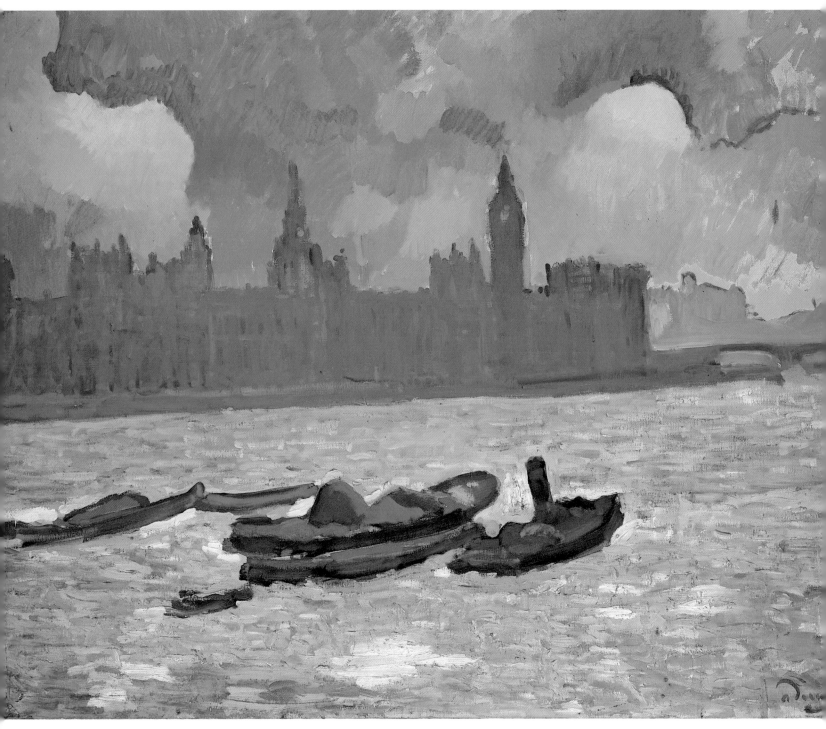

74 Houses of Parliament at Night, 1905
André Derain
French, 1880–1954
Oil on canvas; 31 x 39 in. (78.7 x 99.1 cm.)
Robert Lehman Collection, 1975 (1975.1.168)

Two Fauve Paintings

The movement known as Fauvism, which flourished from 1905 to 1907, realized one of the most important accomplishments of modern art: the liberation of color from its representational role, freeing the artist to use color *as* color, and not solely as description. In this canvas by André Derain (Plate 74), painted in 1905 during the artist's first visit to London, the water in the foreground is composed of shades of pink, yellow, red, and blue; in the background it consists of green and blue-white. Derain's composition is as masterful as his use of color. The pictorial field is divided into two equal sections by the diagonal of the shoreline. The upper half is split again by the use of differing brushstrokes and colors: Short blue verticals and horizontals characterize the buildings, while wider, curving strokes describe the movement of the night sky. Derain repeated this pattern in the water of the Thames: The upper section, close to the shore-

line, is built with parallel strokes, while the large expanse of the water with heavy barges is represented with long, flowing ones. This juxtaposition of rhythms and colors, as well as the diagonals of the shoreline and the boats, imbues the painting with an extraordinary sense of movement.

In *The House Behind Trees* (Plate 75), trees, ground, and house form a dizzying tapestry of color. The trees are blue and red; the earth is blue, red, green, yellow, white, orange, and pink. Even the house is composed of myriad colors. Each color performs a function both decorative and descriptive: We read the same line as both a blue tree trunk, for example, and a stroke of blue paint. Like Derain, Georges Braque has varied his brushstroke within the composition. The trees, plants, and ground are composed of curved, sometimes writhing lines, while the brushstrokes defining the house are rectilinear.

75 *The House Behind Trees*, 1906
Georges Braque
French, 1882–1963
Oil on canvas; 14¾ x 18 in.
(37.5 x 45.7 cm.)
Robert Lehman Collection, 1975
(1975.1.159)

76 Two Nudes, 1905
Georges Rouault
French, 1871–1958
Oil on paper; 39⅜ x 25½ in.
(100 x 64.8 cm.) Gift of
Mr. and Mrs. Alex L. Hillman,
1949 (49.106a,b)

GEORGES ROUAULT
Two Nudes

In his early work, the devoutly religious Georges Rouault expressed Christian themes through the conventional depiction of biblical stories. After a deep spiritual crisis in the last years of the nineteenth century, however, he began to express his Christian feeling through representations of social vices and institutions. The picture here represents two prostitutes, a subject Rouault painted frequently. Confronting us shamelessly with their nakedness, the prostitutes wear expressions of sadness and anger. They are painted in Rouault's characteristic strong, jewellike colors, which may derive from the painter's teenage apprenticeship to a maker of stained glass, and his subsequent employment by a restorer of old glass. The oil in which the figures are rendered has been so diluted that it looks like watercolor. The outlines of the figures seep through the paper and provide the framework for two very similar women on the reverse.

EGON SCHIELE
Self-Portrait

The career of the Austrian Expressionist painter Egon Schiele was short, intense, and amazingly productive. Before succumbing to influenza in 1918 at the age of twenty-eight, he created over three hundred oil paintings and several thousand works on paper. The human figure provided Schiele with his most potent subject matter for both paintings and drawings. The self-portraits of his series produced between 1910 and 1918—of which this watercolor is a prime example —are searing psychological expressions. The emaciated, tortured figure of the artist, bony and angular, bristles with an inner tension that is made visible by the agitated pencil line and the painted-white aura. Schiele stares out wildly, his large, dark eyes glaring menacingly, his mouth open, and his shock of hair standing on end. In a pose suggestive of the crucified Christ, his arm is thrust out awkwardly and bent sharply at the elbow.

77 Self-Portrait, 1911
Egon Schiele
Austrian, 1890–1918
Watercolor, gouache, and pencil on
paper; 20¼ x 13¾ in. (51.4 x 35 cm.)
Bequest of Scofield Thayer, 1982
(1984.433.298)

HENRI MATISSE
Seated Nude with Arms Crossed

Having tried a variety of printing techniques in 1903 and 1906, Henri Matisse returned enthusiastically to printmaking in 1914, producing several lithographs, a large group of etchings, and some thirty monotypes, an example of which is shown here. Matisse drew the images for his monotypes by scratching on an inked metal plate, and he printed them on a small handpress for etchings that had been installed in his Paris apartment on the Quai Saint-Michel. He presented a variety of subjects in these prints—nudes, portraits, still lifes, and interiors—and while he developed and expanded all these themes in his paintings, the monotype process challenged him to distill them. Taking a black-inked plate in hand like a note pad, this compulsive, masterful draftsman achieved maximum expression with a minimum of lines.

There are at least six studies of figures among Matisse's monotypes. These are sparely, poignantly drawn and positioned perfectly within the picture's space. Gossamer outlines somehow manage to suggest real flesh as well as the pressure of a leaning shoulder.

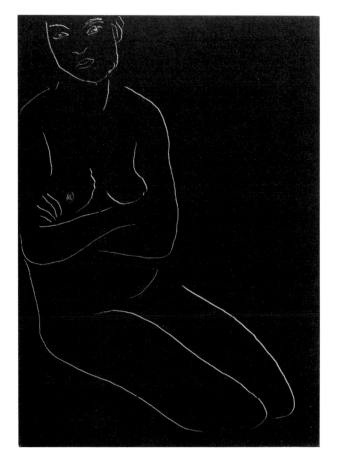

78 Seated Nude with Arms Crossed,
1914–17
Henri Matisse
French, 1869–1954
Monotype in black ink;
6¾ x 4¾ in. (17.1 x 12.1 cm.)
Gift of Stephen Bourgeois, 1917
(17.75)

79 Nasturtiums and the "Dance," II, 1912
Henri Matisse
French, 1869–1954
Oil on canvas;
75½ x 45⅜ in. (191.8 x 115.3 cm.)
Bequest of Scofield Thayer, 1982
(1984.433.16)

HENRI MATISSE
Nasturtiums and the "Dance," II

This composition, a view of Matisse's studio in Issy-les-Moulineaux, southwest of Paris, was painted in 1912, when the artist returned to France after an extended stay in Morocco. In the left foreground a wooden armchair is partially cut off by the picture frame. Behind it and to the right a tripod table, intended for sculpture, supports a vase of nasturtiums. Occupying the entire background is a section of Matisse's large canvas *Dance, I* of 1909 (now in the Museum of Modern Art in New York), which was actually standing on the studio floor at the time. This device of incorporating his own works—both painting and sculpture—into his compositions was one that Matisse repeated many times in his oeuvre, and *Dance, I* is among the images most often recalled. Matisse made two versions of *Nasturtiums and the "Dance."* The first was bought by the Russian collector Sergei I. Shchukin within a few weeks of its completion (now in the State Pushkin Museum of Fine Arts, Moscow).

The luxurious, singing color of *Nasturtiums and the "Dance," II* proves Matisse to be one of the greatest colorists of all time. Pale pinks, medium blues and greens, peach tones, a lively yellow ocher, and a strip of fuchsia, all of similar intensity, are masterfully combined. The picture is thinly painted with broad, spontaneous brushstrokes, allowing the white of the unpainted canvas to come forward, creating a halo around the figures that intensifies the bright color.

While Matisse's composition seems at first to be a simple, flat pattern of sumptuous color and greatly abbreviated forms, upon further examination it reveals itself to be quite complex in its spatial organization. The table, for example, is situated within the interior of both the studio and the painting *Dance, I*. Moreover, the composition is highly animated. Not only are the figures in the painting dancing with great energy, but even the flowing nasturtiums partake of their joyful movement.

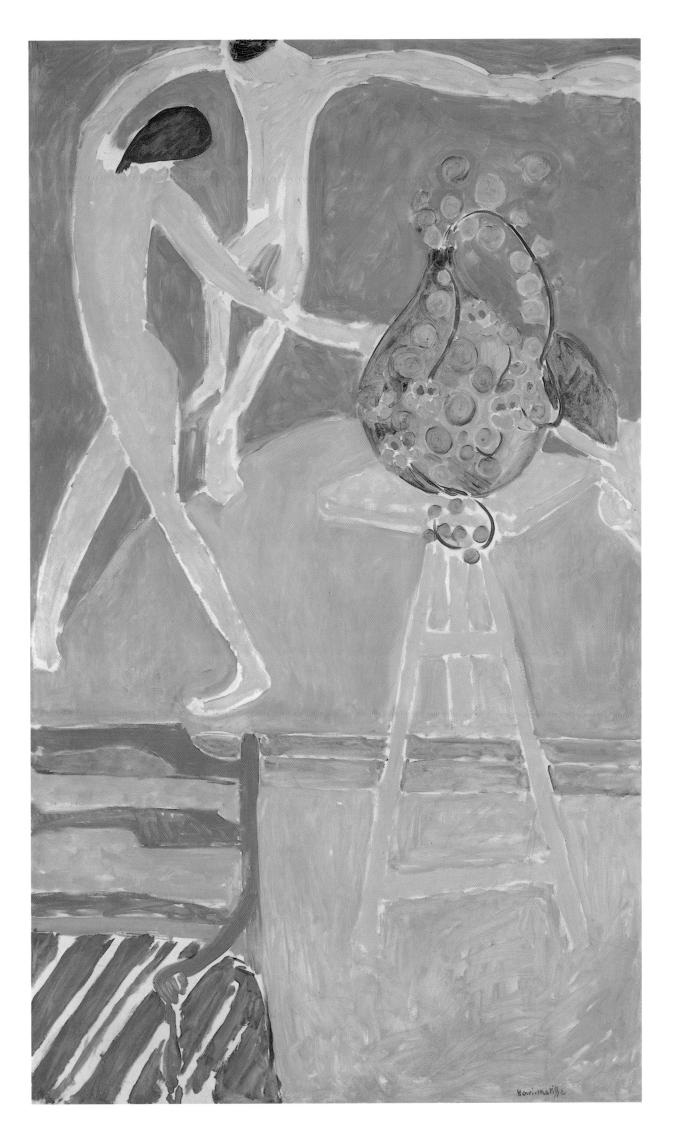

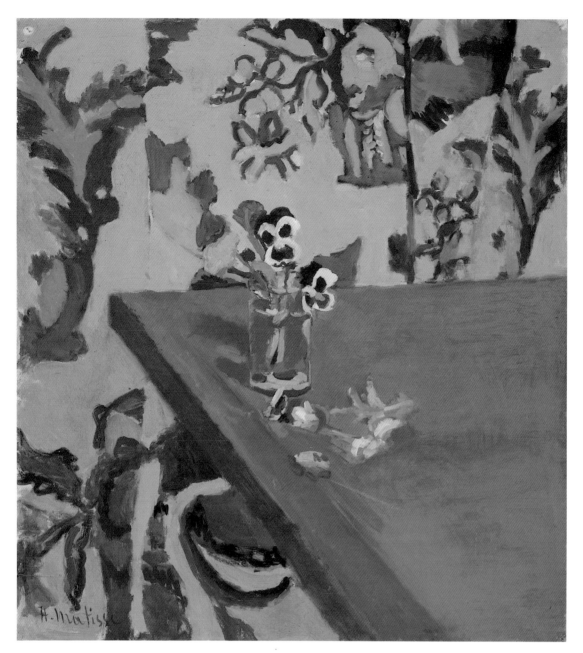

80. Pansies on a Table, ca. 1918–19
Henri Matisse
French, 1869–1954
Oil on paper;
19¼ x 17¾ in. (48.9 x 45.1 cm.)
Bequest of Joan Whitney Payson,
1975 (1976.201.22)

HENRI MATISSE
Pansies on a Table

From the simplest elements—a table, a drinking glass, flowers, and drapery—Matisse has fashioned a sophisticated and complex composition in this still life. The large expanses of pure color that lent such force to *Nasturtiums and the "Dance," II* (Plate 79) have here given way to Matisse's interest in small, rather elaborate patterns such as that seen in the drapery. This pattern is further complicated by the fact that although the drapery appears to comprise three panels, none of these matches its neighbor. The modest garden flowers, placed unassumingly in a drinking glass and lying randomly on a table, play a crucial role in the composition, as their sparkling colors—deep purple, pink, orange, yellow, white, and green—enliven the virtually monochromatic background. Finally, and most forcefully, the oblique angle at which the corner of the simple brown table juts into the picture adds tremendous drama and power to the composition.

HENRI MATISSE
Goldfish

In *Goldfish*, painted some ten years after *Nasturtiums and the "Dance," II*, Matisse similarly incorporates one of his previous paintings into the composition. A portion of his small picture *Two Young Women in a Landscape in the Loup Valley*, of 1921 (now in a private collection in Canada), is seen in the upper right-hand corner. Matisse humorously creates a situation in which the two women in the painting gaze out at the still-life arrangement on the table, which is dominated by a footed glass bowl containing goldfish. Miscellaneous objects adorn the table: At the left a tall glass bottle half-filled with clear liquid reveals the patterned wallpaper behind it; a periodical, entitled *Les Modes*, lies diagonally in front; and four apples and a small, covered glass jar are grouped in the center and at the right. The motif of figures contemplating goldfish recurs in several of Matisse's paintings, drawings, and etchings of the teens and twenties. Evident in these pictures is the artist's appreciation of the idyllic, uncomplicated existence of the fish swimming in their protected, crystalline world, unencumbered by the cares of human life.

81 Goldfish, ca. 1921–22
Henri Matisse
French, 1869–1954
Oil on canvas; 21⅜ x 25¾ in.
(54.3 x 65.4 cm.)
Bequest of Scofield Thayer,
1982 (1984.433.19)

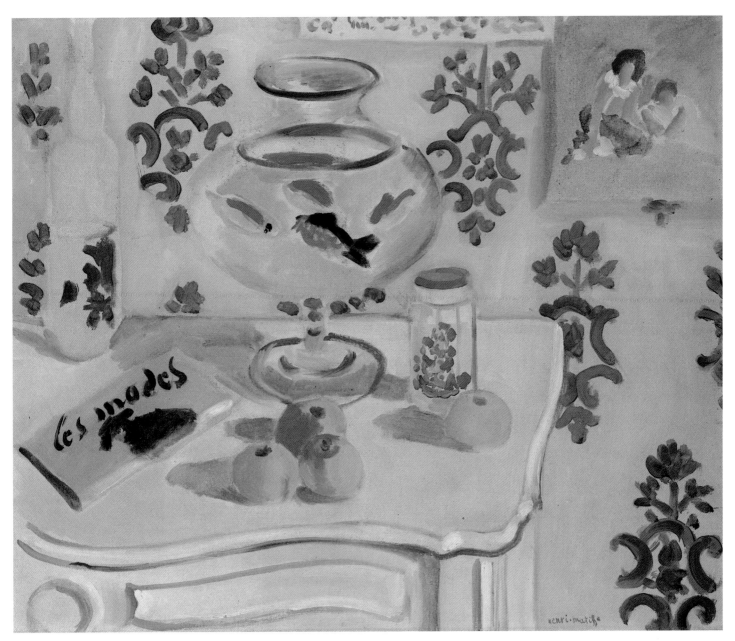

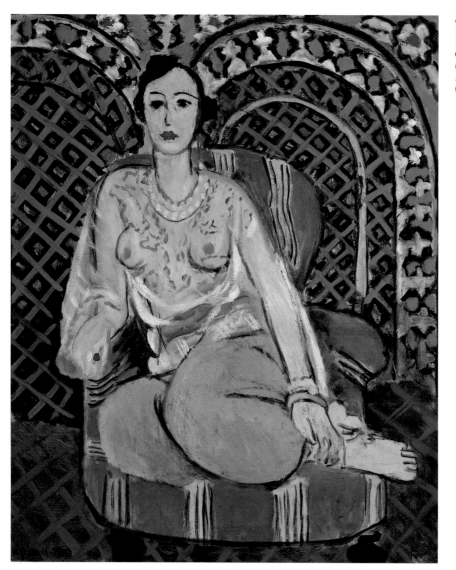

82 Odalisque, 1926
Henri Matisse
French, 1869–1954
Oil on canvas; 28¾ x 23⅝ in.
(73 x 60 cm.) Gift of the
Adele R. Levy Fund, Inc., 1962
(62.112)

83 L'Espagnole: Harmonie en Bleu, 1923
Henri Matisse
French, 1869–1954
Oil on canvas;
18½ x 14 in. (47 x 35.6 cm.)
Robert Lehman Collection, 1975
(1975.1.193)

HENRI MATISSE

Odalisque and *L'Espagnole: Harmonie en Bleu*

From 1911 to 1913, Matisse visited North Africa three times, and his experiences there remained an important influence on his art at various points throughout his career. The motif of the odalisque, a slave or concubine in a harem, preoccupied the artist during the 1920s, when he painted them in various exotic settings. Indeed, the subject had been painted by many artists before him, including Eugène Delacroix and Jean Auguste Dominique Ingres.

The odalisque in Plate 82 is seated before an elaborate Moorish screen. Matisse creates a densely ornamented background by placing the screen in proximity to the diamond-patterned carpet and striped chair. Next to this profusion of pattern the curvaceous, pink-skinned woman, dressed in a diaphanous white blouse and green pantaloons, is refreshing but in no way incongruous. The chair in which she sits is decidedly European, reminding us that the Moroccan setting was recreated in the artist's studio in France. In fact, for Matisse the theme of the odalisque was a continuation of his studio subjects (Plate 79). Now, however, exotic mod-

els and settings, rather than figures from his own paintings and sculptures, inhabit his composition. The artist's studio has become the paradise he depicted in so many of his earlier works.

In Plate 83, Matisse's exotic woman is dressed not as an odalisque but, with her mantilla and fan, as a Spanish lady. She is seated upright at a table so that only the upper half of her erect torso is visible. Unlike the curves of the odalisque's body, which provided a foil to the geometric design of her environment, the flowing mantilla worn by the Spanish lady serves as a link between the geometric pattern of the tabletop and the profusion of soft, full flowers behind her. While these flowers are presumably part of a repetitive pattern on wallpaper or a screen, no two are painted alike. Here, too, every part of the picture except the figure is patterned, and yet the composition is not the slightest bit cluttered. Matisse's subtitle for this picture—*Harmonie en Bleu*—testifies to his concern for the decorative aspects of painting.

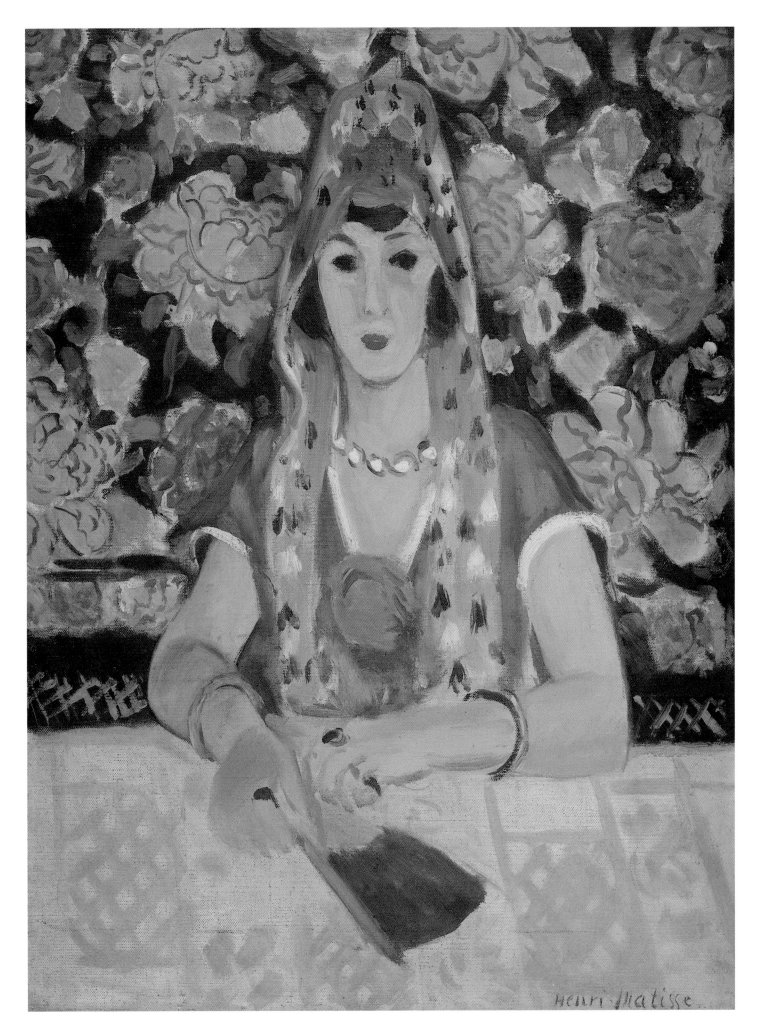

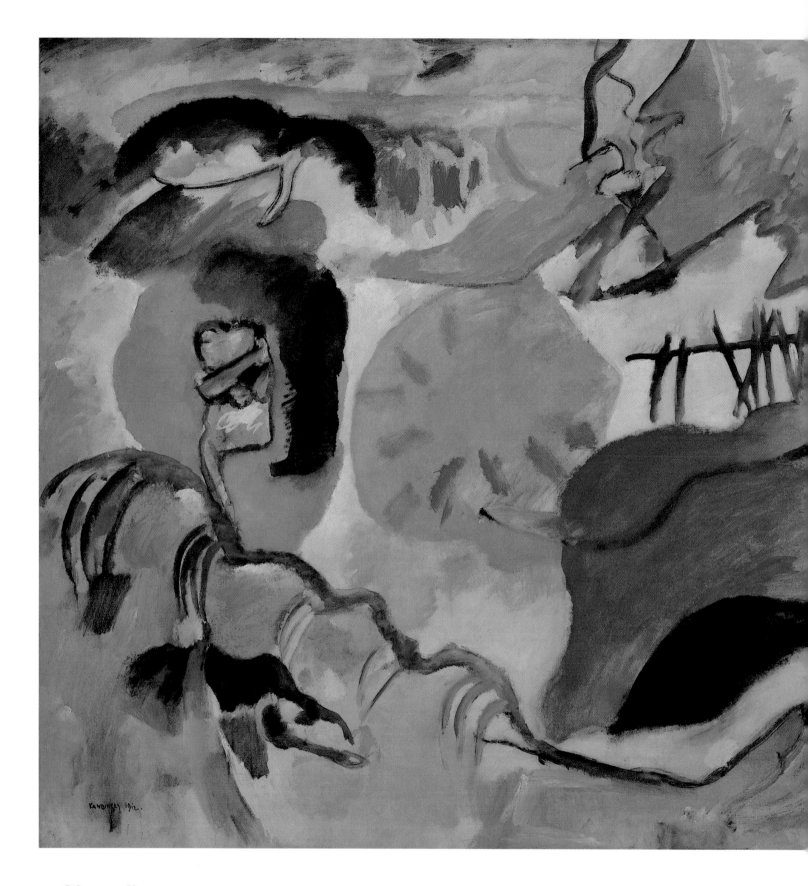

WASSILY KANDINSKY
Garden of Love (Improvisation No. 27)

Russian artist Wassily Kandinsky moved to Munich to study painting in 1896. There he became one of the founding members of *Der Blaue Reiter* (The Blue Rider), a loose association of artists that formed in 1911 to promote a new art, one that would reject the material world in favor of the world of emotion and of the spirit. The following year

marked the publication of Kandinsky's theoretical book, *On the Spiritual in Art*.

The specific source for the imagery in this painting is most likely the biblical story of Paradise and the Garden of Eden. Several figures, animals, and landscape motifs are placed around a large, yellow sun. They include three cou-

84 Garden of Love
(Improvisation No. 27), 1912
Wassily Kandinsky
Russian, 1866–1944
Oil on canvas; 47⅜ x 55¼ in.
(120.3 x 140.3 cm.)
Alfred Stieglitz Collection,
1949 (49.70.1)

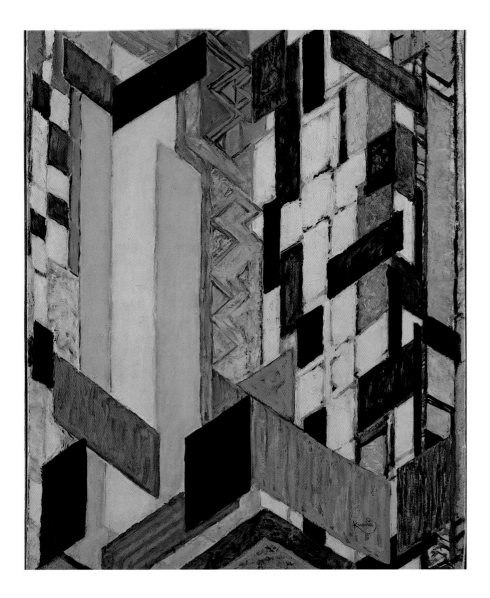

85 Vertical Planes, 1912–13
František Kupka
Czech, 1871–1957
Oil on canvas; 24⅛ x 19¾ in.
(61.3 x 50.2 cm.) Gift of
Joseph H. Hazen Foundation,
Inc., 1971 (1971.111)

FRANTISEK KUPKA
Vertical Planes

The first abstract pictures were painted shortly after 1910 by František Kupka, a Czech living in France, and Wassily Kandinsky, a Russian living in Bavaria (see Plate 84). Both artists swiftly evolved a new pictorial language, spiritual in intent, emotional in expression, and abstract in effect. Kupka's abstractions, executed in Paris, were inspired by the architecture of Gothic cathedrals, in particular their stained-glass windows and the slender, closely massed columns that supported their interiors. There is an architectural feel to *Vertical Planes* not only in the piece's vertical orientation, but also in its interlocking forms, which remind us of stained glass. Not all of Kupka's planes are tightly interlocked, however. Many of the larger parallelograms seem to float gracefully and rotate slowly in space.

ples painted in various poses of intimacy, and three animals. The landscape setting is more generalized and broadly painted than the narrative elements. However pastoral this landscape, it is not without a threatening tone, as indicated by the presence of ominous black spots of paint and the slithering snake at center right.

FREDERICK EVANS
Kelmscott Manor: In the Attics

Broad public acceptance of photography as an independent artistic medium came at the end of the nineteenth century, when a movement called Pictorialism became widespread in Europe and the United States. Pictorialists believed that the criteria for judging a photograph should be the same as those for judging painting; thus, their concern for the formal elements of a photograph—composition, touch, and tone—equaled their interest in subject matter. Frederick Evans, a Pictorialist photographer, moved the image of Gothic architecture away from strict archaeological documentation into the realm of private experience. His photographs of the great English cathedrals are among the most graceful, subtle, and atmospherically resonant compositions produced at the end of the nineteenth century.

This photograph represents the attic of the sixteenth- and seventeenth-century Oxfordshire manor of William Morris. It is a leaf in an album of some thirty pictures Evans made during the last year of Morris's life, an album which not only describes the historic house but which also traces the photographer's movement from a straightforward presentation of the place to a celebration of the play of light within its space. Evans's appreciation of the attic's spare, rude simplicity and handsome proportions is rendered with smooth, rich tones.

ALVIN LANGDON COBURN
Untitled

In 1903, American-born Alvin Langdon Coburn was elected to both the American Photo-Secession and the British Brotherhood of the Linked Ring, two of the most advanced groups of photographers dedicated to furthering the cause of Pictorialism (see Plate 86). Coburn first gained recognition for his portraits of British men of letters, but his lasting contribution to modern art was the "Vortograph," the first intentionally abstract photograph. The seeds of abstraction can be seen in the photographs Coburn took in 1911–12 at the Grand Canyon and in New York. By angling his camera down from the tops of skyscrapers or the edge of the canyon, he eliminated conventional horizons and created flat, distinctly patterned pictures. His first abstract photographs were created in 1916–17, when he was working in London with Ezra Pound and the Vorticists, a group of English artists with beliefs similar to those of the Futurists (see Plate 98). Coburn made his so-called Vortographs by attaching to the lens three mirrors which fractured the camera image into a pattern of nonrepresentational planes, as in a kaleidoscope.

The picture reproduced here is in fact an image of a studio skylight, refracted by the use of mirrors.

86 *Kelmscott Manor: In the Attics*, 1896
Frederick Evans
British, 1853–1943
Platinum print; 6¹/₁₆ x 7¹⁵/₁₆ in.
(15.4 x 20.2 cm.)
David Hunter McAlpin Fund, 1968
(68.519.26)

87 *Untitled*, 1916–17
Alvin Langdon Coburn
British (b. United States), 1882–1966
Gelatin-silver print; 11 x 7⅞ in.
(28.1 x 20 cm.)
Gift of Silas R. Mountsier III, 1986
(1986.1008.3)

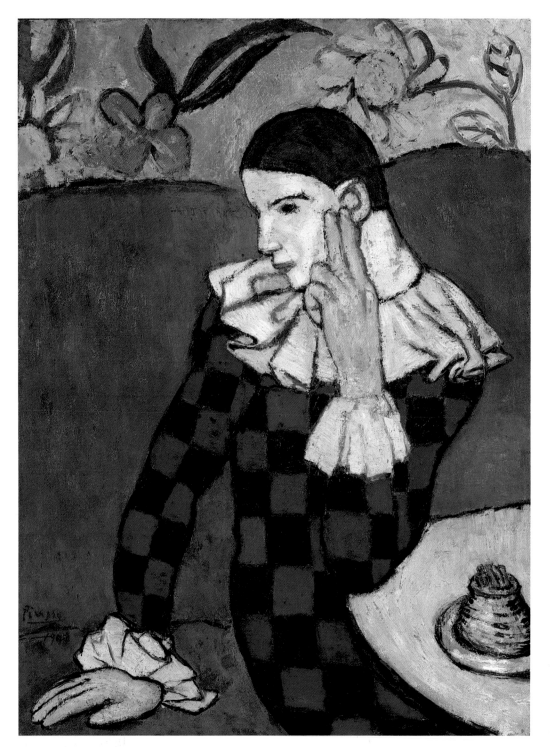

88 Harlequin, 1901
Pablo Picasso
Spanish, 1881–1973
Oil on canvas; 32⅝ x 24⅛ in.
(82.9 x 61.3 cm.) Purchase,
Mr. and Mrs. John L. Loeb
Gift, 1960 (60.87)

PABLO PICASSO
Harlequin and *The Blind Man's Meal*

In the early years of the twentieth century, Pablo Picasso's subject matter shifted from lively scenes of urban life to pictures of a more tender and melancholy mood. In the autumn of 1901 he introduced into his work the themes of the circus and the harlequin. For centuries, such traveling entertainers were painted by artists who saw in them a sadness made even more moving by its attempted disguise under the gay costume and makeup of their profession. This har-

lequin, wearing the checked and ruffled costume and white makeup of his trade, is seated alone at what appears to be a café table. His body is so attenuated and insubstantial that it seems to be in danger of floating away, and it is locked into the composition only by the table and banquette. The gentle curve of the harlequin's silhouette, which finds its response in the flowers on the wall, adds to the melancholy air.

Soon after Picasso began painting performers such as the

harlequin, he turned also to depicting society's outcasts, evoking their miseries of poverty and despair. *The Blind Man's Meal*, painted in Barcelona in the autumn of 1903, shows a single figure holding a piece of bread in one hand while he feels for a jug with the other. An empty dish sits before him. The man's stark, unadorned surroundings are perhaps emblematic of his blindness as well as his poverty, and they make the decoration on the empty dish—invisible to the sitter—all the more poignant. The overall blue tonality of the composition, characteristic of many of Picasso's works of this period, adds to the scene's pathos.

89 The Blind Man's Meal, 1903
Pablo Picasso
Spanish, 1881–1973
Oil on canvas; 37½ x 37¼ in.
(95.3 x 94.6 cm.) Gift of
Mr. and Mrs. Ira Haupt, 1950
(50.188)

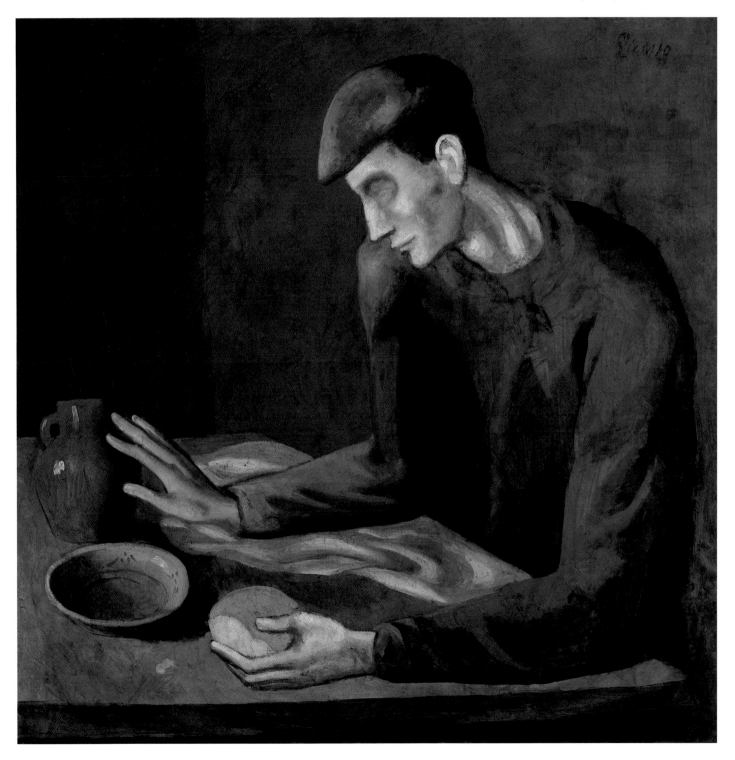

PABLO PICASSO
The Watering Place

In *The Watering Place*, Picasso's subject matter has shifted from the despair and oppression of the poor and afflicted to a calm, arcadian world in which man and nature interact harmoniously. The unity of the world Picasso depicts is expressed in his composition: The figures and horses echo one another in pose and form, while the evenly modulated tones and uniformly subdued rose coloring further enhance the cohesive image. Both figures and landscape are non-specific.

This composition is one of several studies Picasso made in Paris from late 1905 to early summer 1906 for a large-scale painting that was never executed. Only the detail of the standing boy was ever fully realized, in *Boy Leading a Horse*, of 1905–06, in New York's Museum of Modern Art.

PABLO PICASSO
La Coiffure

Though Picasso's art was, at times, radically new in style, it was quite traditional in subject matter. The theme of women combing their hair, which preoccupied the artist through a large part of 1906, is reminiscent of Degas's pictures of women at their toilette. In the picture reproduced here, this commonplace activity assumes an aura of mystery. There is no background, and so we cannot place the figures in an identifiable setting. The two visible faces—those of the standing woman and the boy—are generalized, while the other face is completely unseen, lacking even a reflection in the mirror. Furthermore, the women are clothed, while the young boy, sitting on the ground and preoccupied by his own thoughts, is nude.

These figures are not attenuated, as in so much of Picasso's earlier work. Sculptural and heavy, they seem to create the space around them with their mass and volume, and reflect Picasso's interest in Iberian sculpture.

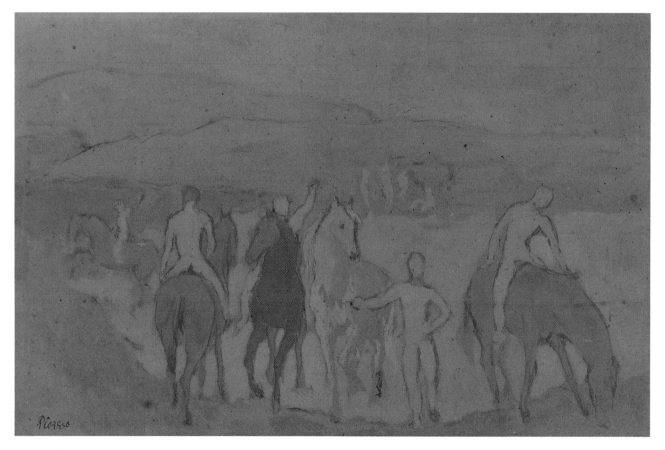

90 *The Watering Place*, 1906
Pablo Picasso
Spanish, 1881–1973
Gouache on pulpboard;
15 x 22¾ in. (38.1 x 57.8 cm.)
Bequest of Scofield Thayer,
1982 (1984.433.274)

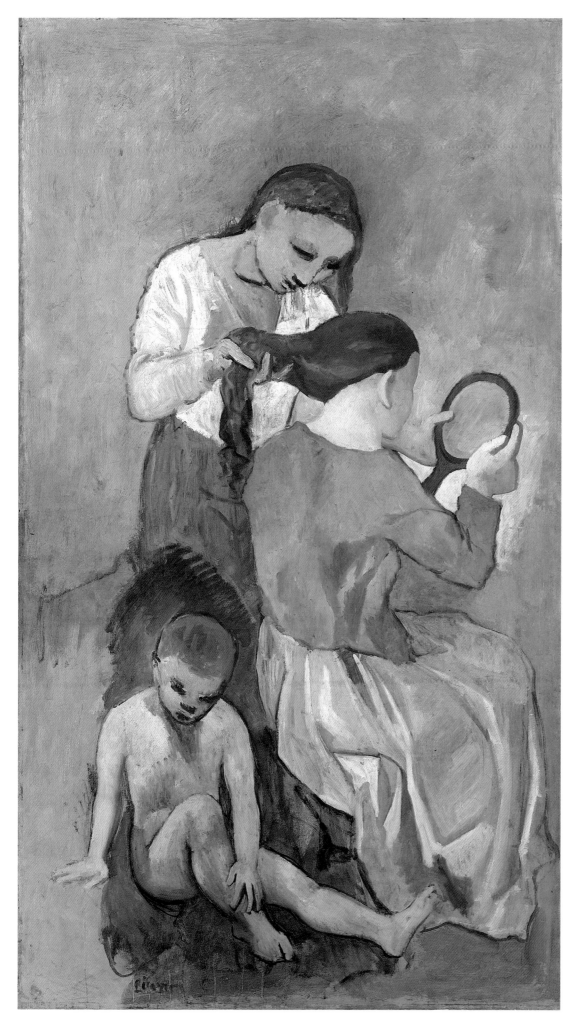

91 *La Coiffure*, 1906
Pablo Picasso
Spanish, 1881–1973
Oil on canvas; 68⅞ x 39¼ in.
(174.9 x 99.7 cm.)
Wolfe Fund, Catharine Lorillard
Wolfe Collection, 1951; acquired
from The Museum of Modern Art,
Anonymous Gift, 1953 (53.140.3)

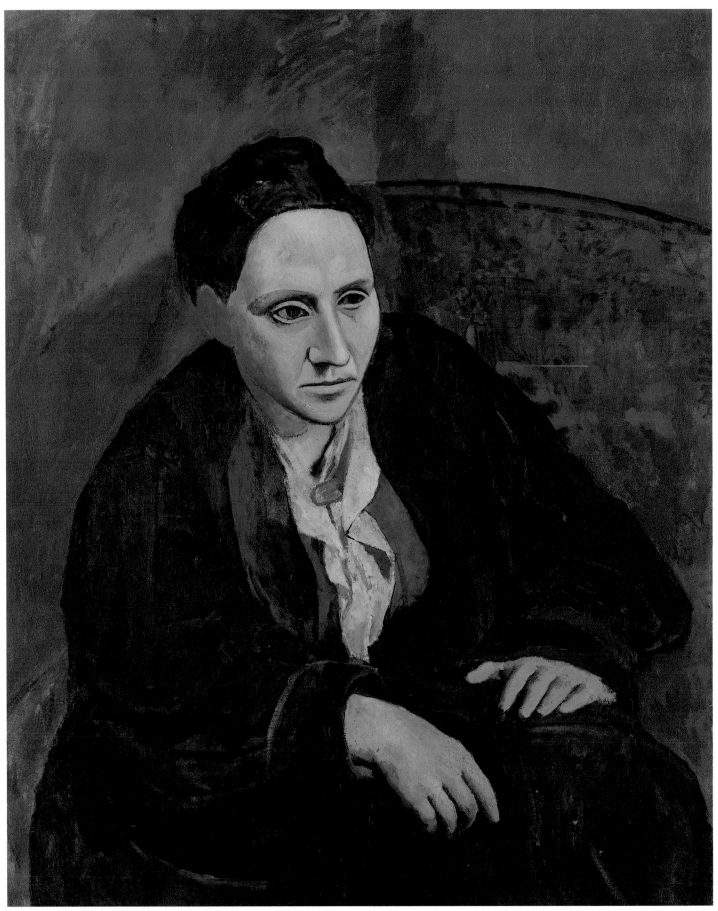

92 *Gertrude Stein*, 1905–06
Pablo Picasso
Spanish, 1881–1973
Oil on canvas; 39⅜ x 32 in. (100 x 81.3 cm.)
Bequest of Gertrude Stein, 1946 (47.106)

PABLO PICASSO
Gertrude Stein

Gertrude Stein and her brother Leo were among the first Americans to respond with enthusiasm to the artistic revolution in Europe in the early years of this century. She was one of Picasso's earliest patrons, and he began this portrait of her in the winter of 1905. Stein describes the making of the picture in her book, *The Autobiography of Alice B. Toklas:*

> Picasso had never had anybody pose for him since he was sixteen years old. He was then twenty-four and Gertrude had never thought of having her portrait painted, and they do not know either of them how it came about. Anyway, it did, and she posed . . . for this portrait ninety times. . . . There was a large broken armchair where Gertrude Stein posed. There was a couch where everybody sat and slept. There was a little kitchen chair upon which Picasso sat to paint. There was a large easel and there were many canvases. . . . She took her pose, Picasso sat very tight in his chair and very close to his canvas and on a very small palette, which was of a brown gray color, mixed some more brown gray and the painting began. . . . All of a sudden one day Picasso painted out the whole head. I can't see you any longer when I look, he said irritably. And so the picture was left like that.

In fact, Picasso completed the head after a trip to Spain in the fall of 1906, nearly one year after beginning the portrait. The masklike face with its heavy-lidded eyes reflects Picasso's recent encounter with Iberian sculpture.

The fact that he painted the head, which differs in style from the body and hands, without the sitter, tells us that it was his personal vision, rather than a visible reality, that guided his work. When someone commented that Stein did not look like her portrait, Picasso replied, "She will."

CONSTANTIN BRANCUSI
Sleeping Muse

Romanian-born Constantin Brancusi, who worked in Paris, was a highly important figure in the movement toward abstract art. Yet his work is best described as abstracted rather than abstract. Much of his sculpture comprises extremely refined, elegant works, in which he has allowed no trace of his hand to be seen. These are derived from natural forms, especially the human figure. He did not want to describe these forms but rather to capture their essence. The sleeping head, one of Brancusi's first thematic cycles, occupied him for about twenty years. Early versions depict a particular individual sleeping; as the series progressed, however, the head was increasingly abstracted until it became a simple ovoid. In *Sleeping Muse* the face of Baroness Renée Irana Frachon is reduced to a slender V denoting eyebrows and a nose, a small mouth, and the suggestion of closed lids. Such simplification may have been partly inspired by the so-called primitive art that many artists of the period found so powerful. This head is one of four bronzes cast in 1910 from a marble of the previous year; each version was individually worked and differs in size and surface treatment.

Brancusi's work has been highly influential throughout the century. We can see his inspiration in works as varied as that of Modigliani (see Plate 103) and of the Minimalist sculptors of the 1960s.

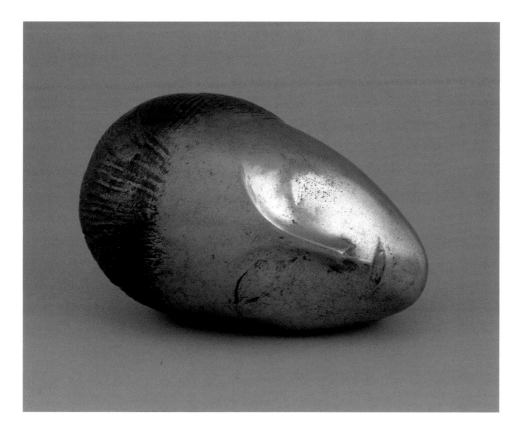

93 Sleeping Muse, 1910
Constantin Brancusi
French (b. Romania),
1876–1957
Bronze; H. 6¾ in. (17.1 cm.)
Alfred Stieglitz Collection,
1949 (49.70.225)

PABLO PICASSO
Still Life

"Cubism" is a misleading name for a style of painting in which virtually nothing is as regular as a cube. Based on intuition rather than geometry, Cubism is the expression of the artist's personal perception of forms and their relationships to one another. The multiple planes in a Cubist picture do not define the sides of geometric forms, but slip and slide—fragile as a house of cards—in an ambiguous space in which objects overlap and share parts, and in which they are depicted as if seen simultaneously from more than one viewpoint.

Yet no matter how radically the objects in a Cubist picture are disassembled and reassembled by the artist's vision, the subject is always rooted in objective reality. The Cubist still life reproduced here, for example, represents a large wine bottle or siphon and a stemmed glass on a table. The incomplete circle near the center of the composition is the rim of the glass, viewed as if seen from above, while the rest of the glass is depicted as if seen from straight on. To the left of the glass is the bottle or siphon, part of its body and its label signified by a cutting from a newspaper. The headline reads, "M. Millerand, Ministre de la guerre, flétrit l'antimilitarisme" ("Mr. Millerand, Minister of War, denounces anti-militarism")—a poignant indication of the coming of the First World War.

The addition of the newspaper makes this drawing a collage. Picasso made the first collage in 1912, when he glued to a painting a piece of oilcloth printed with a pattern of chair caning. With the addition to art of objects from everyday life, Cubism made the line between art and reality still more ambiguous.

94 Still Life, 1912–13
Pablo Picasso
Spanish, 1881–1973
Charcoal, ink, and pasted newspaper on paper;
24⅝ x 18⅝ in. (62.6 x 47.3 cm.)
Alfred Stieglitz Collection, 1949 (49.70.33)

95 The Guitar, 1919
Henri Laurens
French, 1885–1954
Painted terra-cotta;
H. 11½ in. (29.2 cm.)
Gift of Mr. and Mrs.
Daniel Saidenberg,
1984 (1984.209)

GEORGES BRAQUE
Le Guéridon

The years around 1920 constituted a transitional period in the career of Braque, who, with Picasso, had helped develop Cubism in the second decade of the century. Approaching the age of forty, Braque had resumed painting after serving in the army during World War I. His work began to show the reemergence of naturalistic elements, while retaining many of the formal innovations of Cubism. This still-life composition, *Le Guéridon* (a *guéridon* is a small, round pedestal table) of 1921–22, is typical of the period. Braque retains the Cubist palette of greens, beiges, and whites and adds a prominent use of black. The pictorial space is compressed to the front of the picture plane, and the tabletop is tilted to display the still-life arrangement of fruits, pipes, newspapers, and musical instruments. The fragmented geometric forms and flat patterned shapes are related to the collage technique first explored by Braque and Picasso some ten years earlier. Braque did no fewer than fifteen paintings of this subject between 1921 and 1930. This painting is probably the earliest of the series and was exhibited at the Salon d'Automne in November 1922.

96 *Le Guéridon*, 1921–22
Georges Braque
French, 1882–1963
Oil with sand on canvas; 75 x 27¾ in.
(190.5 x 70.5 cm.) Jointly owned by
The Metropolitan Museum of Art and
Mrs. Bertram Smith, 1979 (1979.481)

HENRI LAURENS
The Guitar

The Guitar, of 1919, is a beautifully executed Cubist sculpture by Henri Laurens, a friend of the Cubist painters Braque, Picasso, and Gris, who were all in Paris in the early 1900s. Although produced several years after these artists' most innovative Cubist work, this small sculpture nevertheless displays the same vitality and ingenuity that characterize their earlier paintings and drawings. Laurens adopted the Cubists' subject matter (figures, still lifes, and musical instruments) and translated their planar analysis of volume into the idiom of sculpture. He employed varied materials—metal, wood, stone, and terra-cotta—in his sculptures and reliefs, and he often painted their surfaces in an effort to suppress the effects of changing light and to clarify the intricately faceted form. The delightful staccato rhythm established by the varied placement of colors is matched by the multitude of projecting and receding planes and the asymmetrical configuration of forms. *The Guitar* is an important example of the sculptural implications of Cubism.

JACQUES VILLON
The Dining Table

From 1910 to 1914, Jacques Villon was associated with the "Puteaux" group of Cubists, including Albert Gleizes, Jean Metzinger, Fernand Léger, and Francis Picabia, whose styles were derived from the analytical Cubism of Picasso and Braque. *The Dining Table*, one of Villon's masterpieces from this period, is a summation of his experiments in the depiction of form and space. The architectural details of the interior scene are generalized, and the pictorial space is shallow and intimate. The table and the items on it—a vase of flowers, a carafe of water, a Chianti bottle, and various dishes placed on a table set for a meal—are thrust diagonally to the fore of the picture plane in a treatment very unlike the frontal perspective of Picasso's and Braque's still lifes. Villon used overlapping, transparent geometric planes of light and dark tones to denote space. The volumetric forms of the objects are defined by a network of black lines that meander over the faceted planes. The artist has animated the characteristically sober Cubist palette with blue, green, white, and touches of yellow.

97 *The Dining Table*, 1912
Jacques Villon
French, 1875–1963
Oil on canvas; 25¾ x 32 in.
(65.4 x 81.3 cm.) Purchase, Gift of
Mr. and Mrs. Justin K. Thannhauser,
by exchange, 1983 (1983.169.1)

98 *Danseuse-Hélice-Mer*, 1915
Gino Severini
Italian, 1883–1966
Oil on canvas; 29⅞ x 30¾ in.
(75.2 x 78.1 cm.)
Alfred Stieglitz Collection, 1949
(49.70.3)

GINO SEVERINI
Danseuse-Hélice-Mer

Futurism, an Italian artistic and literary movement, hailed "dynamism" as the expression of the modern world. The Italian poet Filippo Tommaso Marinetti energetically announced the birth of the movement in a manifesto published in 1909. He insisted that artists renounce the past and instead concern themselves with the vital life of the modern city. "Dynamism" was offered as an expressive means that emphasized process and pulse rather than actual objects and forms. The artist was called on to synthesize the manifold experiences of sense and memory into a coherent "simultaneity."

Gino Severini was a leading Futurist painter. The title of this work, which means "Dancer-Helix-Sea," establishes an analogy, or dynamic equivalent, among the three elements, all of which are characterized by an insistent, impelling rhythm. While there are certainly suggestions of the sea, a helix, and a dancer here, Severini's purpose is clearly not to depict them specifically; rather, he is expressing pure movement through his rhythmic composition of echoing and contrasting forms and his multicolored palette. Even the diamond shape of the canvas, with its suggestion of rotation, adds to the picture's movement.

PAUL KLEE

Paul Klee's training as a painter began in 1898, when he went to Munich for three years to draw and paint; it can be said to have lasted until 1914, when he visited Tunisia. The light of North Africa inspired him, and there he made his now famous statement, "Color and I are one. I am a painter."

In 1914, Klee visited Hammamet, a small town on the Mediterranean southeast of Tunis, and captured a view of the city in *Hammamet with Its Mosque* (Plate 99). As happens so often in Klee's works, the picture consists of both representational and nonrepresentational elements. The upper part

shows the mosque surrounded by two towers and gardens; the lower area is made up of translucent color planes following Robert Delaunay's example of making pure color and its contrasts the sole subject of a picture.

Klee also admired the Cubists' handling of pictorial space. In *Phantom Perspective* (Plate 100), traditional, three-dimensional space is abstracted in the Cubist manner, with interlocking and interpenetrating planes. Trained as a violinist, Klee found affinities between painting and music, and incorporated into his drawing, various musical symbols, a

101 *Oriental Garden*, 1925
Paul Klee
German, 1879–1940
Oil on cardboard; 16⅛ x 20⅜ in.
(41 x 51.8 cm.)
The Berggruen Klee Collection,
1984 (1984.315.41)

102 *Stricken City*, 1936
Paul Klee
German, 1879–1940
Gypsum and oil on canvas;
17¾ x 13⅞ in. (45.1 x 35.2 cm.)
The Berggruen Klee Collection,
1984 (L. 1984.70.2)

music stand, and what appears to be a piano.

In 1920, Klee received an invitation to teach at the Bauhaus. Dedicated to architecture and the interweaving of fine and applied arts, the Bauhaus was the ideal place for Klee to pursue his interest in structural essences; he was to remain there until 1931. Paintings that combine strong form with evocative color predominate Klee's work of this period. He often painted the Tunisian gardens that had so impressed him in 1914. *Oriental Garden* (Plate 101), painted entirely from memory, captured what Klee called the "latent reality" of the site. His warm Southern palette, consisting primarily of lavender and golden hues, is applied with soft, impressionistic brushstrokes, which are stabilized by lyrical black lines.

In 1936–37, Klee completed a series of deceptively simple "rhythmic" paintings such as *Stricken City* (Plate 102). Full of symbols and signs, they resemble musical scores or recently unearthed hieroglyphs. The arrow was one of Klee's favorite symbols. He wrote, "The father of the arrow is the thought. Over this river? This lake? That mountain?"

103 Jeanne Hébuterne, 1918
Amedeo Modigliani
Italian, 1884–1920
Oil on canvas; 36 x 28¾ in. (91.4 x 73 cm.)
Gift of Mr. and Mrs. Nate B. Spingold, 1956
(56.184.2)

104 Self-Portrait, 1911
Giorgio de Chirico
Italian, 1888–1978
Oil on canvas; 34⅜ x 27½ in.
(87.3 x 69.9 cm.)
Gift in memory of Carl Van Vechten
and Fania Marinoff, 1970 (1970.166)

AMEDEO MODIGLIANI
Jeanne Hébuterne

Italian artist Amedeo Modigliani moved to Paris as a young man in 1906. Although he witnessed and absorbed the new movements in art, notably Fauvism and Cubism, during the first decades of the twentieth century, his work, which is dominated by the human figure, remains an expression of his unique sensibility and personal history. This picture of the artist's nineteen-year-old mistress, Jeanne Hébuterne, was painted in the south of France, where Modigliani had gone to be with her while she was pregnant with their daughter, who was born in November 1918. Typical of Modigliani's style are the elongated body and elegant linearity, both of which are reminiscent of Italian Renaissance and Mannerist art. Figure and setting are both greatly simplified; the oval head, with its incised features, reminds us of the sculpture of Brancusi (see Plate 93), with whom Modigliani apprenticed early in his career. Jeanne Hébuterne's relaxed and graceful pose, as well as her rosebud mouth, add an intimate note to the portrait.

GIORGIO DE CHIRICO
Self-Portrait

This self-portrait in profile is one of two that de Chirico painted after moving to Paris in 1911. Although the work was painted at a time when Cubism was at its height, it reflects a very different approach to presenting reality. De Chirico employs a bizarre mixing of elements, using a super-real representational painting style to depict a disturbing, irrational scene. Though the atmosphere is still, the pennants on top of the tower blow furiously. Indeed, the entire empty setting, with its enormous tower and low brick wall, is uncanny, as if it represents the artist's inner vision or dream, an effect enhanced by the unearthly color and arbitrary disposition of light and shadow. De Chirico's visionary work, with its surprising juxtaposition of elements, proved to be a strong influence on the Surrealists (see Plates 113, 125).

105 *The Market Place, Vitebsk,* 1917
Marc Chagall
French (b. Russia), 1887–1985
Oil on canvas; 26⅛ x 38¼ in.
(66.4 x 97.2 cm.) Bequest of
Scofield Thayer, 1982 (1984.433.6)

Page 128: text

MARC CHAGALL *(Pages 126–127)*
The Market Place, Vitebsk

Marc Chagall, who grew up in a suburb northeast of Vitebsk, left Russia for Paris in 1910. He returned to Russia for a visit in 1914, but the outbreak of the First World War prevented him from leaving again. He had to remain in Russia until 1922. During the summer of 1917, Chagall painted a series of landscapes and local scenes in his native town.

In *The Market Place, Vitebsk* everything appears slightly unbalanced, with the buildings standing at various angles. The shifting, unstable nature of the composition is enhanced by the faceted planes, most notable in the shadows, and owes much to Chagall's experience of Cubism while in Paris. Unlike in Cubism, however, here objects maintain their integrity. Chagall has even added highly realistic touches, such as the siphon painted on the shop sign at the left, to further anchor his poetic vision to reality. It is as if we are looking not through the shattered glass of Cubism, but through a translucent window—the window of Chagall's imagination.

PABLO PICASSO
Head of a Woman and *Woman in White*

After Cubism, with its fragmented forms, Picasso's interest in the art of antiquity reemerged, and he often painted figures of a classical wholeness and unity. The pastel drawing *Head of a Woman* (Plate 106), of 1921, strongly recalls the art of antiquity. It is related to the standing figure at the left side of the large neoclassical painting *Three Women at the Spring* in the Museum of Modern Art in New York. Like the figures in the painting, the woman in this drawing is remote, her eyes vacant as if she were in a trance. Although her features are severely stylized, the model, with her dark wavy hair parted in the middle and pulled back, her round face, and her heavily lidded eyes, bears a strong resemblance to Picasso's young wife, Olga Koklova.

For *Woman in White* (Plate 107) the model is once again Olga, but here there is a softness and refinement in both conception and rendering that differentiates this work from the earlier drawing. The tilt of Olga's head and the way she leans back, as well as her loose-fitting dress, give her a gentle, relaxed air. Furthermore, this figure is less sculptural than that in the pastel. She is rendered with a much more delicate line, and with less dramatic and forceful color.

106 Head of a Woman, 1921
Pablo Picasso
Spanish, 1881–1973
Pastel on paper;
25⅝ x 19¾ in. (65.1 x 50.2 cm.)
Bequest of Scofield Thayer,
1982 (1984.433.270)

107 Woman in White, 1923
Pablo Picasso
Spanish, 1881–1973
Oil on canvas; 39 x 31½ in.
(99.1 x 80 cm.)
Rogers Fund, 1951; acquired from
The Museum of Modern Art,
Lillie P. Bliss Collection (53.140.4)

129

Jacques Emile Ruhlmann
Art Deco Cabinet

Jacques Emile Ruhlmann was the leading decorator and furniture designer of the Art Deco style. The *artiste décorateur* par excellence, he showed furniture in the salons of the Société des Artistes Décorateurs from 1913 and undertook interior designs with his own firm of Ruhlmann et Laurent after the First World War. His pavilion, tellingly titled "l'Hôtel d'un Riche Collectionneur," was the most popular exhibit at the 1925 Exposition Internationale.

Ruhlmann maintained flawless quality in his workshops, where the highest-paid artisans in Paris were employed under his close supervision. The extravagant prices he asked were justified by the elegance of his concepts and their su-

perb execution. Ruhlmann used *ébénisterie*, the technique of veneered furniture perfected in eighteenth-century France, to execute designs distilled from earlier furniture forms. Details of the work reveal the lengths to which Ruhlmann was willing to go to realize his exquisite designs. To enhance the effect of luxury he contrasted ivory ornament against exotic wood veneers in seemingly simple designs that were extraordinarily difficult to execute.

The Museum's cabinet, with its marquetry basket of flowers, was sold to the French state, but—after considerable persuasion—the artist agreed to repeat the model for the Metropolitan Museum.

108 Cabinet, 1926
Jacques Emile Ruhlmann
French, 1879–1933
Macassar ebony, rosewood, and ivory;
H. 50¼ in. (127.6 cm.)
Purchase, Edward C. Moore, Jr. Gift,
1925 (25.231.1)

109 Armchair, 1922
Marcel Lajos Breuer
American (b. Hungary), 1902–31
Oak with wool upholstery; 37¼ x 22¼ in.
(94.5 x 56.5 cm.) Purchase,
Theodore R. Gamble, Jr. Gift, in honor of
his mother, Mrs. Theodore Robert Gamble
and Lita Annenberg Hazen Charitable
Trust Gift, 1983 (1983.366)

110 Armchair, 1927
Ludwig Mies van der Rohe
German, 1886–1969
Chrome steel tubing, caning;
H. 31½ in. (80 cm.), W. 22 in. (55.9 cm.),
D. 37½ in. (95.3 cm.)
Purchase, Theodore R. Gamble, Jr. Gift,
in honor of his mother, Mrs. Theodore
Robert Gamble, 1980 (1980.351)

MARCEL BREUER
Armchair

Marcel Breuer, one of the most important industrial de-
signers of this century, was a student and teacher at the
Bauhaus in the 1920s. It was during his early years there
that he conceived this extraordinary armchair. The chair's
design indicates the profound influence on Breuer of the
artists and architects associated with De Stijl, a movement
which originated in Holland and which sought to integrate
art, architecture, and design into a new unity. This chair,
which is reminiscent of the work of De Stijl architect and
designer Gerrit Reitveld, features a dramatic juxtaposition
of minimal upholstery with a highly articulated frame.

LUDWIG MIES VAN DER ROHE
Armchair

Architect Ludwig Mies van der Rohe's well-known philoso-
phy of "less is more" is evident in his extremely elegant,
understated chairs, ottomans, and tables: Each piece is dis-
tilled to its essential elements, which are then exquisitely
refined and crafted. Mies was a pioneer in the use of tubu-
lar steel, seen here in an armchair of 1927. While made of
the minimum number of parts, this is an extremely grace-
ful and elegant object. Mies's superb sense of proportion
and his unerring instincts for what to leave out of a piece
have made his furniture some of the most enduring of the
twentieth century.

111 *Day Ensemble*, ca. 1927
Label: *Chanel*
Coco Chanel
French, 1883–1971
Black and ivory silk charmeuse
Purchase, Gift of The New-York
Historical Society, by exchange,
1984 (1984.29a–c)

Day Ensemble, ca. 1927
Label: *Chanel*
Coco Chanel
French, 1883–1971
Black wool jersey and black satin
Purchase, Gift of The New-York
Historical Society, by exchange,
1984 (1984.28a–c)

Theater Coat, ca. 1927
Label: *Chanel*
Coco Chanel
French, 1883–1971
White and black ombre silk
Purchase, Irene Lewisohn Bequest, Catharine Breyer
Von Bomel Foundation Fund and Hoechst Fibers
Industries and Chauncey Stillman Gifts, 1984 (1984.30)

112 Theater Suit, 1937
Label: *Schiaparelli*
Elsa Schiaparelli
French (b. Italy), 1890–1973
Jacket of dark green velvet
embroidered with gold tinsel
and red glass stones; dark green
rayon dress with shirring detail
Gift of Julia B. Henry, 1978
(1978.288.19ab)

Coco Chanel
Day Ensembles and a Theater Coat

Coco Chanel has been acknowledged as one of the most significant twentieth-century couturieres. Her day clothes, which for later designers were some of the more influential of her creations, have been quite uncommon in major collections. Each of these ensembles typifies a lasting contribution made by Chanel. For example, the charmeuse suit at the left has the mannish tailoring that she championed. The wool-jersey dress demonstrates Chanel's desire to give clothing ease and comfort, elements that we have come to expect. Finally, the evening coat of Japanese kimono fabric is representative of the elegant simplicity of line now considered essential in fashion design.

Elsa Schiaparelli
Theater Suit

This theater suit by Elsa Schiaparelli is dated December 22, 1937, and represents the Surrealist influence in fashion for which the designer was justly famous. Also apparent in this costume is Schiaparelli's imaginative use of new synthetic materials such as rayon and plastic, and of applied decoration, which on this jacket combines metallic, glass, and plastic elements. Wide plastic zippers, a recent development, were also used decoratively at each wrist, another remarkably inventive touch. Because Schiaparelli was so much a part of the artistic milieu, artists often worked with her. Salvador Dali, for example, designed textiles as well as accessories for the designer.

113 *Painting*, 1927
Joan Miró
Spanish, 1893–1984
Tempera and oil on canvas;
28¾ x 36¼ in. (73 x 92.1 cm.)
Gift of Pierre Matisse, in memory
of Pierre Loeb, 1984 (1984.207)

JOAN MIRO
Painting

In the 1920s, as a result of their awareness of the work of Sigmund Freud, many artists began to explore their unconscious. These artists, called Surrealists, did not attempt to represent ordinary reality, but rather to depict intense subjective and imaginary experiences. Although they were united in name, the Surrealists, whose ranks included poets and writers, did not constitute a unified stylistic movement. The ways in which different artists explored and opened up their psyches varied widely and included both abstract and representational art in many mediums.

Spanish Surrealist Joan Miró explored the world of dreams in an art comprising shapes and forms that in their radical simplicity and seemingly unsophisticated execution remind us of hieroglyphs or a child's squiggles. However, these pictures, such as *Painting*, of 1927, are not literal representations of dreams; Miró consciously composed his work so it appears to have been created in a dreamlike state. The shapes in this painting are asymmetrical and flat; they were not painstakingly drawn and modeled but were placed onto the canvas as they first took shape in the artist's mind. Most of them are open: There is nothing to stop the line at the bottom; by its very nature the spiral has no beginning or end, and two of the lines forming the triangle at the top seem to want to continue. With *Painting*, we feel that we are at the very beginning of art, before the intervention of the conscious mind, before the artist begins to alter, adjust, balance, and build the composition. Yet far from unfinished, *Painting* is a complete—and very beautiful—work of art.

114 *Madeleine Castaing*, 1928
Chaim Soutine
French (b. Lithuania), 1893–1943
Oil on canvas; 39⅜ x 28⅞ in.
(100 x 73.3 cm.) Bequest of
Miss Adelaide Milton de Groot
(1876–1967), 1967 (67.187.107)

115 *Large Sunflowers I*, 1928
Emil Nolde
German, 1867–1956
Oil on wood; 30½ x 36½ in.
(77.5 x 92.7 cm.) Bequest of
Walter J. Reinemann, 1970
(1970.213)

CHAIM SOUTINE
Madeleine Castaing

Like Chagall, Chaim Soutine was a Russian Jew who immigrated to Paris and joined the vanguard in art. For a time he lived in a complex of studios called *La Ruche* (The Beehive), where Chagall, Modigliani, and several other artists also lived. Although he restricted himself to conventional subject matter—landscapes, still lifes, and portraits—Soutine's works are highly charged, conveying with an almost palpable force a sense of tragedy, vulnerability, and sometimes ecstasy. This portrait depicts Madeleine Castaing, who with her husband, Marcellin, was a friend, supporter, and early collector of Soutine's. Madame Castaing's facial features appear somehow unstable, or slightly displaced; her sad eyes and nervous hands convey a sense of frailty. There is in this portrait little conventional drawing, contour lines, or tonal shading. Rather, the figure of Madame Castaing is created with an accumulation of thick strokes of color. Soutine clearly reveled in handling oil paint, which he has applied broadly, freely, and heavily.

EMIL NOLDE
Large Sunflowers I

The German painter Emil Nolde identified closely with his native land, Schleswig-Holstein, near the German–Danish border, and with the peasants around whom he lived all his life. In fact, in 1902 he changed his name from Emil Hansen to Emil Nolde in honor of the town of Nolde, where he was born.

Nolde loved flowers and began painting them early in the century. In the bleak countryside in which he lived he planted a lush flowerbed that was the source for many of the oils and watercolors of the last thirty years of his life. (Though forbidden to paint by the Nazis, Nolde continued to produce his flowers in watercolor during the 1930s.) In *Large Sunflowers I*, Nolde has orchestrated intense yellow, green, and red, applied with heavy, direct brushstrokes, into a composition of great beauty. The flowers are isolated from their environment, increasing the visual impact of the color. They are in full bloom—large, open, and sensuous. The thick impasto, engulfing blossoms, and large, heavy leaves endow the work with an almost palpable energy and life, and convey Nolde's feel for the powerful force of nature.

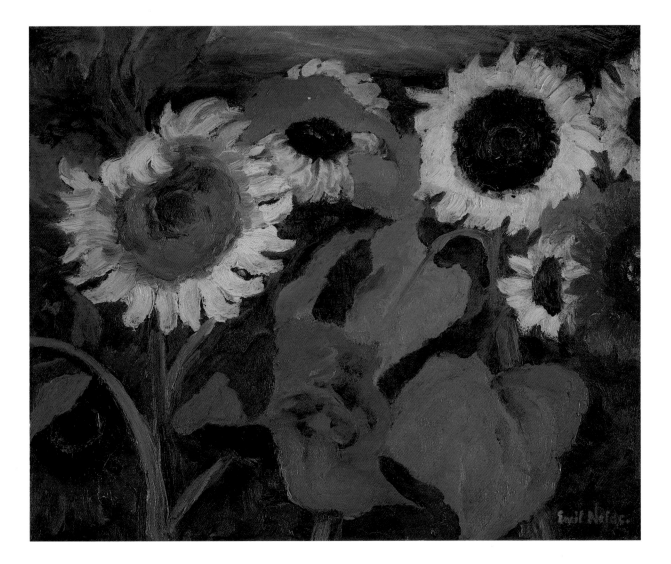

116 *Street Scene*, ca. 1922
George Grosz
German, 1893–1958
Lithograph; 15¼ x 10⅜ in.
(38.7 x 26.4 cm.)
Bequest of Scofield Thayer,
1982 (1984.1203.193 (4))

GEORGE GROSZ
Street Scene

World War I had a profound impact on advanced art. The Berlin Dada artists, for example, believed that if civilization could lead to the unthinkable violence and destruction of the war, then artists must turn away from that civilization and point out its evil and corruption through their work. The German artist George Grosz was an active member of the Berlin Dada group in 1917–20, and for long after the members disbanded his works pointed to the moral disintegration of German culture, expressing what he termed his "profound disgust with life." Though the Prussian military class and powerful industrialists were his particular targets, no one was exempt from Grosz's ironic, biting satire. This lithograph, made around 1922 and published in Weimar in 1923, is inhabited by the coarse, boorish figures typical of much of the artist's work. Emblems of a corrupt society, they move along the crowded street, itself a confused jumble of buildings, with complete disregard for one another, each absorbed in his or her own thoughts.

AUGUST SANDER
The Painter Anton Räderscheidt

During the 1920s, August Sander developed a new sort of photographic portraiture—confrontational and analytical—which paralleled the emergence in Germany of the "New Objectivity," a realist style of painting. Working as a professional portrait photographer, he sought out members of the various trades, professions, and classes, whose portraits he would organize into portfolios with the view of creating a grand sociological survey—never realized—entitled *Men of the Twentieth Century*. In his quest to describe German society at that troubled moment in its history, Sander proceeded with a strong sense of order and method. All of the subjects represented, treated as archetypes, were separated into forty-five specific categories within several general classes. Despite the disparate types of characters represented, the work is unified by Sander's consistent style: The sitters were generally viewed in full or three-quarter length and photographed in evenly distributed daylight with the camera placed on a tripod set at eye level.

The subject of this photograph, the painter Anton Räderscheidt, was a close friend of Sander's during the 1920s. Although this picture contains none of the traditional attributes of the artist, it does recall the painter's self-portraits, in which he typically stands dressed in his black suit and bowler hat in an empty landscape. Standing uncomfortably in the foreground of this bleak cityscape, the figure also mirrors the general alienation of many other avant-garde painters in Cologne.

117 *The Painter Anton Räderscheidt*
August Sander
German, 1876–1964
Gelatin silver print, 1976;
11⅝ x 8½ in. (29.4 x 21.5 cm.)
Warner Communications Inc. Purchase
Fund, 1979 (1979.521.4)

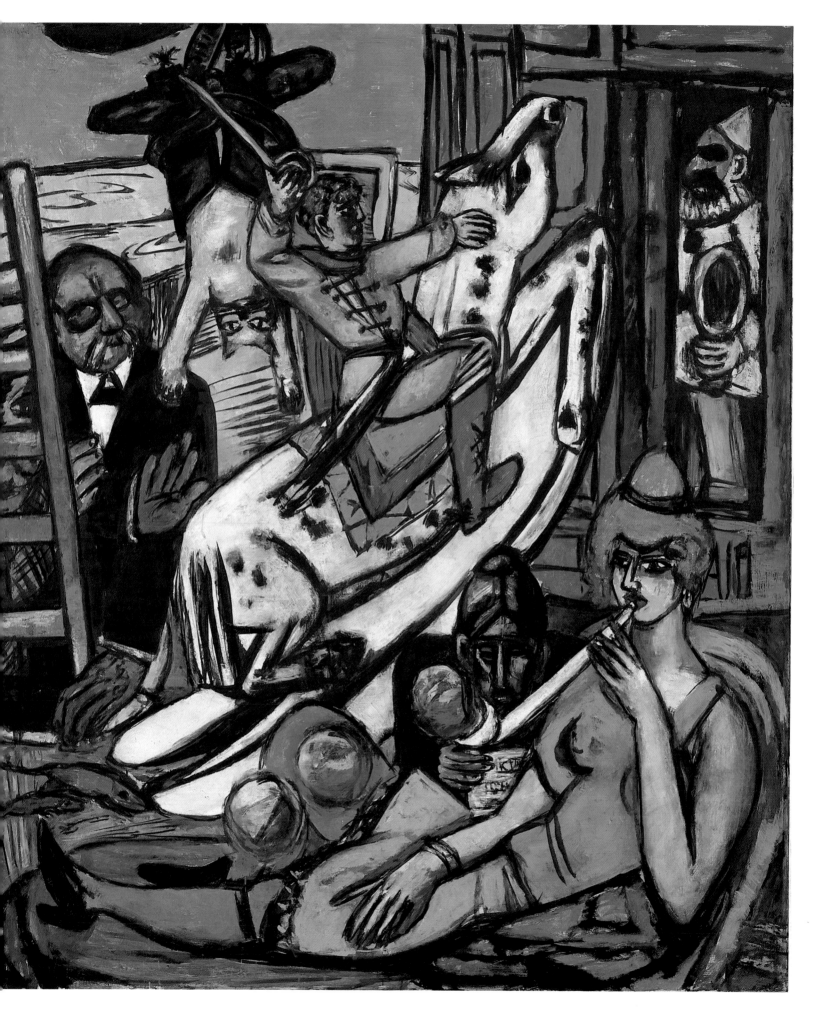

MAX BECKMANN
The Beginning

Born in Leipzig in 1884, Max Beckmann was one of Germany's leading Expressionist painters. He taught in Frankfurt until 1933, when he was dismissed by the Nazi regime as a "degenerate artist." In 1937 the Nazi officials in charge of culture assembled two shows: one consisted of Nazi-approved art, the other, of a group of 730 works known as "degenerate art" and held up for public ridicule. Among the latter were some eight or nine paintings by Beckmann. In the wake of these exhibitions, Beckmann left for Holland, where he lived in hiding while continuing to paint throughout the war. In 1947 he immigrated to America, where he spent the last three years of his life.

The Beginning is the eighth of nine triptychs Beckmann produced during the last two decades of his life—between 1932 and 1950. By using the triptych form, he makes reference to Late Gothic altarpieces that recorded the lives of martyrs and saints.

The Beginning was mentioned at an early stage in its development in Beckmann's diary (December 2, 1948), where it was referred to as *L'Enfance* (childhood). The three panels are autobiographical, dwelling on Beckmann's childhood. Memories of schooldays in Germany in the right panel are balanced by the heavenly vision in the left. In the central panel, childhood memories and the dream world intermingle. In the spring of 1949, Beckmann wrote in his diary of having finished *The Beginning* with "marvelous success."

118 The Beginning, 1949
Max Beckmann
German, 1884–1950
Oil on canvas;
Left and right panels: 65 x 33¼ in. (165.1 x 84.5 cm.),
Center panel: 69 x 59 in. (175.3 x 149.9 cm.)
Bequest of Miss Adelaide Milton de Groot (1876–1967),
1967 (67.187.53abc)

Opposite: center panel

MAN RAY
Meret Oppenheim at the Printing Wheel

In 1921 Man Ray moved from New York to Paris, where he spent most of his adult life as a key member of the avant-garde. As an artist he was highly inventive and diverse, not only in his choice of mediums—painting, sculpture, film, and photography—but also in the range of techniques he employed and the subjects he treated with each of these. In addition to conventional photographs, he made "Rayo-grams," or cameraless pictures, by placing objects directly on the photographic paper prior to its exposure, and solar-ized photographs, in which the tones are partially reversed by exposing the half-developed negative to light. He took portraits of the leading cultural figures in Paris, as well as fashion photographs, pictures of Dada and Surrealist ob-

jects, nudes, and abstractions. In much of his work, Man Ray used photography less for its inherent realism than as a vehicle for the expression of his inner thoughts and fantasies.

This picture represents the artist Meret Oppenheim, one of Man Ray's Surrealist colleagues and friends, standing by the etching press of the artist Louis Marcoussis. The unex-pected juxtaposition of the nude—emblem of sexuality and traditional artistic subject matter—with a machine—sign of man's intelligence and industry—creates an enigmatic and wryly disturbing image. The importance of the female nude as a subject for the Surrealists is pointedly suggested by the ink on Oppenheim's arm; she has literally become the tem-plate or text for the artist's press.

119 *Meret Oppenheim at the Printing Wheel*, 1935
Man Ray
American (worked in France), 1890–1976
Gelatin-silver print; 4¹³⁄₁₆ x 7 in. (12.3 x 17.7 cm.)
Purchase, The Horace W. Goldsmith Foundation
Gift, 1986 (1986.1015)

120 *Nature Morte I
(Mondrian's Pipe and Glasses)*, 1926
André Kertész
American (b. Hungary), 1894–1985
Gelatin-silver print;
6³⁄₁₆ x 7³⁄₁₆ in. (15.7 x 18.2 cm.)
Warner Communications Inc. Purchase
Fund, 1977 (1977.501.1)

ANDRE KERTESZ

Nature Morte I (Mondrian's Pipe and Glasses)

Escaping family pressure to remain in Budapest as a clerk on the stock exchange, André Kertész arrived in Paris in 1925. There he found a studio in Montparnasse and became a habitué of the Café Dome, a cosmopolitan gathering place for journalists and artists, among them another Hungarian refugee, Brassaï (see Plate 123).

This picture is one of a series Kertész took of Piet Mondrian's studio and living quarters. Although Kertész knew Mondrian from the Dome, he was unfamiliar with his paintings. He understood them as soon as he saw them, however: "I went to his studio and instinctively tried to capture in my photographs the spirit of his paintings. He simplified, simplified, simplified."

Nature Morte I (Mondrian's Pipe and Glasses), like Mondrian's paintings of the period, is deceptively simple. The manifestly ordinary objects, comprising elemental geometric forms, are placed in such careful relationship to both the frame and the table that they lose any connotations of the artist's daily experience and become emblems of his artistic and contemplative powers.

121 Francis Bacon, 1963
Bill Brandt
British (b. Germany), 1904–83
Gelatin-silver print;
13⁷⁄₁₆ x 11⁷⁄₁₆ in. (34 x 29.2 cm.)
Warner Communications Inc.
Purchase Fund, 1978 (1978.535)

BILL BRANDT
Francis Bacon

The preeminent British photographer of this century, Bill Brandt was born in Hamburg and lived in Switzerland and Austria before moving in the late Twenties to Paris, where he became an apprentice to Man Ray (see Plate 119). After settling in London in the Thirties, Brandt worked virtually alone, with only distant ties to Modernist photography in Europe and America. In his solitude he developed a vision which was at first relatively realistic but grew increasingly dramatic and personally expressive with the years.

Brandt photographed many of Great Britain's leading artistic and literary figures. This portrait of the painter Francis Bacon was taken at Primrose Hill in London's Camden Town. Using an extremely wide-angle lens, Brandt photographed Bacon close up. Because of the camera's optical distortions, the empty road rushes away and the lamppost leans eerily, while the painter gazes past us as if fleeing this haunted place.

LASZLO MOHOLY-NAGY
Lucia

Moholy-Nagy worked in many mediums, like Man Ray (see Plate 119). In 1921 he, too, invented a technique of camera-less photography, analogous to Man Ray's Rayographs, which he called "photograms." This process, in which objects were laid directly on light-sensitive photographic paper before its exposure, produces pictures that trace objects in light and shadow without really describing their surfaces.

The photograph produced here is a negative print of his wife Lucia's face, in which her normal appearance is tonally reversed. The shoulder and face were actually struck by a triangular patch of light over the nose and right eye. In the negative print this light area reads as a deep shadow, while the balance of the woman's face, which was actually in shadow, reads here as though it were bathed in a ghostly light. This photograph and others in a series made just prior to their publication in 1930 are striking revelations both of photography's extraordinary vitality as a creative medium, and of Moholy's seminal importance in making that new truth evident.

122 *Lucia*, 1924–28
László Moholy-Nagy
American (b. Hungary), 1895–1946
Gelatin silver print;
9¼ x 6⅞ in. (23.4 x 17.5 cm.)
Warner Communications Inc. Purchase
Fund, 1981 (1981.1163)

BRASSAÏ
Couple d'amoureux

Brassaï arrived in Paris from Romania in 1924. He later claimed, "I was not a photographer then and had no intention of becoming one.... I looked down upon photography and almost despised it." Then he met André Kertész (see Plate 120), who became his mentor.

Brassaï, however, eschewed the humanistic naturalism common to the work of Kertész and other contemporary photographers in favor of artifice and illusion. In *Couple d'amoureux dans un petit café, quartier Italie*, his compositional skill is evident in the way he framed his subjects, who sit in the corner booth of a small café, smoking cigarettes, ready to kiss, each lover's gaze reflected in a mirror. Such formal elegance, rather than the harsh realities of photographic realism, was of supreme importance to Brassaï. Indeed, this and many of Brassaï's photographs were staged, leading to a complicity between photographer and photographed that adds to the picture's sophistication and playfulness.

HENRI CARTIER-BRESSON
Banks of the River Marne

In Henri Cartier-Bresson's photographs, which are unstaged pictures of ordinary people and events, a piece of everyday life is transformed into art by virtue of being captured by the photographer's camera. His pictures fix a fleeting moment and show us its significance or mystery.

The photograph reproduced here shows two couples picnicking on the banks of the Marne River. The subject of picnickers has been popular among artists for centuries, from eighteenth-century pictures of idealized figures to Impressionist pictures of bourgeois boating parties on riverbanks. Here, despite the ordinary, even awkward-looking men and women, Cartier-Bresson's picture is poised, balanced, and witty: The sleek, graceful boat floats lightly on the water in marked contrast to the heavy bodies it carried to the site, the hands of the women are caught in surprisingly delicate gestures, and the slender forks poised on the dishes add a final note of grace and delicacy.

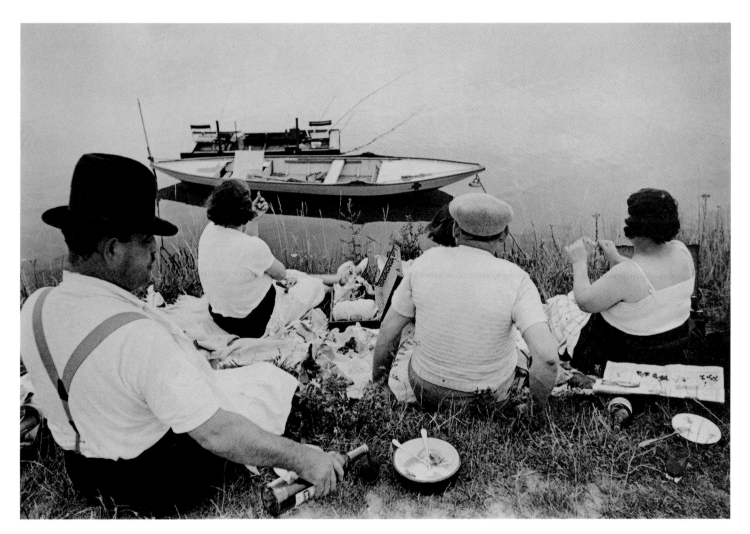

123 Couple d'amoureux dans un petit café, quartier Italie, 1932
Brassaï (Gyula Halász)
French (b. Transylvania), 1899–1984
Gelatin silver print, ca. 1970;
11³⁄₁₆ x 8⅝ in. (28.3 x 22.7 cm.)
Warner Communications Inc. Purchase Fund, 1980
(1980.1023.5)

124 Banks of the River Marne, 1938
Henri Cartier-Bresson
French, b. 1908
Gelatin silver print, before 1950;
9¾ x 11½ in. (24.7 x 37 cm.) Warner Communications
Inc. Purchase Fund and Gift of Creilly Pollack,
in memory of Peter Pollack, 1981 (1981.1152.1)

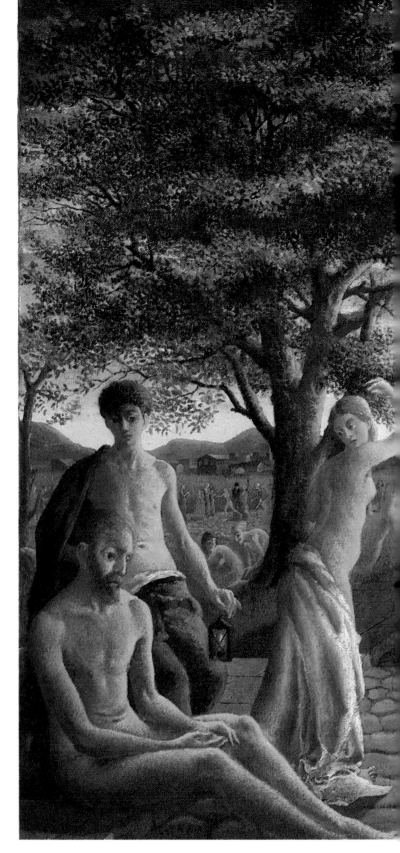

PAUL DELVAUX
The Ancient City

Paul Delvaux is a Belgian Surrealist who creates mythic fantasies out of his dream life. In *The Ancient City*, classical-looking figures inhabit a town whose entry is strewn with boulders, and whose architecture is enigmatic. The street and adjacent building seem to recall a setting from ancient Roman times—perhaps the city of Pompeii or Ostia Antica. The supple, full-bosomed women in the foreground stare with eyes wide open, but with vacant, placid expressions. Two men at the left are equally preoccupied and take no notice of the women. The older, bearded man is seated nude on the stoop, while behind him a slender youth, partially robed, holds a small, lit lantern. The figures in the background are engaged in more active, though no less ambiguous, interaction. Although the message of this allegory is unclear, Delvaux seems to touch on themes of unrequited love, erotic fantasy, youth and old age, and, ultimately, life and death.

OVERLEAF:

BALTHUS *(Pages 150–51)*
The Mountain

The scene in this picture by Balthus takes place on an imaginary plateau near the top of the Niederhorn in the Bernese Oberland. The sharp outlines of the figures and landscape elements evoke the clear atmosphere of high altitudes, in which forms are accentuated and magnified. The strong, simplified forms show the influence of Piero della Francesca and Georges Seurat, while the posture of the pipe-smoking guide recalls that of Courbet's well-known stone-breaker. Balthus based the reclining woman on Poussin's *Echo and Narcissus*.

Although the scene is serene, the relationship among the three foreground figures and the man in the red jacket in

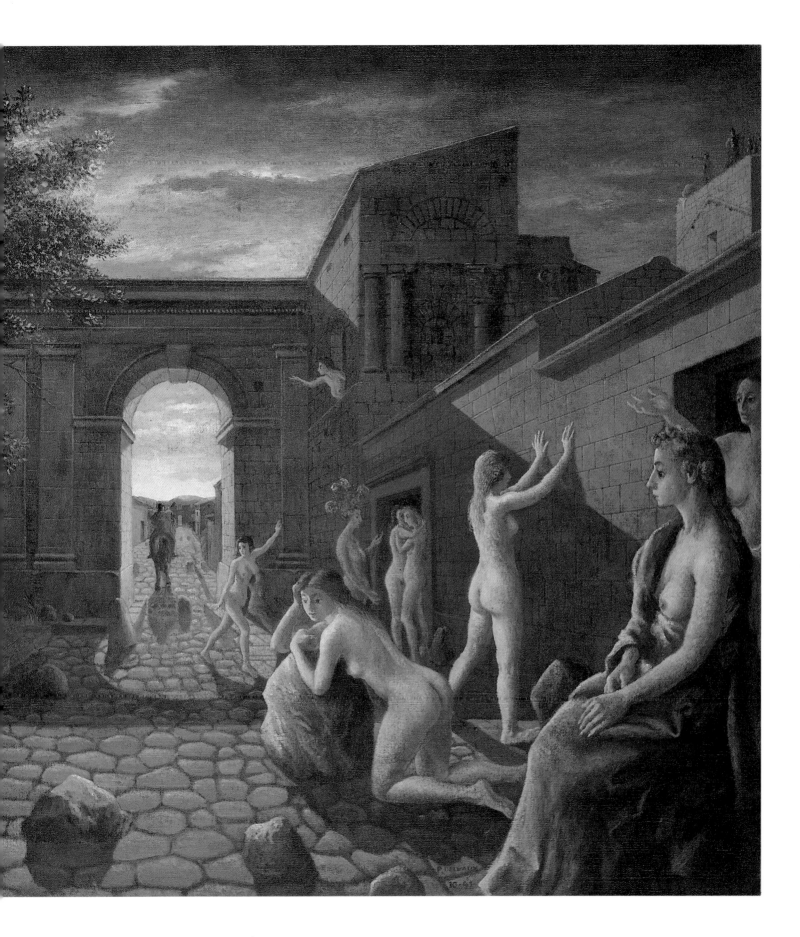

the middle ground is enigmatic. Though they are physically close, each of the three foreground figures is lost in private thought or dreams, while the man in the middle distance seems to be staring at them. And though the standing woman (modeled after the artist's wife) is stretching her arms, all four of these figures seem frozen.

126 The Mountain, 1937
Balthus (Balthasar Klossowski de Rola)
French, b. 1908
Oil on canvas; 98 x 144 in. (248.9 x 365.8 cm.)
Purchase, Gifts of Mr. and Mrs. Nate B. Spingold
and Nathan Cummings, Rogers Fund and The
Alfred N. Punnett Endowment Fund, by exchange,
and Harris Brisbane Dick Fund, 1982 (1982.530)

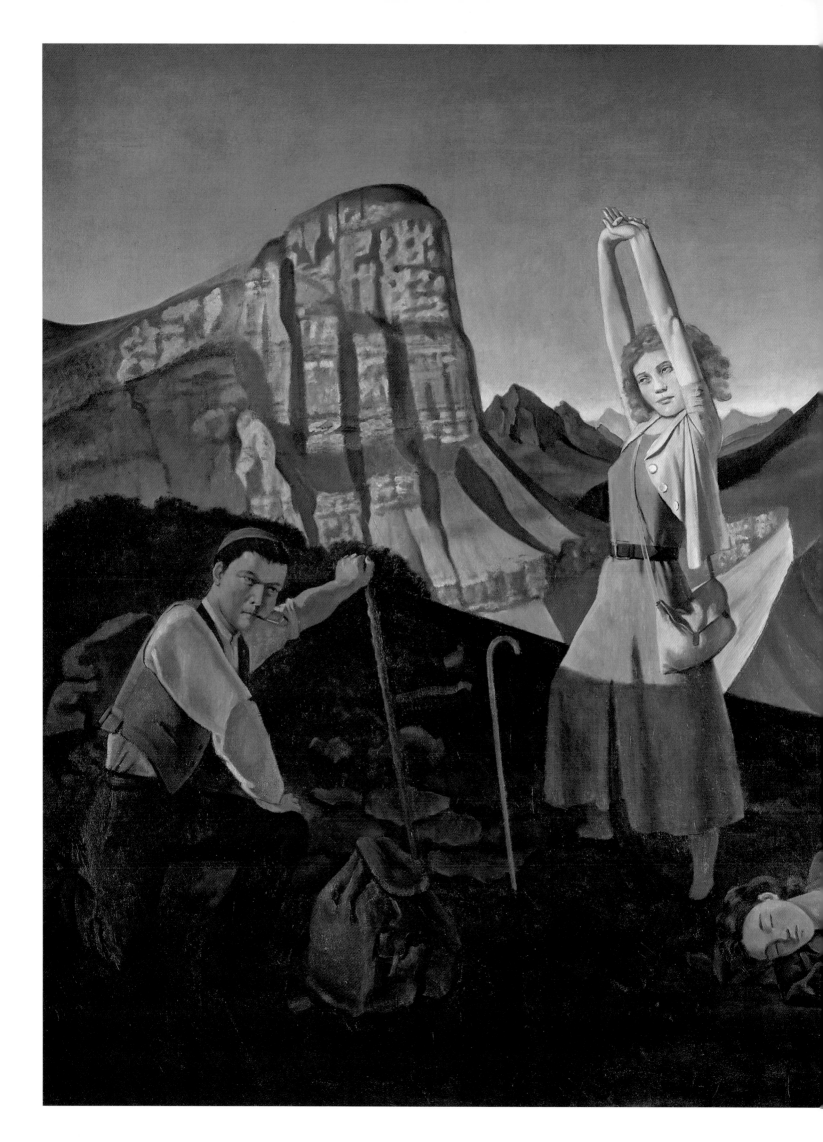

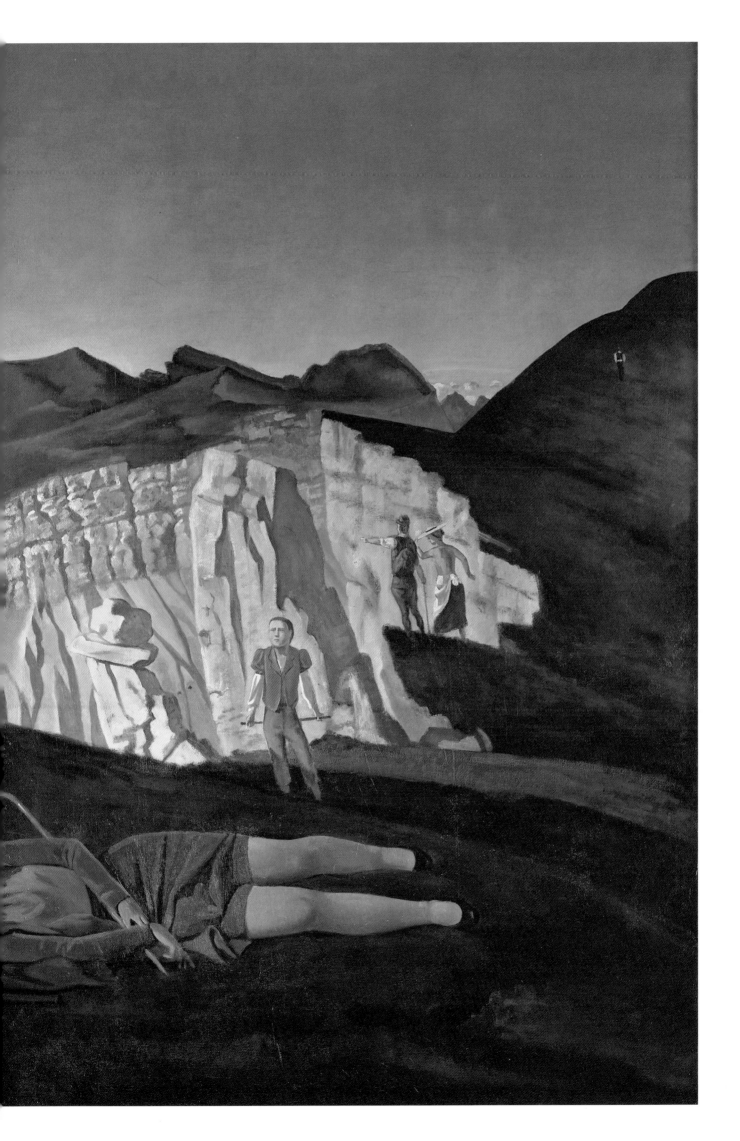

127 *Mrs. Atkinson*, 1900
Gwen John
British, 1876–1939
Oil on board; 12 x 12¼ in.
(30.5 x 31.1 cm.) Bequest of
Mary Cushing Fosburgh,
1978 (1979.135.27)

128 *Jeanne Daurment (The Cigarette)*, 1906
Walter Sickert
British, 1860–1942
Oil on canvas; 20 x 16 in. (50.8 x 40.6 cm.)
Bequest of Mary Cushing Fosburgh, 1978
(1979.135.17)

FOUR BRITISH PAINTERS

English artists of the twentieth century, particularly those of
its early decades, have not been as closely unified by stylistic
movements as have artists in other countries. Yet one
element—a strong emphasis on draftsmanship—is consis-
tently characteristic of British painting; accordingly, repre-
sentation has remained an important aspect of British art
throughout the century.

Gwen John (Plate 127) is best known for her portraits of
single figures. The strong character of the elderly woman
depicted here is expressed through her subtly modeled face
and hands. John's equally sensitive handling of color and
tone enhances our sense of the sitter's quiet dignity.

As an apprentice to Whistler and a close friend of Degas's,
Walter Sickert (Plate 128) was knowledgeable about the ad-
vanced art of the late nineteenth century. He chose as his
subjects not the refined, drawing-room life of London soci-
ety, but life as it was lived beyond the niceties of the tea
table, and his work included pictures of members of all
classes. In this portrait of Jeanne Daurment, a milliner, there
is no recognizable background; Sickert has chosen a straight-
forward, bust-length presentation of the figure in profile,
holding a cigarette. Though Jeanne Daurment has not been
idealized, Sickert has clearly delighted in his paint, which is
laid down in broken brushstrokes.

From 1913 to 1919, Duncan Grant (Plate 129) worked at
the Omega Workshops, a London organization dedicated
to raising the standards of the decorative arts in England.
There the artist showed great aptitude for devising new and

129 *The Coffee Pot*, ca. 1916
Duncan Grant
British, 1885–1978
Oil on canvas; 24 x 20 in.
(61 x 50.8 cm.) Purchase,
Mr. and Mrs. Milton Petrie
Gift, 1981 (1981.197)

130 *King's Cookham Rise*, 1947
Stanley Spencer
British, 1891–1959
Oil on canvas; 20 x 30 in.
(50.8 x 76.2 cm.) Purchase,
Lila Acheson Wallace Gift,
1981 (1981.193)

seductive harmonies of color. Grant's paintings are also marked by a decorative charm, yet they obtain subtleties of form and color belonging to pictorial rather than decorative design. In *The Coffee Pot*, Grant's sense of color and design are manifest. Like Chardin, whom he admired, Grant was able to endow the simplest objects of everyday life with great dignity and refinement.

Stanley Spencer (Plate 130) is perhaps best known for his paintings of religious scenes. Many of these take place in Cookham, the artist's native village on the banks of the Thames. In 1945 he moved to Cookham Rise, near the old village center, where he painted this view of a cottage garden. Spencer has left nothing out of his intensely detailed picture. We know how many panes of glass are in the door in the distance, and we see the garden proprietor peering through a fence in the background; even the plants are identified, and almost every leaf is painted individually. Indeed, the detail of *King's Cookham Rise* demonstrates not only the strong British tie to representational painting, but also the loving attention Spencer gave to his village.

131 Column of Peace, 1954
Antoine Pevsner
French (b. Russia), 1886–1962
Bronze; H. 53 in. (134.6 cm.)
Gift of Alex Hillman Family
Foundation, in memory of
Richard Alan Hillman, 1981
(1981.326)

132 Annette VI, 1962
Alberto Giacometti
Swiss, 1901–66
Bronze; H. 25⅞ in. (65.7 cm.)
Jointly owned by The
Metropolitan Museum of Art and
Mr. and Mrs. Joseph Zimmerman,
1981 (1981.491)

ANTOINE PEVSNER

Column of Peace

For several years before the Russian Revolution, brothers Naum Gabo and Antoine Pevsner lived in Europe, where they witnessed the advances of modern art. Three years after their return to Russia in 1917, they published a broadside in which they proclaimed that art should be abstract rather than representational, that it should interact with the surrounding space, and that it should include the materials of modern technology. Because of this emphasis on the materials of the modern world and on our perceptions as they have been shaped by that world, they called their publication the *Realist Manifesto*.

Thirty-four years after the manifesto appeared in Moscow, Pevsner executed the *Column of Peace*. While the work is made of bronze, an ancient material, it is informed by the other principles of the *Realist Manifesto*. Ridges made in the bronze reflect light, producing highlights and shadows that articulate the forms and planes. The graceful extension of four turned columns creates a strong sense of upward movement and growth. From one view, the rods open out like a flower, exploring the play between solid and void; from another, the piece retracts into a compact, thrusting, vertical mass.

pelling psychological and physical presence. Here Giacometti has emphasized the sitter's eyes, traditionally believed to be windows onto the soul. On one occasion the artist remarked that if he could only reproduce an eye successfully, he would have the whole sculpture.

HENRY MOORE
Family Group

By 1940, Henry Moore was an internationally acclaimed sculptor. In 1944–45, under commission from a Cambridge college, he completed a series of fourteen sketch-models for sculptures of family groups. Most of the models were made of terra-cotta; the *Family Group* was one of the few to be executed in bronze. Its figures, unlike Moore's biomorphic forms of the 1930s, are readily recognizable as a mother, father, and two children. They succeed, as Moore wished, in conveying "human psychological content" with the "greatest directness and intensity." Modeled simply, like the primitive art in which Moore found inspiration, and reaching a height of only six inches, these figures are nonetheless powerful and convincing. As Moore himself said, "A small carving only a few inches in height can give the feeling of huge size and monumental grandeur because the vision behind it is big."

133 Family Group, 1944
Henry Moore
British, 1898–1986
Bronze; H. 5⅞ in. (14.9 cm.)
Anonymous Gift, in honor of
Alfred H. Barr, Jr., 1981
(1981.488.4)

ALBERTO GIACOMETTI
Annette VI

During the early 1930s, Alberto Giacometti created abstract and figurative sculptures inspired by Surrealism. After 1935, he produced figurative works exclusively, and during the following decade the artist's unique vision of reality found expression in the exaggeratedly elongated figures that typify his subsequent oeuvre. The figures executed during the last ten years of Giacometti's life, however, are more substantially rendered. *Annette VI* is the largest of ten portrait busts modeled after his wife that the artist created between 1960 and 1964. The pieces in the series, some of which are painted, are remarkable for their steadfast gaze and com-

135 Mount Fuji and Flowers, 1972
David Hockney
British, b. 1937
Acrylic on canvas; 60 x 48 in.
(152.4 x 121.9 cm.) Purchase,
Mrs. Arthur Hays Sulzberger
Gift, 1972 (1972.128)

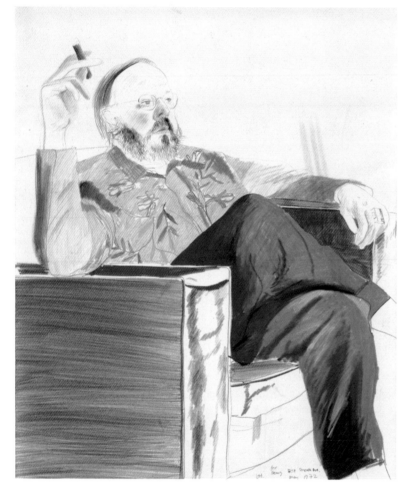

134 Henry, Seventh Avenue, 1972
David Hockney
British, b. 1937
Crayon on paper; 17 x 14 in.
(43.2 x 35.6 cm.)
Gift of Henry Geldzahler, 1979
(1979.546)

DAVID HOCKNEY

Henry, Seventh Avenue and *Mount Fuji and Flowers*

In the early 1960s, Pop Art found ready followers in England, where figurative art remained strong despite international trends toward abstraction. Painter, printmaker, draftsman, photographer, and set designer David Hockney was a member of this group, and he has remained a leading figurative artist of international stature. Apart from his innovative theater designs, Hockney's subjects are autobiographical, depicting friends and travel experiences, particularly from his lengthy and numerous stays in the United States, which he first visited in 1961.

Henry, Seventh Avenue (Plate 134) depicts Henry Geldzahler, Curator of Twentieth Century Art at The Metropolitan Museum of Art from 1967 to 1977 and one of Hockney's earliest and most influential champions in this country. Hockney's drawing here is, as always, extremely sensitive. The weight of the sitter and the feel of the large, soft chair in which he sits are made palpable with the simplest lines and shading. The contrast between Geldzahler's deadpan expression and the more animated flowers on his shirt adds a witty note.

Mount Fuji and Flowers (Plate 135) was painted in London after a two-week visit to Japan. Disappointed by the commercialism of the country, Hockney nevertheless painted a scene of classical beauty, perhaps reflecting the cliché image of unspoiled nature that the artist had expected to find. The images derive from a flower-arrangement manual and a postcard of Mount Fuji, rather than from direct observation. We can appreciate this representational picture for the same qualities we appreciate in many abstract paintings: beautiful color, pleasing forms, and balanced composition.

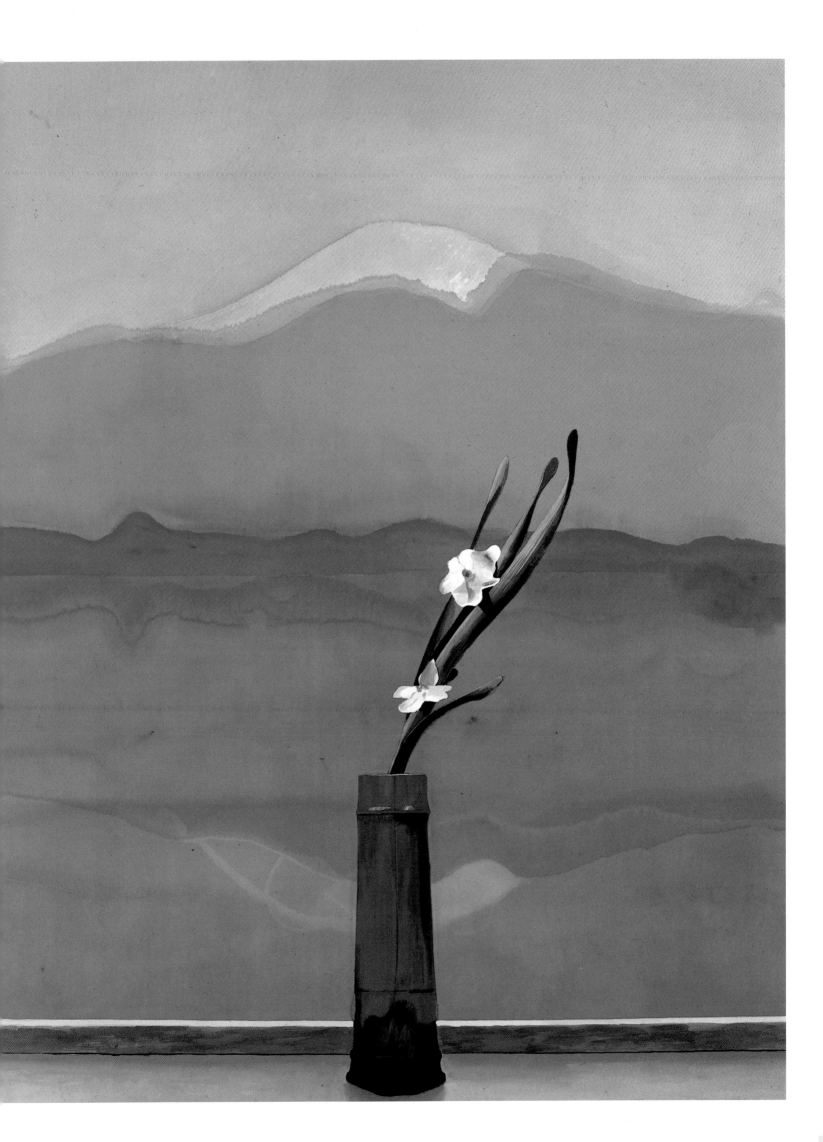

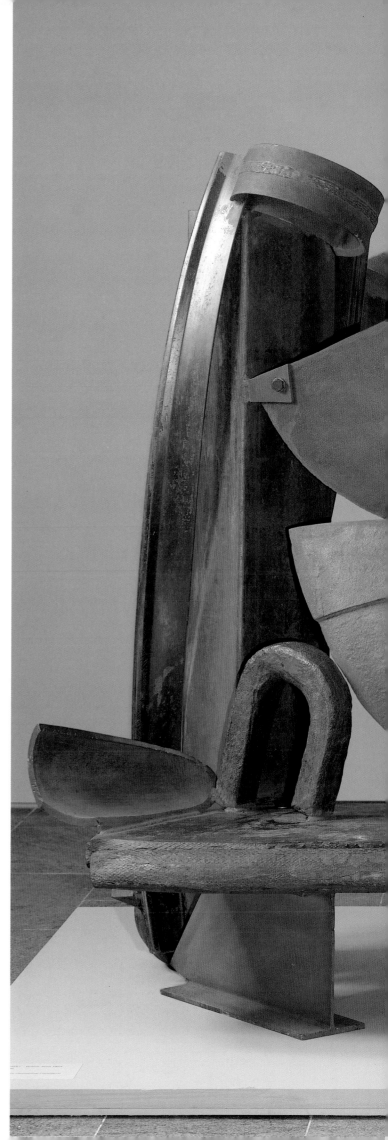

136 Odalisque, 1984
Anthony Caro
British, b. 1924
Steel; W. 97 in. (246.4 cm.)
Gift of GFI/Knoll International
Foundation, 1984 (1984.328a–d)

ANTHONY CARO
Odalisque

Odalisque represents the direction British sculptor Anthony Caro took in the late 1970s, away from a linear, open sculpture of horizontal orientation, toward sculpture of more concentrated, solid forms that emphasize volume and weight. *Odalisque* is composed of several massive pieces of rusted steel, some of which are actual parts of maritime buoys and chains that have been cut apart and joined to other abstract elements. With these, Caro has created an elegant dialogue between vertical and horizontal movements, curved and straight lines, and convex and concave forms. Unlike much of Caro's earlier work, which had a single, frontal orientation, this piece can be viewed from both front and back. The front is dominated by rectilinear, inverted forms and sharp, straight edges, the back by large rounded shapes and arcs. The ample forms and voluptuous curves of the sculpture correspond to the image of a sensual harem concubine suggested by the title.

EUROPE

1851 Giuseppe Verdi's *Rigoletto*
1852–70 French Second Empire under Napoleon III
1854–56 Crimean War

a EDOUARD MANET
(French)
Woman with a Parrot

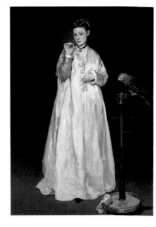

1857 Gustave Flaubert's *Madame Bovary*
1857 Charles Baudelaire's *Fleurs du Mal*
1857 Discovery of Hokusai's sketchbook by Bracquemond
1859 Charles Darwin's *Origin of Species*
1859 Wagner completes *Tristan and Isolde*

1861 Pop. (in millions): Russia, 76; England, 23; Ireland, 6; Italy, 25
1861 Manet awarded honorable mention at Salon for *The Spanish Singer*
1861 Czar Alexander II emancipates Russian serfs
1861 Ivan Turgenev's *Fathers and Sons*
1862 Victor Hugo's *Les Misérables*
1863 Salon de Refuśes, for artists rejected by official Salon

b EDGAR DEGAS
(French)
A Woman with Chrysanthemums

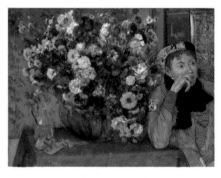

1865 Manet's *Olympia* exhibited at Salon, vehemently attacked
1865–69 Leo Tolstoy's *War and Peace*
1866 Mary Cassatt in Paris
1867 Paris World's Fair; pavilions by Courbet and Manet
1867 Marx's *Das Kapital* published
1867 Monet's *Woman in the Garden* rejected by Salon
1869 Monet and Renoir's *La Grenouillère*

1870 Papal States annexed, Rome becomes capital of united Italy
1870–71 Franco-Prussian War
1871 Paris Commune
1871 William I proclaimed emperor of Germany
1871–72 George Eliot's *Middlemarch*
1872 Friedrich Nietzsche's *Birth of Tragedy*
1874 First Impressionist exhibition, in Paris

UNITED STATES OF AMERICA

1850 California admitted to the Union
1850 Nathaniel Hawthorne's *Scarlet Letter*
1850 Pop. 23 million, including 3 million slaves
1851 Herman Melville's *Moby Dick*
1852 Harriet Beecher Stowe's *Uncle Tom's Cabin*
1854 Henry Thoreau's *Walden*

WINSLOW HOMER
(American)
Prisoners from the Front

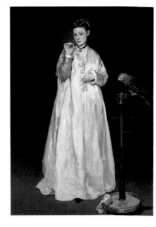

1855 Walt Whitman's *Leaves of Grass*

1860 Abraham Lincoln elected president
1861 Telegraph wires connect New York and San Francisco
1861 Civil War begins

1865 Confederate Army surrenders, Lincoln assassinated
1869 Transcontinental railway completed

1870 Pop. 40 million
1870 The Metropolitan Museum of Art founded in New York
1871 Thomas Eakins's *Max Schmitt in a Single Scull*
1874 Louis Comfort Tiffany opens glass factory

d THOMAS EAKINS
(American)
Max Schmitt in a Single Scull

ASIA, AFRICA, LATIN AMERICA

1851 Chinese pop. 430 million
1854 Admiral Perry negotiates treaty to open Japan to western trade

1857 Sepoy rebellion in India

e MAYURI
(Indian)

1863 Austrian Archduke Maximilian proclaimed emperor of Mexico
1864 Englishman Samuel Baker discovers source of Nile in central Africa

1867 Shogunate abolished in Japan;
 Meiji dynasty restored;
 capital moved from Kyoto to Tokyo
1869 Suez Canal completed

1871 Feudalism abolished in Japan; pop. 33 million

1875 Republican constitution adopted in France
1876 Richard Wagner's *Ring des Nibelungen* first performed
1877 Johannes Brahms's *Symphony in D Major*
1878 Pyotr Tchaikovsky's *Violin Concerto in D*
1879 Henrik Ibsen's *A Doll's House*
1879–80 Fyodor Dostoyevsky's *The Brothers Karamazov*

1880 Auguste Rodin's *The Thinker*
1880 Emile Zola's *Nana*
1882 Manet's *Bar at the Folies-Bergère* exhibited at Salon
1883 Manet dies
1884 Founding of Société des Indépendants by artists rebelling against orthodoxy of official Salon; group holds first exhibition
1884 Les XX, group of vanguard artists, founded in Brussels

1886 Eighth and final Impressionist exhibition
1886 Van Gogh comes to Paris
1886 Seurat exhibits *Sunday Afternoon on the Island of La Grande Jatte* at Impressionist exhibition
1888 William II ("the Kaiser") becomes German emperor
1889 Van Gogh's *Wheat Fields and Cypress Trees*

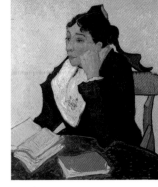

f VINCENT VAN GOGH
(Dutch)
Madame Ginoux

1890 Van Gogh commits suicide
1890 Paul Cézanne's *Card Players*
1891 Gauguin goes to South Seas
1891 Oscar Wilde's *Picture of Dorian Gray*
1891 Claude Monet exhibits series of fifteen *Haystacks*
1891 Trans-Siberian Railroad begun

1895 First collection of poems by William Butler Yeats
1895 Lev Ivanov and Marius Petipa choreograph *Swan Lake*
1895 Sergey Rachmaninoff's *First Symphony*
1897 Henri Rousseau's *Sleeping Gypsy*
1899 Maurice Ravel's *Pavane for a Dead Princess*
1899 Anton Chekhov's *Uncle Vanya*

g PAUL CEZANNE
(French)
The Card Players

1877 Alexander Graham Bell patents telephone
1879 Thomas Alva Edison invents incandescent light

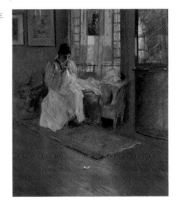

h WILLIAM MERRITT CHASE
(American)
For the Little One

1881 Henry James's *Portrait of a Lady*
1883 Brooklyn Bridge completed
1884 Mark Twain's *Huckleberry Finn*

1886 Indian wars in Southwest end with Apache surrender
1888 George Eastman perfects Kodak hand camera

i JOHN SINGER SARGENT
(American)
Madame X

1898 Spanish-American War begins

1875 Kuang Hsu becomes Chinese emperor
1877 Porfirio Díaz elected president of Mexico
1879 British take control of Khyber Pass

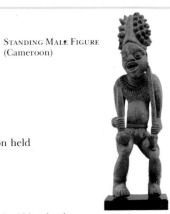

j STANDING MALE FIGURE
(Cameroon)

1881 India's pop. 253 million

1885 Indian National Congress founded
1889–90 Japanese emperor grants constitution; first general election held

1894–95 First Sino-Japanese war

k YOGI COVERLET
(Japanese)

1898 Boxer rebellion in China begins
1899 War in South Africa between British and Boers

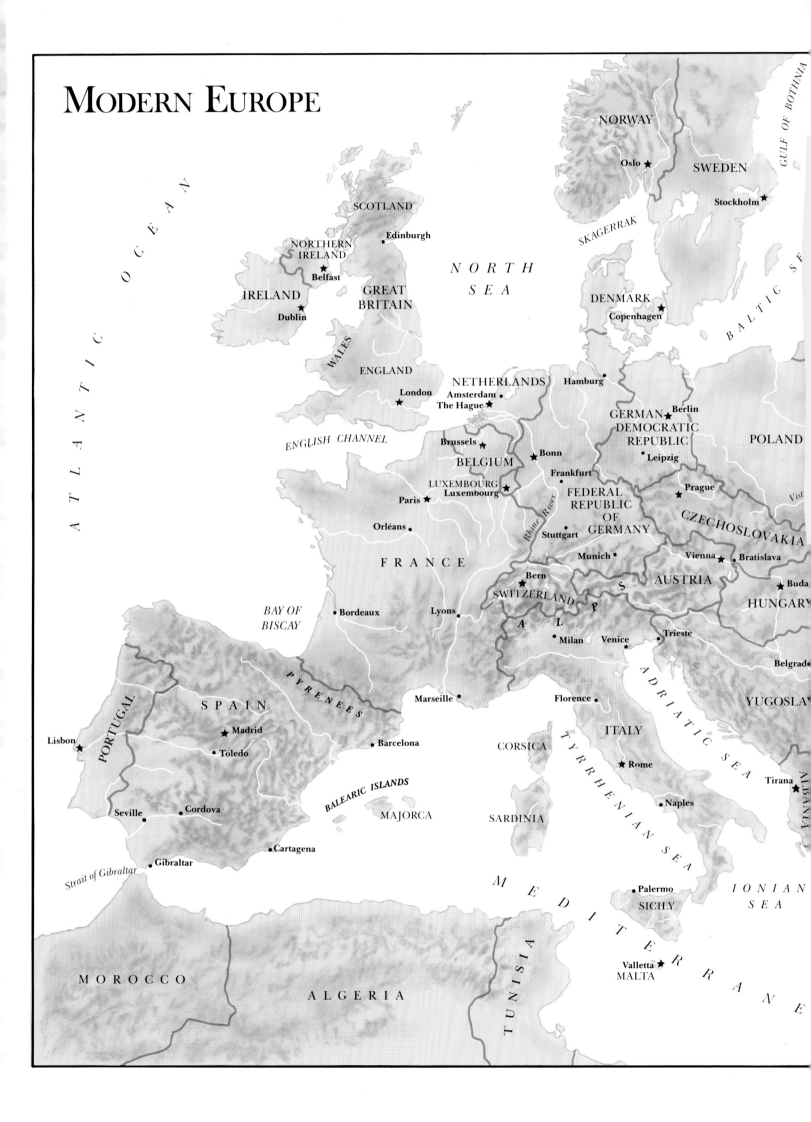

MODERN EUROPE

ATLANTIC OCEAN

NORWAY

Oslo ★

SWEDEN

Stockholm ★

GULF OF BOTHNIA

SKAGERRAK

BALTIC SEA

NORTH SEA

SCOTLAND

Edinburgh •

NORTHERN IRELAND

Belfast ★

IRELAND

Dublin ★

GREAT BRITAIN

WALES

ENGLAND

London ★

ENGLISH CHANNEL

DENMARK

Copenhagen •

Hamburg •

NETHERLANDS

Amsterdam •

The Hague ★

GERMAN DEMOCRATIC REPUBLIC

Berlin ★

Leipzig •

POLAND

Brussels ★

BELGIUM

Bonn •

Frankfurt •

LUXEMBOURG

Luxembourg •

Paris ★

Orléans •

FEDERAL REPUBLIC OF GERMANY

Stuttgart •

Prague ★

CZECHOSLOVAKIA

Vist

FRANCE

Munich •

Vienna ★

Bratislava •

Bonn

Bern ★

SWITZERLAND

A L P S

AUSTRIA

Buda

HUNGARY

BAY OF BISCAY

Bordeaux •

Lyons •

Rhine River

Milan •

Venice •

Trieste •

Belgrade

PORTUGAL

PYRENEES

SPAIN

Madrid ★

Toledo •

Marseille •

Florence •

ADRIATIC SEA

ITALY

YUGOSLA

Lisbon ★

Barcelona •

CORSICA

Rome ★

TYRRHENIAN SEA

Tirana •

ALBANIA

Seville •

Cordova •

BALEARIC ISLANDS

MAJORCA

SARDINIA

Naples •

Cartagena •

Gibraltar •

Strait of Gibraltar

MEDITERRANEAN

Palermo •

SICILY

IONIAN SEA

MOROCCO

ALGERIA

TUNISIA

Valletta ★

MALTA

FRANCE: PRINCIPAL LANDSCAPE SITES

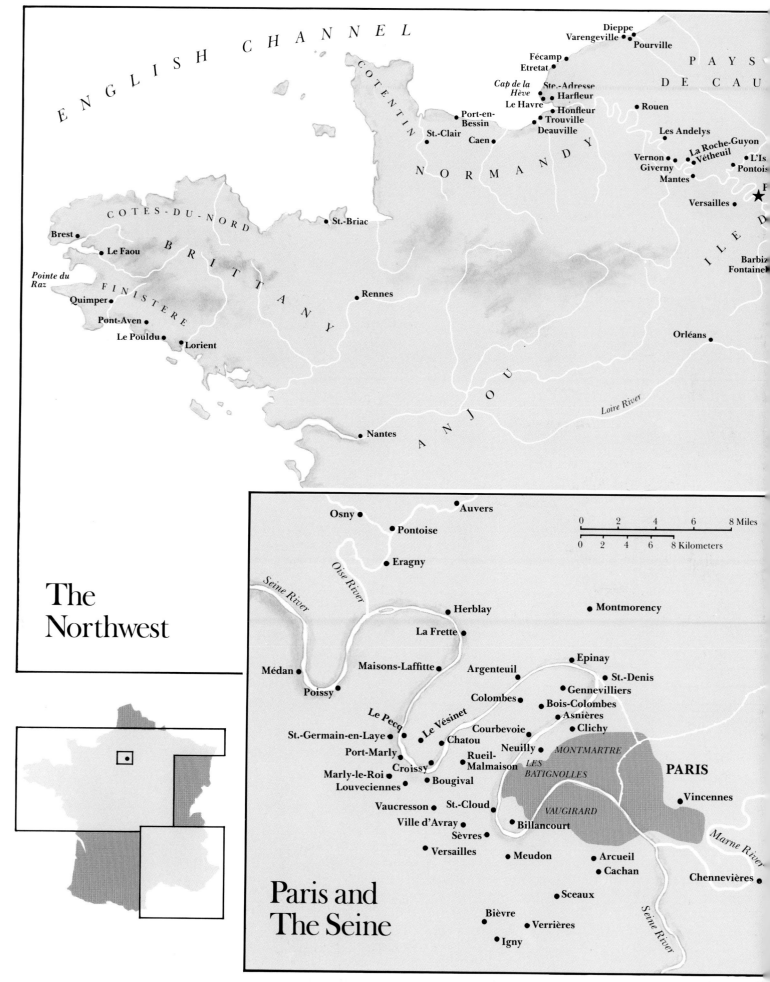

ENGLISH CHANNEL

Dieppe
Varengeville • Pourville
Fécamp
Etretat
Cap de la Hève • Ste.-Adresse
Harfleur
Le Havre • Honfleur
Trouville
Deauville
Port-en-Bessin
St.-Clair
Caen

PAYS DE CAU

Rouen

Les Andelys
La Roche-Guyon
Vernon • Vétheuil • L'Is.
Giverny • Pontois
Mantes

Versailles ★

Barbiz
Fontaine

COTENTIN

NORMANDY

COTES-DU-NORD

St.-Briac

Brest
Le Faou

BRITTANY

Pointe du Raz

FINISTERE

Quimper
Pont-Aven
Le Pouldu • Lorient

Rennes

ANJOU

Orléans

Loire River

Nantes

The Northwest

Paris and The Seine

Osny •
Auvers •
Pontoise •
Eragny •

Seine River
Oise River

Herblay •
Montmorency •
La Frette •

Médan •
Maisons-Laffitte •
Argenteuil •
Epinay •
St.-Denis •
Colombes •
Gennevilliers •
Bois-Colombes •
Poissy •
Le Pecq
Le Vésinet
Asnières •
Clichy •
St.-Germain-en-Laye
Chatou
Courbevoie
Neuilly
MONTMARTRE
Port-Marly
Rueil-Malmaison
LES BATIGNOLLES
PARIS
Croissy
Marly-le-Roi
Bougival
Louveciennes
VAUGIRARD
Vincennes
Vaucresson • St.-Cloud
Ville d'Avray
Billancourt
Sèvres
Meudon •
Arcueil •
Versailles •
Cachan •
Chennevières •
Sceaux •
Bièvre •
Verrières •
Seine River
Igny •

Marne River

0 2 4 6 8 Miles
0 2 4 6 8 Kilometers

1927 Proust completes *Remembrance of Things Past*
1927 Virginia Woolf's *To the Lighthouse*

r BALTHUS
(French)
The Mountain

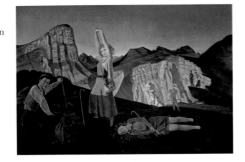

1929–30 Le Corbusier's Villa Savoye
1933 Hitler appointed chancellor of Germany

1935 Nuremberg Laws deprive German Jews of civil rights
1936–39 Spanish Civil War
1937 Picasso's *Guernica*
1939 World War II begins

s PIERRE BONNARD
(French)
The Terrace at Vernon

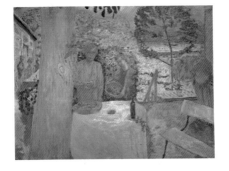

1942 Albert Camus's *The Stranger*
1944 Allied invasion of France ("D-Day")
1944 Jean-Paul Sartre's *No Exit*

t HENRY MOORE
(British)
Family Group

1945 End of World War II in Europe
1949 Ireland (Eire) declares itself a republic
1949 George Orwell's *1984*

1927 Charles Lindbergh's transatlantic flight
1927 Early sound film *The Jazz Singer* released
1928 Charles Demuth's *I Saw the Figure 5 in Gold*
1929 Stock market crash leads to Great Depression
1929 Ernest Hemingway's *A Farewell to Arms*
1929 William Faulkner's *The Sound and the Fury*

u CHARLES DEMUTH
(American)
I Saw the Figure 5 in Gold

1930 Grant Wood's *American Gothic* exhibited
1932 Franklin Roosevelt elected president; launches New Deal

1941 U.S. enters World War II
1942–43 Piet Mondrian's *Broadway Boogie-Woogie*
1943 Thomas Hart Benton's *July Hay*
1943 Jackson Pollock's *Pasiphaë*

v GEORGIA O'KEEFFE
(American)
Black Iris, III

1945 Roosevelt dies; succeeded by Harry S. Truman

w FEMALE FIGURE
(Caroline Islands)

1926 Nationalists overthrow Manchu dynasty in China
1929 National Revolutionary Party organized in Mexico

1932 Japanese troops invade China and seize Manchuria
1934 Mao Tse-tung leads Chinese Red Army on Long March

1935 Italy invades Ethiopia
1937 Japanese attack China

1942 Chiang Kai-shek becomes president of Chinese National Republic

1945 World War II ends
1947 British India divided into independent India and Pakistan
1947 Dead Sea Scrolls discovered
1948 State of Israel proclaimed
1948 South African author Alan Paton's *Cry, the Beloved Country*
1949 People's Republic of China proclaimed

x MASK
(New Hebrides)

1900 Sigmund Freud's *Interpretation of Dreams*
1901 In England, Queen Victoria dies; succeeded by Edward VII
1901 Thomas Mann's *Buddenbrooks*
1901 Pop. (in millions): Russia, 146; Germany, 56; England and Ireland, 41; France, 39; Italy, 32
1901 Guglielmo Marconi sends first transatlantic telegram
1903 George Bernard Shaw's *Man and Superman*
1904 Giacomo Puccini's *Madame Butterfly*

 1905 Sinn Fein organized in Dublin
 1905 Henri Matisse and others exhibit Fauvist paintings
 1905 Albert Einstein's special theory of relativity
 1905–06 Matisse's *Joy of Life*
 1907 Pablo Picasso's *Demoiselles d'Avignon*
 1908 Brancusi's *The Kiss*
 1909 First Futurist manifesto

l Henri Matisse
(French)
Nasturtiums and the "Dance," II

 1910 Wassily Kandinsky's *Composition No. 2*
 1910 Igor Stravinsky's *Firebird*
 1912 Marcel Duchamp's *Nude Descending a Staircase*
 1913 Marcel Proust's *Swann's Way*
 1913 Apollinaire's poems, *Alcools*
 1914 World War I begins

m Pablo Picasso
(Spanish)
Gertrude Stein

 1915 Franz Kafka's *Metamorphosis*
 1916 Dada founded in Zurich
 1917 Russian Revolution
 1917 Journal *De Stijl* appears
 1918 World War I ends
 1918 Malevich's *Suprematist Composition, White on White*
 1919 Weimar Republic founded in Germany
 1919 Walter Gropius establishes Bauhaus in Weimar

 1922 Benito Mussolini forms Fascist government in Italy
 1922 James Joyce's *Ulysses*
 1924 André Breton's *Surrealist Manifesto*

1900 Pop. 76 million
1903 Wright brothers' airplane flight

n Stuart Davis
(American)
Edison Mazda

 1905 Alfred Stieglitz opens gallery "291" in New York
 1908 Henry Ford introduces Model T car
 1909 Frank Lloyd Wright's Robie House, Chicago, Illinois

 1912 New Mexico and Arizona become 47th and 48th states
 1913 Armory Show in New York City

 1917 U.S. enters World War I

o Marsden Hartley
(American)
Portrait of a German Officer

 1921 Congress severely restricts immigration
 1922 T.S. Eliot's "The Wasteland"
 1924 George Gershwin's *Rhapsody in Blue*

1901 Pop. (in millions): China, 350; India, 294; Japan, 45
1902 British victorious in Boer War
1904–05 Russo-Japanese War

p Shrine
(Nigerian)

 1905 Sun Yat-sen organizes Chinese revolutionary alliance

 1910 British establish Union of South Africa
 1912 Edwin Lutyens designs New Delhi, India

q Stool
(Zaire)

 1922 Mohandas Gandhi imprisoned for civil disobedience
 in India

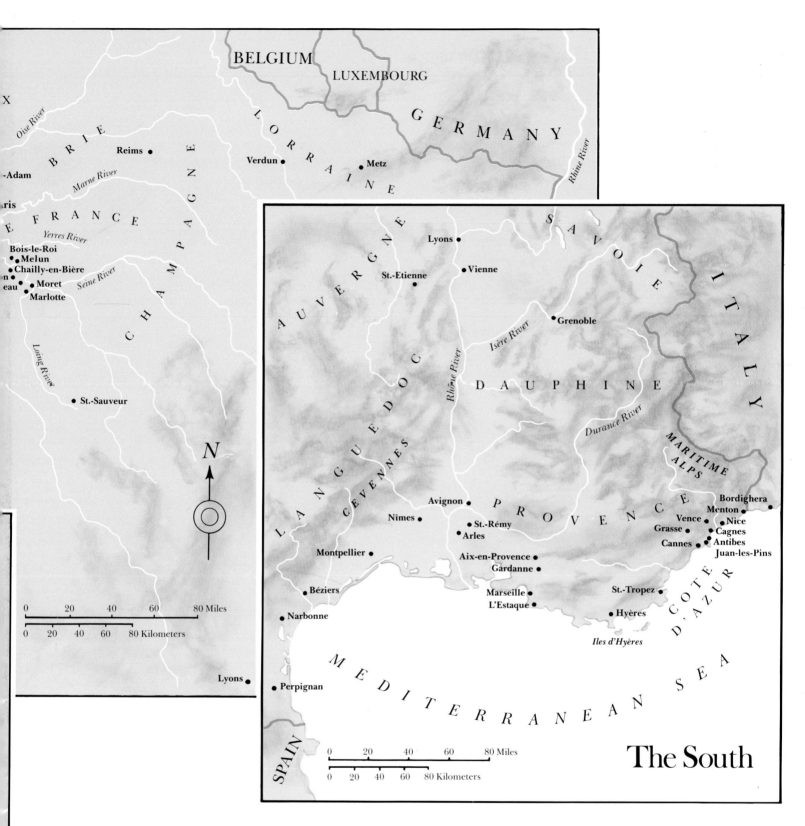

The South